Apple Pro Training Series
Aperture 1.5

Orlando Luna and Ben Long

Apple
Certified

Apple Pro Training Series: Aperture 1.5
Orlando Luna and Ben Long
Copyright © 2007 by Orlando Luna and Ben Long

Published by Peachpit Press. For information on Peachpit Press books, contact:

Peachpit Press
1249 Eighth Street
Berkeley, CA 94710
(510) 524-2178 or (800) 283-9444
Fax: (510) 524-2221
http://www.peachpit.com
To report errors, please send a note to errata@peachpit.com.
Peachpit Press is a division of Pearson Education.

Editor: Serena Herr
Apple Series Editor: Nancy Peterson
Production Coordinator: Laurie Stewart, Happenstance Type-O-Rama
Technical Reviewers: Brendan Boykin, Estelle McGechie
Copy Editor: Karen Seriguchi
Compositors: Chris Gillespie, Robin Kibby, Happenstance Type-O-Rama
Indexer: Jack Lewis
Media Production: Eric Geoffroy
Cover Illustration: Kent Oberheu
Cover Production: Chris Gillespie, Happenstance Type-O-Rama

ISBN 0-321-49662-0
9 8 7 6 5 4 3 2 1
Printed and bound in the United States of America

Contents at a Glance

Table of Contents

Getting Started

Welcome to the official Apple Pro training course for Aperture, Apple's all-in-one postproduction tool for photographers. This book is a comprehensive guide to Aperture and uses a variety of real-world photography projects to show the many uses of the application.

Whether you're a fashion, wedding, sports, portrait, fine art, commercial, or editorial photographer, Aperture's Camera RAW workflow and flexible image organization and editing tools give you more control and greater efficiency than ever before.

And it doesn't matter if you are a seasoned guru or a beginner in digital shooting: Aperture will help you create beautiful prints and engaging websites. So let's get started.

The Methodology

This book takes a hands-on approach to learning Aperture. The lessons are designed to let you be a "fly on the wall" at several real-world photo assignments, performing importing, organizing, image editing, and all the other tasks associated with a photo shoot in the context of a professional workflow. The projects represent a cross-section of specialty photography genres and types of shoots. Whether or not your type of photography is specifically featured, you will find that the depicted assignments and shoots can be applied to any type of photography.

Aperture has an extensive list of keyboard shortcuts and varied ways of navigating through its menus and interface. We will focus on the most common keyboard shortcuts you can use to increase your efficiency. Aperture's *Getting Started* guide (available from the Help menu) includes a comprehensive list of keyboard shortcuts.

Course Structure

This book is divided into two sections. The first section, Lessons 1–7, is a single photo assignment of a typical catalog shoot and provides a comprehensive introduction to the Aperture interface, its features and capabilities, and the most common ways to use the tool in a professional workflow.

The second section, Lessons 8–12, uses several different photo assignments to explore Aperture's more advanced capabilities. In particular, this section focuses on more advanced techniques for organizing images, using metadata, image editing, web output, and archiving.

System Requirements

Aperture leverages the Core Image layer in Mac OS X and your GPU (graphics processing unit) to achieve real-time performance previously not available for RAW files. Applications such as Final Cut Pro are designed to scale from G4-based systems all the way up to fully equipped Mac Pro systems. While this is also the case with Aperture, certain hardware is required in order to take advantage of its real-time performance capabilities.

Minimum System Requirements

Aperture requires one of the following Macintosh computers:

- ▶ Mac Pro with a 2 GHz or faster Dual-Core Intel Xeon processor
- ▶ Power Mac G5 with a 1.8 GHz or faster PowerPC G5 processor
- ▶ 15- or 17-inch PowerBook G4 with a 1.25 GHz or faster PowerPC G4 processor
- ▶ iMac with 1.8 GHz or faster PowerPC G5 or Intel Core Duo processor
- ▶ MacBook Pro

Aperture also requires:

- ▶ Mac OS X version 10.4.8 (or later)
- ▶ 1 GB of RAM
- ▶ One of the following graphics cards:
 - ▶ ATI Radeon x600 Pro or x600 XT
 - ▶ ATI Radeon X800 XT Mac Edition
 - ▶ ATI Radeon X850 XT
 - ▶ ATI Radeon X1600
 - ▶ ATI Radeon X1900 XT
 - ▶ ATI Radeon 9800 XT or 9800 Pro
 - ▶ ATI Radeon 9700 Pro
 - ▶ ATI Radeon 9600, 9600 XT, 9600 Pro, or 9650
 - ▶ ATI Mobility Radeon 9700 or 9600
 - ▶ ATI Mobility X1600
 - ▶ NVIDIA GeForce 6600 LE or 6600
 - ▶ NVIDIA GeForce 6800 Ultra DDL or 6800 GT DDL
 - ▶ NVIDIA GeForce 7300 GT
 - ▶ NVIDIA GeForce 7800 GT
 - ▶ NVIDIA Quadro FX 4500
- ▶ 5 GB of disk space for application, sample projects, and tutorial

Recommended System

Apple Computer recommends the following system configuration to run Aperture:

▶ Mac Pro with a 2 GHz or faster Dual-Core Intel Xeon processor, or Power Mac G5 with dual 2 GHz or faster PowerPC G5 processors

▶ Mac OS X version 10.4.8 (or later)

▶ 2 GB of RAM

▶ One of the following graphics cards:

 ▶ ATI Radeon X800 XT Mac Edition

 ▶ ATI Radeon 9800 XT or 9800 Pro

 ▶ ATI Radeon X1600

 ▶ ATI Radeon X1900 XT

 ▶ NVIDIA GeForce 6800 Ultra DDL or 6800 GT DDL

 ▶ NVIDIA GeForce 7300 GT

 ▶ NVIDIA GeForce 7800 GT

 ▶ NVIDIA Quadro FX 4500

▶ 5 GB of disk space for application, sample projects, and tutorial

Check for the Latest Recommendations

Minimum and recommended system requirements are constantly evolving as new configurations of hardware and software become available. To check for the latest requirements, go to www.apple.com/aperture.

Copying the Aperture Lesson Files

To follow along with all the lessons, you will need to copy the lesson files onto your hard drive. The lesson files are located on the DVD accompanying this book.

1 Insert the *APTS_Aperture1.5* DVD into your computer's DVD drive.

 The Finder window will open, displaying the contents of the DVD. If the window does not appear, double-click the *APTS_Aperture1.5* DVD icon to open it.

2 Create a new folder on your hard drive. Name the folder *APTS_Aperture_ book_files*.

The location of this folder is important. You will be adding lessons and referring to this folder throughout the book.

3 Drag the Lessons folder from the DVD into the APTS_Aperture_book_files folder you just created. The files will be copied onto your hard drive.

4 Eject the DVD.

NOTE ▶ In the event of a project file error, any corrected or updated project files will be posted at: www.peachpit.com/apts.aperture1.5.

NOTE ▶ The content on this book's DVD is built for Aperture 1.5. If you are opening an Aperture Library created with version 1.0 or 1.1, Aperture will inform you that it is updating the Library structure and creating pre-views for version 1.5. For information on migrating images, see Aperture's documentation. Note that once you open a Library with Aperture 1.5, you will not be able to move backward and open it with 1.1.2 or earlier ver-sions, so be sure to back up your Library first if this is an issue.

Keeping Your Work Environment Neutral

Your work area affects how you judge your images. Your eyes are both your best friend and your worst enemy when it comes to evaluating images. Paint the wall behind your display a bright shade of red, and you have just desensitized your eyes to that hue. Your brain has a built-in filtering system that constantly compensates for your viewing environment. As a result, if you work in a room painted bright red and manually adjust the color of an image, it will undoubtedly result in unwanted excess red values.

Adjusting Your Work Environment

1 Paint your walls a neutral gray.

2 Purchase daylight-balanced lighting for your work area. These lights are readily available in specialty lighting stores and can replace fluorescent and other type of lighting.

3 Dim the lights so that your display's luminance is brighter than the room.

Okay, you don't have to paint your office to do the lessons in this book, but taking all of these steps will create a work environment that will help you more accurately evaluate the color and quality of your images.

Adjusting Your System Preferences

The look of your default desktop background and interface colors are awe-inspiringly stylish. The experts who created these looks and backgrounds are certainly talented artists. However, when you are making critical color corrections and working with images in postproduction, it pays to be bland. Let's adjust some System Preferences to neutralize your workspace.

1 In the Finder, choose System Preferences from the Apple menu.

2 Select Display.

3 Choose your working resolution, and choose Millions from the Colors pop-up menu.

> **NOTE ▶** If you are using an LCD display, make sure you select the native resolution of that display. Native resolution information can be found in the manufacturer's documentation.

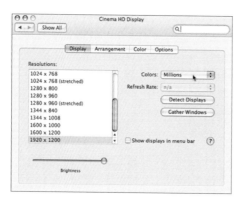

4 Click the Show All button in the upper left corner of the System Preferences pane.

5 Click the Desktop & Screen Saver icon. If the Screen Saver pane appears, click the Desktop button to view the Desktop pane.

6 Choose Solid Colors from the list at the left. Then, choose the Solid Gray Dark color square.

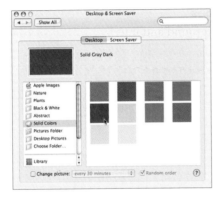

7 Click the Show All button.

8 Choose Appearance.

9 Choose Graphite from the Appearance pop-up menu, and choose Graphite from the Highlight Color pop-up menu.

If you have been using Mac OS X's default setup, you should now notice that your close, minimize, and maximize buttons are gray instead of red, yellow, and green.

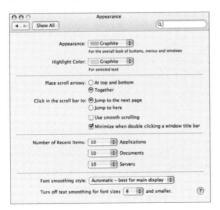

10 Close System Preferences.

Welcome to your new life working in a dark cave.

Calibrating Your Display

One of the most important aspects of managing your photos is achieving predictable color. Mac OS X uses a built-in color-management technology called ColorSync, which uses industry-standard ICC profiles to manage your color across multiple devices. Displays and printers often ship with ICC profiles that can be installed along with their drivers. These generic profiles are a good starting point, but in order to implement an advanced color-management workflow, all of the devices in your production loop should be calibrated with instruments such as colorimeters and spectrophotometers. Colorimeters are used to measure color values on LCD or CRT displays; spectrophotometers measure the wavelength of light across the visible spectrum of colors and can be used to profile both displays and printers.

Colorimeter Spectrophotometer

Unfortunately, it's beyond the scope of this book to walk through the process of color calibrating your display, input devices, and output devices. But you should know that it's an important part of setting up any digital darkroom. For more information on color calibration, see the Apple Pro Training Series book *Color Management in Mac OS X: A Practical Approach*, by Joshua Weisberg.

About the Apple Pro Training Series

Apple Pro Training Series: Aperture is part of the official training series for Apple Pro applications, developed by experts in the field and certified by Apple Computer. The lessons are designed to let you learn at your own pace. If you're new to Aperture, you'll learn the fundamental concepts and features you'll need to master the program. Although each lesson provides step-by-step instructions for making specific changes to your Aperture Library, there's plenty of room for exploration and experimentation.

For those who prefer to learn in an instructor-led setting, Apple also offers training courses at Apple Authorized Training Centers worldwide. These courses, which use the Apple Training Series books as their curriculum, are taught by Apple Certified Trainers and balance concepts and lectures with hands-on labs and exercises. Apple Authorized Training Centers have been carefully selected and have met Apple's highest standards in all areas, including facilities, instructors, course delivery, and infrastructure. The goal of the program is to offer Apple customers, from beginners to the most seasoned professionals, the highest-quality training experience.

To find an Authorized Training Center near you, go to www.apple.com/software/pro/training.

For a complete catalog of Apple Pro Training Series titles, visit www.peachpit.com/applepro.

Apple Pro Certification Program

The Apple Pro Training and Certification Programs are designed to keep you at the forefront of Apple's digital media technology while giving you a competitive edge in today's ever-changing job market. Whether you're a photographer, digital technician, photographer's assistant, studio manager, or stock photo manager, these training tools are meant to help expand your skills.

Upon completing the course material in this book, you can become an Apple Pro by taking the certification exam at an Apple Authorized Training Center. Certification is offered in Final Cut Pro, DVD Studio Pro, Shake, Motion, and Logic Pro. Certification as an Apple Pro gives you official recognition of your knowledge of Apple's professional applications while allowing you to market yourself to employers and clients as a skilled, professional-level user of Apple products.

To find an Authorized Training Center near you, go to www.apple.com/software/pro/training.

Resources

Apple Pro Training Series: Aperture is not intended as a comprehensive reference manual, nor does it replace the documentation that comes with the application. For comprehensive information about the program features, refer to these resources:

▶ *User Manual:* Accessed through the Aperture Help menu, the *User Manual* contains a complete description of all features.

▶ Aperture product Web site: www.apple.com/aperture.

Aperture Basics

1

<table>
<tr><td>Lesson Files</td><td>APTS_Aperture_book_files > Lessons > Lesson01</td></tr>
<tr><td>Media</td><td>Aperture Tibet sample project
Aperture Library</td></tr>
<tr><td>Time</td><td>This lesson takes approximately 1 hour to complete.</td></tr>
<tr><td>Goals</td><td>Open Aperture and view RAW images
Set up Aperture as your default image-capture application
Tour Aperture's main window
Explore Aperture's preset workspaces
Customize the toolbar
Customize the workspace
Change the Aperture default Library</td></tr>
</table>

Exploring the Aperture Workflow

Apple Aperture is a revolutionary image management program that allows commercial photographers to work with Camera RAW images from capture to output. As you will learn throughout the lessons of this book, Aperture makes working with RAW images as easy as using TIFF or JPEG images, allowing you to import, edit, organize, publish, and archive them without ever converting them to another format.

The best way to see how efficient it is to work in Aperture is to simply get started. In this lesson, you will open Aperture, preview some RAW images in Aperture, navigate the interface, and learn how Aperture organizes images using its Library, albums, projects, and folders.

Before opening Aperture, be sure that you have read "Getting Started" on page 1, that you have the proper system requirements and resources, that you've copied the lesson and project files to your hard disk as instructed, and that you've calibrated your display for optimal color accuracy.

Opening Aperture

There are three ways to open Aperture:

▶ By double-clicking the Aperture application icon

▶ By defining Aperture as your default image application and inserting a camera card or attaching a camera

▶ By clicking the Aperture application icon in the Dock

Let's start by opening Aperture from the Dock.

Adding Aperture to the Dock

You can add Aperture to the Dock as you would any other Mac OS X application.

1 Click the desktop to make sure you're in the Finder.

You should see the word *Finder* next to the Apple logo in the upper left corner of your screen.

2 Choose Go > Applications. The Applications folder opens in a Finder window.

3 Locate Aperture in the Applications window and drag the Aperture application icon to the Dock.

If you inadvertently release the mouse button outside the Dock, the Aperture icon will be moved to your desktop. If that happens, drag it back to the Applications folder and try again.

4 Close the Applications window.

That's it. Now you're ready to open Aperture and get to work.

Launching Aperture for the First Time

It's time to take Aperture on its maiden voyage.

> **NOTE** ▶ If you are upgrading from a previous version, during installation Aperture will ask you whether you want to upgrade your Library. Once you open a Library with Aperture 1.5, you will not be able to move backwards and open it with 1.1.2 or earlier versions, so be sure to back up your Library first if this is an issue.

1 Click the Aperture icon in the Dock to open the application.

When you open Aperture for the first time, the Welcome screen appears.

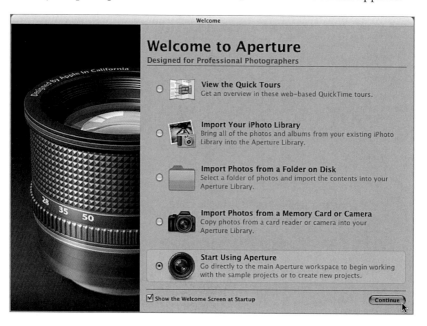

The Welcome screen has five options plus a checkbox. Let's take a look at all of the options before we move on.

▶ View the Quick Tours—points your web browser to QuickTime movies about Aperture

▶ Import Your iPhoto Library—allows you to import the current iPhoto Library

▶ Import Photos from a Folder on Disk—allows you to import from a variety of media, including hard disks, CDs, and DVDs

▶ Import Photos from a Memory Card or Camera—looks for a mounted camera or media card to import from

▶ Start Using Aperture—opens directly into Aperture

▶ Show the Welcome Screen at Startup—a checkbox that should be deselected if you would like to bypass the Welcome screen in future sessions

We will learn how to import images from iPhoto, from a disc, and from a memory card or camera in Lesson 2. Right now, let's start using Aperture.

2 Make sure Start Using Aperture is selected, and then click the Continue button in the lower right corner of the Welcome screen.

Aperture prompts you to set it as the default application for your digital camera.

3 Click the Use Aperture button to select Aperture as the default application for importing images from a connected camera or media card.

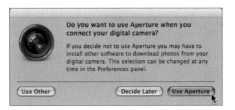

NOTE ▶ If you have previously opened Aperture and selected either Use Other or Use Aperture, this screen will not appear. If you are not sure Aperture has been set as your default image-capture application, do the following when Aperture opens: Choose Aperture > Preferences. In the Preferences dialog, choose "When a camera is connected, open" > Aperture, if it is not already chosen. Close the Preferences window.

Next, Aperture asks if you'd like to import a sample project. We'll start our real-world, though fictional, project in Lesson 2. For the purposes of simply learning the interface in this lesson, let's import a sample project of RAW images that ships with the application.

4 Click the Import button to import the Tibet sample project included with the Aperture installation disc.

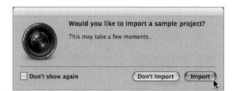

NOTE ▶ If this window did not appear, it may be because you've opened Aperture before and you previously checked the "Don't show again" box. To import the Tibet project manually, choose File > Import > Projects, navigate to Macintosh HD/Library/Application Support/Aperture/Sample Projects, select the Tibet project, and open it.

Aperture adds the Tibet project to the Projects panel in the upper left corner of the Aperture main window, displays image thumbnails in the Browser at the bottom of the main window, and displays one large image in the Viewer in the center of the main window. Let's get acquainted with these and other aspects of the Aperture interface next.

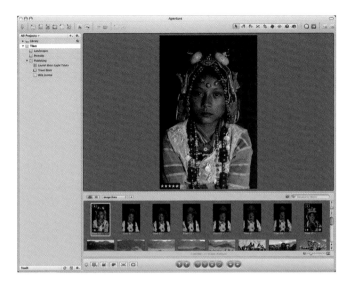

Getting to Know the Aperture Interface

The Aperture interface opens to the Basic layout. This layout doesn't show some particularly useful inspectors, however, so let's open those before we continue.

1 Make sure the Tibet project is selected in the Projects panel.

2 Click the Show Adjustments button in the upper right of the main window. The Inspectors panel opens at the right side of the main window and displays the Adjustments Inspector.

3 Click the Show Metadata button (next to the Show Adjustments button)
to display the Metadata Inspector in the Inspectors panel.

Now, all of the fundamental panels and inspectors are open onscreen. Let's
learn what each one is and does.

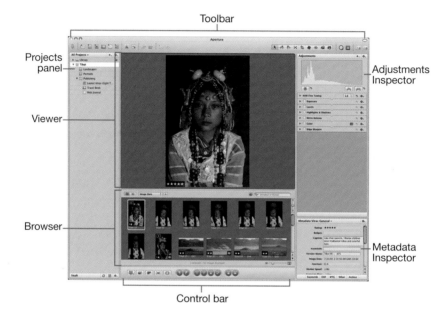

▶ Projects panel—This panel displays your organizational hierarchy.
It can contain projects, albums, folders, books, web galleries, and web
journals.

▶ Browser—The Browser displays all of the photos in a selected project,
folder, or album, in a thumbnail (grid) or column view. You can use the
Browser to select, move, copy, and sort images.

▶ Viewer—The Viewer displays one or more images that are selected in
the Browser. You can zoom in to images in the Viewer and see metadata
about the images in a pop-up window. Currently, the first image in the
Tibet project, **Tibet 05 – 075**, is selected in the Browser, so it appears in
the Viewer.

▶ Toolbar—The toolbar provides one-click access to your most frequent tasks. You can customize the toolbar to include the options you want to appear.

▶ Control bar—The control bar provides options for adding keywords and ratings, and for selecting views.

▶ Adjustments Inspector—The Adjustments Inspector provides controls and options for image correction and stylization.

▶ Metadata Inspector—The Metadata Inspector allows you to view and edit image metadata, such as copyright information, captions, and keywords.

Aperture offers robust support for metadata. We'll use metadata extensively over the course of the lessons in this book. Take a quick minute now to see something nifty.

4 Position the cursor over an image thumbnail in the Browser, or over the image in the Viewer. Aperture displays the image metadata in a floating pop-up window. You can toggle this information on and off by pressing the T key. Go ahead and try, but make sure you leave the information on for an exercise you'll do later in this lesson.

Using the Aperture Layouts

Aperture ships with a number of preset workspace layouts, including the Basic workspace that appeared when you opened Aperture earlier. Each of these workspace layouts emphasizes different panels, and each can be customized to suit your work style and personal taste. Let's explore them further now.

1 Choose Window > Layouts > Basic, or press Command-Option-S, to display the Basic layout.

The Basic layout shows the Projects panel as well as the Browser in a grid or list view and the Viewer above the Browser. This layout is good when you want to evaluate images, perform basic image rating, and create and work with stacks.

2 Press Command-Option-B to bring up the Maximize Browser layout.

The Maximize Browser layout provides a large view of the Browser and closes all panels except the Projects panel, making it easy to select and work with multiple projects. You can quickly open different projects in the Projects panel and make changes as needed.

3 Choose Window > Layouts > Maximize Viewer, or press Command-Option-V, to bring up the Maximize Viewer layout.

The Maximize Viewer workspace shows the Browser on the bottom and a large Viewer on the top, with the Projects panel and the control bar hidden to maximize space. In this layout, you can easily select images in the Browser and see a large view of selected images in the Viewer.

You can use buttons on the default toolbar to activate the layouts. Let's add the three layouts to the toolbar.

4 Control-click the toolbar and choose Customize Toolbar from the contextual menu that appears.

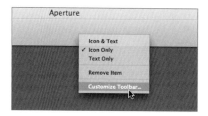

An untitled window appears, displaying items that you can add to the toolbar. Simply drag any of the elements to the toolbar to customize it.

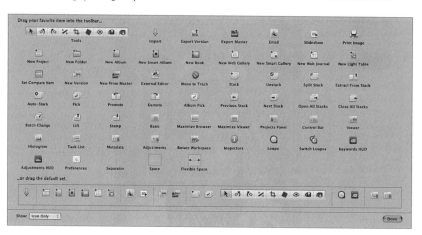

5 Drag the Basic, Maximize Browser, and Maximize Viewer buttons to the left of the Show Adjustments button on the toolbar.

6 Drag the Separator between the Maximize Viewer button and the Show Adjustments button.

7 Click Done to close the Customize Toolbar window.

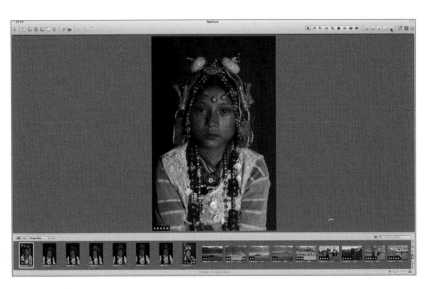

The toolbar can be customized with buttons that you want to use in your own workflow. It can be hidden by choosing View > Hide Toolbar or by pressing Shift-T on the keyboard.

Customizing the Workspace

Although these preset layouts are very useful in Aperture, you don't have to be limited by them. You can selectively display and hide just about any interface element to suit your needs. Finding a layout that works for you, and knowing how to open and close panels quickly with keyboard shortcuts, will greatly enhance your work experience and make you more productive in Aperture. For a quick refresher of modifier keys, refer to the following figure.

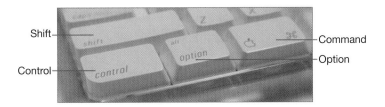

1 Press Command-Option-S to return to the Basic layout.

2 Press the I key to display the Inspectors panel.

3 Press the W key to hide the Projects panel.

4 Press the V key to hide the Viewer.

5 Press D to hide the control bar.

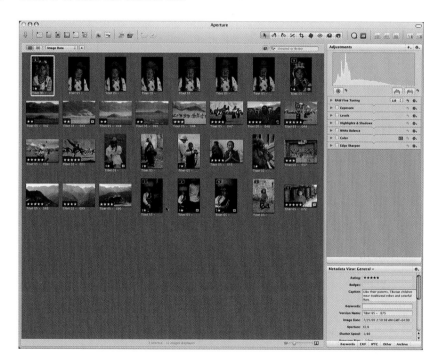

6 Press Command-Option-S to return to the Basic layout.

7 Press Option-W to flop the Browser and Viewer positions.

8 Press Shift-W to rotate the Browser to the right.

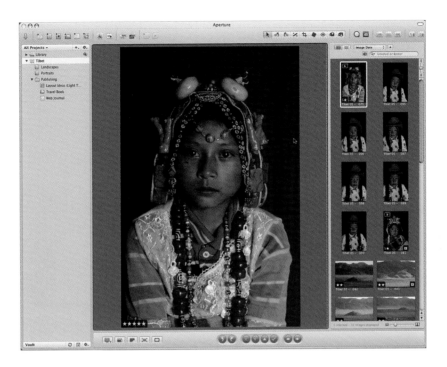

Taking time to learn these shortcuts is a good way to quickly increase your productivity in Aperture. Until you memorize them, however, note that most of these commands are also available in the Window menu.

In addition to the keyboard shortcuts available for customizing the interface, Aperture offers numerous other shortcuts that can dramatically speed your productivity as you perform routine tasks. These shortcuts are also worth memorizing. To help you become more familiar with them, we will use them increasingly throughout this book.

TIP ▶ Choose Help > Quick Reference to access a complete list of keyboard shortcuts.

Understanding Camera RAW

As stated earlier, Aperture is revolutionary in its handling of Camera RAW image files. The Tibet images that you're viewing in Aperture now, and many of the images we'll use throughout this book, are Camera RAW images. If you're new to Camera RAW, here's a brief explanation of the format and what makes it so special.

The image sensor in a digital camera is made up of millions of individual light-sensitive elements. When struck by light, these elements convert light energy to voltage values. Then, an analog-to-digital chip converts the voltage values into digital data. At this stage, the data is in "raw" form. Many cameras allow you to save the raw data in a proprietary Camera RAW image file, without processing the image in another file format. In essence, all cameras with an image sensor use a RAW workflow.

NOTE ▶ In some ways, the relationship between a camera's image sensor and Aperture is much like the relationship between the human eye and the brain. The image sensor in a camera is similar to an eye's rods and cones. In the same way that Aperture processes the data from the camera's image sensor, our brain processes information from our eyes' rods and cones.

The RAW format allows up to 16 bits of color to be stored, or 65,536 colors per channel. The analog-to-digital converters in high-end digital cameras use a 10- to 14-bit color space and then store images in a 16-bit RAW format. If

you choose to process the data in your camera in a format other than RAW, you may be reducing perfectly good color information.

The decision to save in a RAW format is an option on many cameras. The RAW format contains the unprocessed image data plus additional, specific information about when and how a frame was shot. (This information is called *metadata*, which we touched on briefly earlier.) If you decide to save your images as JPEG or TIFF files, the camera processes the data in a format that may reduce the image's bit depth, thus permanently affecting its color. Decisions you make for image settings, such as sharpness and color, become permanently etched into the saved JPEG or TIFF files. Saving to a RAW format allows you to make such image-processing decisions during the postproduction workflow instead. Some cameras have a RAW+ mode that enables you to save RAW data and a processed version concurrently, which you may prefer if you plan on printing directly from the camera to a personal printer. Using this mode does, however, take up additional storage, as you are storing two files for each image.

There is no one RAW standard. RAW files have different nuances from manufacturer to manufacturer. Even products from a given manufacturer may have different versions of RAW. Aperture supports most of the major RAW variants, including CR2, CRW, DNG, NEF, and OLY, and Apple will continue to expand support as new RAW versions appear.

> **NOTE ▶** Mac OS X has some built-in basic support for RAW images. RAW images can be previewed directly in the Finder's column view and in the Info window. Apple's Preview application can also open RAW images. These mechanisms are solely for preview purposes, and they provide basic information about file size, format, and pixel count without your having to open the image in an imaging application.

Understanding Other Image Formats

In addition to RAW, Aperture works with a number of processed-image file formats, including JPEG, PSD, and TIFF.

JPEG (Joint Photographic Experts Group) JPEG is often the default setting for point-and-shoot digital cameras, and most of the photos displayed on webpages are in this format. (The file extension is *.jpg*.) JPEG allows for a significant reduction in the file size of photographic images, but it is a *lossy* compression format. That means it groups the image data on the basis of the human eye's inability to perceive certain values. The less-perceptible areas are averaged together, and information is lost. This is referred to as *lossy compression*. Because of this lossy compression, it's important to always keep a digital original of JPEG images in a lossless format.

PSD This is the proprietary format for Adobe Photoshop files. It supports layers as well as a number of other proprietary features within Photoshop. Many applications, including Aperture, can display files in this format.

TIFF (Tagged Image File Format) Originally created by Aldus for PostScript printing, this flexible file format is universally read by most image-processing and layout applications. Files in this format have the extension *.tif*. The TIFF specification is controlled by Adobe Systems.

Working with Aperture's File Structure

Let's turn our attention to the items in the Projects panel in Aperture, which will help us learn how Aperture manages images and allows you to edit them nondestructively. To understand how Aperture works, you need to understand the concept of masters and versions.

Masters and Versions

Aperture is nondestructive. Your original image is always preserved as a digital master file. Any adjustments you make to the image are performed on versions of the original.

The digital master file can be stored inside or outside the Aperture Library. Images stored inside the Library are *managed* images. If an image is stored outside the Library, it is a *referenced* image. You'll learn how to decide whether an image should be managed or referenced when you import images in Lesson 2. In either case, the first appearance of an image in Aperture is considered version 1 of the image.

It's important to understand that while versions appear as images in the Browser and Viewer, and behave like image files in the Projects panel, they are not actually new image files. Versions are instructions; Aperture uses them to show adjustments made to the master file. Because version files are quite small, you can make countless versions of a full-resolution RAW image without significantly increasing your storage needs, and you can always return to your untouched master file.

If you make an adjustment to an image, you don't need to rename it or perform a Save As operation. The version you created is saved within your project. Of course, anytime you make an adjustment to a version, you can create a full image file that incorporates the adjustment by simply exporting the version.

Understanding the Aperture Library

The Library is essentially your database; it is a managed collection of images and versions of both managed and referenced images. Once you import images, the Library records and tracks your digital master files and corresponding versions. It is important not to move a referenced image from the location to which it was originally imported. The Library also tracks projects and albums you create to organize your images.

1 Press Command-Option-S to return to the Basic layout.

2 Select the Library in the Projects panel.

This is the default Aperture Library. The images in the Tibet project, which is underneath the Library in the Projects panel, were added to the Library when they were imported. These are managed images.

Organizing Images Using Projects and Albums

Projects are the basic organizational unit in Aperture. You can also use albums to organize your images.

1 Select the Tibet project in the Projects panel and, if necessary, click the disclosure triangle to open its contents. Open the Publishing folder, too, if it's not already open.

Projects are container files that hold master files, versions, and the metadata associated with images. They are important because they track your digital master files and all changes to versions. They can also contain such elements as folders, albums, web gallery albums, journals, and Light Table sessions. Projects can be created automatically when images are imported and can also be created manually at any time. An image

can be moved from one project to another, but not shared between projects. Projects appear as file cabinet icons in the Projects panel.

2 Select the Landscapes item in the Projects panel.

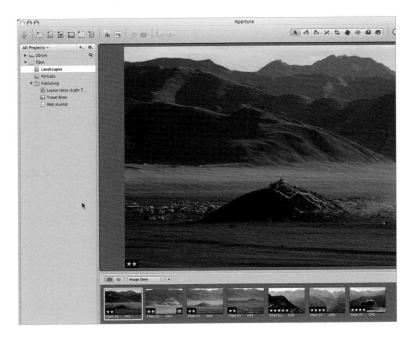

The Landscapes item is an album; it contains landscape images within the Tibet project. Albums are a way to organize images into categories, such as by event, job, or location. Albums contain pointers to images in one or more projects; multiple albums can point to the same images without duplication. Albums can reside inside or outside projects and folders. They appear as book-page icons in the Projects panel. Let's create an album now so that you can see how they work.

3 Select the Tibet icon in the Projects panel and then choose File > New > Album to create a new, empty album in the Tibet project.

4 Name the new album *Tibet Selections* and press Return.

5 Select the Tibet icon again to view all of the images in the Tibet project.

6 Position the cursor over the first image in the Browser, **Tibet 05 – 075**, to
 see the pop-up metadata window.

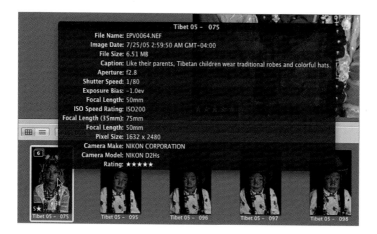

7 Look at the last item in the window: Rating. This image has a five-star rat-
 ing, applied by the person who created the project, indicating that it is one
 of the best images in the collection.

8 Drag this image to the Tibet Selections icon in the Projects panel to add it
 to that album.

9 Select the second image in the Browser, **Tibet 05 – 095**, and with the cur-
 sor over the thumbnail, see if this image has a five-star rating. Nope.

10 Navigate to the rest of the images in the project, and check their ratings in
 the pop-up metadata window. Drag each image with a five-star rating to the
 Tibet Selections album.

11 Select the Tibet Selections album to see its contents.

Congratulations! You've just created an album that contains this photographer's most highly rated Tibet images.

NOTE ▶ You'll learn more about navigating the Browser and rating images in Lesson 3.

Organizing Using Folders

Folders are another important organizational element in Aperture. They simply allow to you group organizational elements together; they do not contain images. For example, you can place projects and albums inside folders. You can also use folders to organize albums within a project. They appear as folder icons in the Projects panel—blue folders if they contain projects and yellow folders if they are within a project.

1 Click the Tibet icon in the Projects panel to select it.

2 Choose File > New Folder (or press Command-Shift-N) to create a new folder inside the Tibet project.

3 Name the new folder *Tibet Albums*, and then press Return.

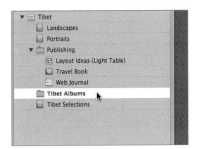

4 Drag the Tibet Selections album to the Tibet Albums folder.

5 Drag the Landscapes album to the Tibet Albums folder.

6 Drag the Portraits album to the Tibet Albums folder.

Now all of the Tibet albums are organized into one folder.

NOTE ▶ You can delete the Tibet project, folder, and albums now if you'd like to free up space on your hard disk. You won't need them for subsequent lessons in this book.

Selecting an Alternate Aperture Library

Although Aperture is most efficient when using one Library, you can work with multiple Libraries if you'd like. You might want to use multiple Libraries when you plan to archive images differently, such as for current jobs versus completed jobs, or for your own images versus someone else's images. Working with multiple Libraries requires a lot of care and organization; it isn't recommended. However, in order to protect your current Aperture Library, we are going to switch to a different Library for the remaining lessons in this book. You can switch back to your user Library after you complete the lessons.

1 Choose Aperture > Preferences.

The default Aperture Library is located in the ~/Pictures folder (the tilde indicates your home directory), but it can be located on any mounted or networked drive.

2 Click the Choose button.

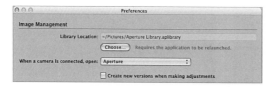

3 Navigate to the APTS_Aperture_book_files > Lessons > Lesson01 folder and select Aperture Library.

4 Click the Select button.

5 Close the Preferences dialog.

Nothing happens yet. You must quit Aperture and reopen the application for the newly selected Library to become active.

6 Quit Aperture.

7 Open Aperture.

Voilà! You are now using the newly selected Library. Any work we do affects this Library unless we go back to Preferences, choose a different Library, and then quit and reopen Aperture. The only way to tell which Library you are currently using is to go back to the Preferences dialog and view the path information in the Library Location field, which is at the top of the dialog.

NOTE ▸ The Library can also be renamed in the Finder after it has been created. If you rename the Library, you must go back to Preferences to select the renamed Library, as Aperture will have created a new Library named **Aperture Library**.

Quitting Aperture

Aperture dynamically updates your Library while you work. Unlike other applications that require you to save your work as you go, Aperture handles this automatically. When you are done with your Aperture session, simply quit the application.

1 Quit Aperture.

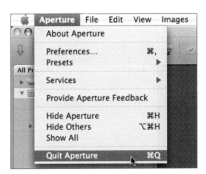

Now that you know your way around Aperture, we will learn how to import images from a variety of media.

Lesson Review

1. Name three ways to open Aperture.

2. How do you set Aperture as your default image-capture application?

3. What is the Maximize Browser view, and how do you display it in Aperture?

4. What is the Camera RAW image format?

5. How do you change the Aperture Library, and when is it appropriate to do so?

Answers

1. You can open Aperture by double-clicking the Aperture application icon, by defining Aperture as your default image application and double-clicking an image, or by clicking the Aperture application icon in the Dock (after you manually add it to the Dock).

2. When you open Aperture for the first time, Aperture prompts you to set it as the default application for your digital camera. You can also set Aperture as your default image-capture application by choosing Aperture > Preferences. In the Preferences dialog, choose "When a camera is connected, open" > Aperture, if it is not already chosen. Then, close the Preferences window.

3. The Maximize Browser layout provides a large view of the Browser and closes all panels except the Projects panel, making it easy to select and work with multiple projects. You can quickly open different projects in the Projects panel and make changes as needed. To display the Maximize Browser layout, choose Window > Layouts > Maximize Browser, or press Command-Option-B.

4. The Camera RAW image format contains the unprocessed "raw" data from a camera's image sensor. The RAW format allows up to 16 bits of color to be stored, or 65,536 colors per channel, and contains additional, specific information about when and how a frame was shot, called metadata. There is no one RAW standard. RAW files have different nuances from manufacturer to manufacturer. Aperture supports most of the major RAW variants, including CR2, CRW, DNG, NEF, and OLY, and Apple will continue to expand support as new RAW versions appear.

5. To change the Aperture Library, choose Aperture > Preferences. Then click
 the Choose button under the Library Location field and choose your new
 Library. Quit Aperture and then reopen it to access the new Library. You
 might want to use different Libraries when you plan to archive images dif-
 ferently, such as for current jobs versus completed jobs, or for your own
 images versus someone else's images.

Keyboard Shortcuts

Command-Option-S	Display Basic layout
Command-Option-B	Display Maximize Browser layout
Command-Option-V	Display Maximize Viewer layout
Control-A	Show Adjustments in the Inspectors panel
Control-D	Show Metadata in the Inspectors panel
I	Display the Adjustments and Metadata Inspectors
W	Hide/show the Projects panel
V	Hide/show the Viewer
D	Hide/show the control bar
T	Hide/show metadata pop-up window
Shift-T	Hide/show the toolbar

2

Lesson Files APTS_Aperture_book_files > Lessons > Lesson02

Media jackson_hole.dmg

Uruguay iPhoto album

sobe.dmg

Time This lesson takes approximately 90 minutes to complete.

Goals Import images from a disc

Import images from iPhoto

Import images from a media card

Add metadata when importing images

Custom name images in the Import dialog

Auto-stack images in the Import dialog

Importing Images into Aperture

In Lessons 2 through 7, you'll be working through the basics of Aperture. For the purposes of illustration, we will follow the real-world workflow of an on-location fashion shoot from start to finish—from scouting and selecting the location to organizing, managing, and evaluating the images, and then to editing the final selections, presenting proofs to the client, delivering the final images, and archiving the job.

For this storyline, imagine that you have received a call from Pepe Creative, the art director at Grande Agency. His agency has been hired to develop next year's ad campaign for a major fashion retailer, and he'd like you to be his photographer. The first task is to choose a location for the photo shoot. To that end, he would like you to send him images from potential locations you have come across during your travels. You happen to have shots taken on recent trips to Colonia, Uruguay, and Jackson Hole, Wyoming. Mr. Creative would also like you to send him some shots from South Beach, Florida, where you live.

In this lesson you will import the location images from three different sources into the Aperture Library: You'll import the Jackson Hole images from a disc, the Uruguay images from iPhoto, and the South Beach images from a media card. Then, in Lesson 3, you'll organize the images and send them to your client.

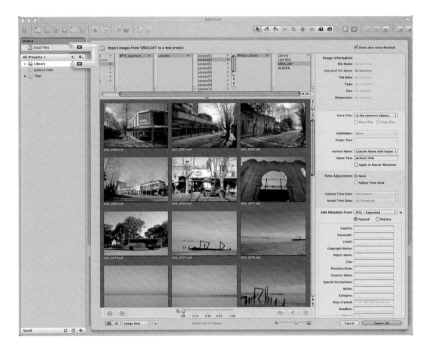

Generating Aperture Previews

Aperture can create JPEG previews of your images during the import process. You can set the size and quality of the previews in Aperture's Preferences window.

1 Open Aperture.

2 Choose Aperture > Preferences.

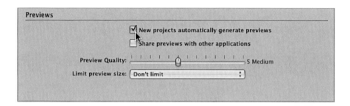

3 Select the checkbox labeled "New projects automatically generate previews" if it is not already selected.

4 Drag the Preview Quality slider to *5 Medium*.

Adjusting the Preview Quality to 5 Medium results in a good-quality image with a reasonable file size.

5 From the "Limit preview size" pop-up menu, choose a resolution that corresponds to your display.

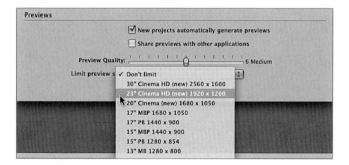

Setting the preview to correspond to your display's resolution will limit the file size but maintain a high-quality 100 percent preview of your image. Changing this parameter affects future imports.

NOTE ▶ Existing images can be updated by Control-clicking a project or image and choosing "Update Previews for Project" or "Update Preview."

6 Close the Aperture Preferences window.

Now that you've set your Preview parameters, it's time to import.

Importing Images from a Disc

Photographers have had to adapt to changes in image gathering and storage since the advent of photography. The digital era has been no less challenging. The standard types of storage media, from floppy disks to CDs to DVDs, have been constantly evolving. As a result, many photographers have files stored on different media and in different formats.

Luckily, Aperture allows you to import from a variety of sources. This includes CDs and DVDs, hard disks, and just about any other source that you can mount on your computer. Let's start by importing images of Jackson Hole, Wyoming, from a CD.

1 Choose Aperture > Hide Aperture. Then in the Finder, navigate to the APTS_Aperture_book_files > Lessons > Lesson02 folder on your hard disk.

2 Double-click the **jackson_hole.dmg** disk image to mount the simulated CD jackson_hole.

3 Switch back to Aperture by clicking its icon in the Dock.

4 In Aperture, click the Import Panel button, which is in the upper left corner of the main window.

The Import panel opens in the upper left corner of the main window, above the Projects panel.

Choosing the Source and Destination

You choose the source of your imported images in the Import panel, and the destination in the Projects panel. Aperture displays an animated Import arrow from the source location in the Import panel to the destination in the Projects panel. You can point to existing projects or albums, or you can create a new, untitled project as your destination by pointing to the Library or to a folder. We'll point to our Library to import the images of Jackson Hole, Wyoming.

1 Select the jackson_hole CD icon in the Import panel.

 The trailing end of the Import arrow appears next to the jackson_hole CD icon. (Be careful not to click the Eject symbol for the jackson_hole CD.)

2 Make sure the head of the Import arrow points to the Library in the Projects panel.

When you specify the source and destination of your import operation, the Import dialog appears. The Import dialog offers a Browser-like area for previewing and selecting images to import, as well as options on the right for specifying metadata.

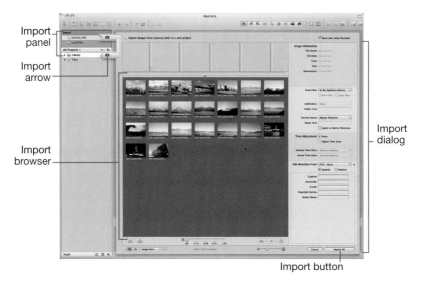

Import panel

Import arrow

Import browser

Import dialog

Import button

Now you can choose the images you want to import.

Making Selections

You can identify which images you want to import by selecting them in the Import dialog.

1 Drag the Thumbnail Resize slider at the lower right of the Import dialog to the right to enlarge the thumbnails until they fill up the Browser.

2 Select the first image in the Browser, **jhff_mtn220905_10**.

A white outline appears around the selected image.

3 Look at the Image Information area located on the upper right of the Import dialog. You can see the filename, the date the image was created, the file type, and the image's size and dimensions. Notice that the selected image is a DNG file. *DNG* stands for *Digital Negative*, which is Adobe's specification for RAW images.

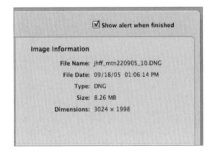

4 Select all of the images in the Browser by dragging from the upper left thumbnail to the lower right thumbnail.

TIP ▶ You can also press Command-A to select all of the images in the Browser.

Notice that one image is framed with a bolder outline than the other images. The image with the bolder outline is the *primary selection*. The metadata in the Image Information area of the Import dialog is for the primary selection.

5 Change your primary selection by clicking any of the other selected thumbnails. Then, use the up, down, left, and right arrow keys until you have selected the **jhff_mtn220905_49** image as your primary selection.

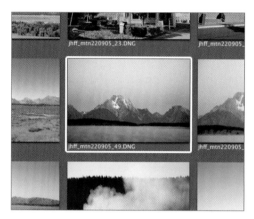

While you were changing the primary selection, you may have noticed that the image information was updated dynamically, even though all of the thumbnails remained selected.

You could click the Import All button now to import the selected images. However, there's a lot more you can do in the Import dialog, so let's explore it further.

6 Click an empty area of the Browser to deselect all the images.

Notice that with no images selected, there is no primary selection, so no image information is displayed.

Adding Metadata

Aperture imports the metadata embedded in image files coming from your camera or other media. This data includes the time and date of the image capture, camera information, and even color-balance information. We can add metadata when importing or wait until the image or images have been added to our Library. Metadata cannot be selectively applied to images as they're being imported; the same metadata (except for filenames) will be uniformly applied to all imported files.

Adjusting the Time Zone

Your digital camera keeps track of the time each photo is taken. Most people set their cameras to the time zone of where they live. You can change the time on the camera whenever you change time zones, but this is rather inconvenient. It is easier to change the time zone metadata when you import the images into Aperture.

1 Under Time Adjustment in the Import dialog, select the Adjust Time Zone button.

2 Choose Camera Time Zone > US/Eastern. This is the time zone of your camera—typically, your residence. (Remember, you live in South Beach, Florida, for the purposes of this project.)

3 Choose Actual Time Zone > US > Mountain (MDT). This is the time zone of Jackson Hole, Wyoming, where the images were captured.

When Aperture imports your images, it will tag them with a time adjustment that reflects the time zone where the images were captured.

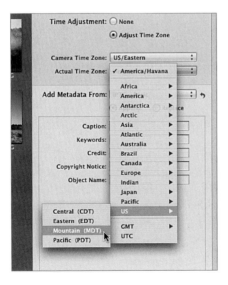

Adding Copyright and IPTC Metadata

One of the most important things you can do to manage digital images is to tag them with the proper copyright information. If you are dealing with images that you've acquired from different sources, it is best to add the copyright when you import them. International Press Telecommunications Council data can also be added to your images. IPTC data is often required in the newspaper and press industries for submissions. Again, both copyright and IPTC metadata can be added afterward, but it is more efficient to add it as you import.

1 Choose Add Metadata From > IPTC – Expanded at the right side of the Import dialog. Aperture adds several metadata input fields.

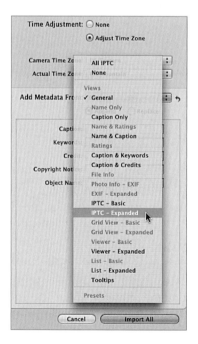

2 Type *Orlando Luna* in the Credit field.

3 Click in the Copyright Notice field.

4 Press Option-G, which is the keyboard shortcut for the copyright symbol ©.

 TIP▶ Option-2 is the shortcut for the trademark symbol ™, and Option-R is the shortcut for the registered-trademark symbol ®.

5 Type *Orlando Luna* after the copyright symbol.

6 Type *Jackson Hole* in the City field.

7 Type *Wyoming* in the Province/State field.

8 Type *USA* in the Country Name field.

 There are a number of additional metadata fields in the Import dialog, but most are appropriate only for individually selected images. Aperture will apply the metadata to all of the images that we import.

Adding Custom Filenames

Image naming on a camera is somewhat limited. The default naming can be quite cryptic, and even when there are custom options, trying to name an image on a camera can be difficult without a keyboard. Naming files when you import them into Aperture is an effective way to differentiate them.

1 Click the Version Name pop-up menu on the right side of the Import dialog to reveal the naming options.

2 Choose Edit to create a custom name.

 The Naming Presets dialog opens, showing a number of presets that ship with Aperture. These presets can be edited, and you can create your own.

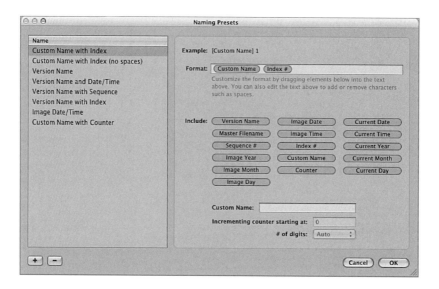

3 Click in a blank area in the Name column, then click the Add (+) button
 in the lower left corner of the Naming Presets dialog.

 A new preset named Untitled appears. Clicking in a blank area deselected
 all of the presets. Clicking the Add (+) button with a preset selected cre-
 ates a new preset with the parameters from the selected preset.

4 In the Name list on the left side of the dialog, rename the Untitled preset
 Custom Name with Sequence.

5 In the Format text field, click to the right of the Version Name element
 and press Delete.

6 Drag the Custom Name element to the Format text field, insert a space,
 and then drag the Sequence # element to the right of Custom Name.

Leaving the Custom Name text field blank will require you to enter a name whenever this preset is used.

7 Click OK to save the preset.

8 Make sure Custom Name with Sequence is selected in the Version Name pop-up menu.

9 Type *Jackson Hole* in the Name Text field under the Version Name pop-up menu. Leave the "Apply to Master filenames" checkbox deselected.

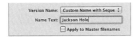

A version name will be created for each image imported The images will be named **Jackson Hole 1**, **Jackson Hole 2**, and so on. The version name is what you will be viewing in Aperture. The original master filename is untouched unless you select the "Apply to Master filenames" checkbox. The metadata is all entered, so we're ready to import the images.

10 Click the Import All button in the lower right corner of the Import dialog.

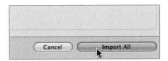

A new, untitled project appears in the Projects panel. An icon to the left of the untitled project provides animated feedback until the import is complete. Preview images are generated in the background once the images are imported. When Aperture finishes importing the images, an Import Complete window appears.

11 Click OK to close the Import Complete window.

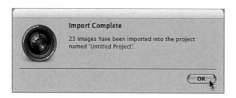

NOTE ▸ In addition to Camera RAW, you can import GIF, JPEG, JPEG2000, PNG, PSD, and TIFF files.

12 Rename the untitled project *Jackson Hole*, and then press Return.

13 Click the Eject symbol for jackson_hole in the Import panel. Click the Import Panel button to close the Import panel.

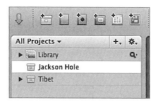

With the Jackson Hole project selected in the Projects panel, you can see your images in the Browser and Viewer of the main window.

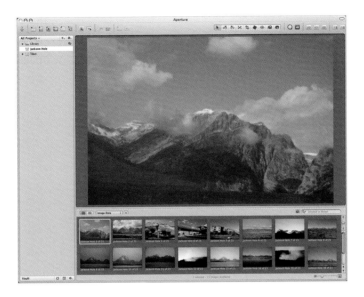

Congratulations! You have imported your first collection of images.

Importing Images from iPhoto

If you have an existing iPhoto Library, you know that iPhoto imports photos and uses a folder hierarchy structure with XML data to organize and track images. iPhoto also offers some basic image-manipulation tools.

Using Aperture, you can import entire iPhoto Libraries, iPhoto albums, or selected images within an iPhoto Library or album. When you choose to import an entire iPhoto Library that includes RAW files, Aperture can import copies of the files or simply reference the files without copying them. For Grande Agency, we will import an iPhoto album of images of Colonia, Uruguay, as referenced images, which allows us to keep the master images in their original location.

> **NOTE ▶** When you import an iPhoto Library, Aperture preserves the album structure, image filenames, EXIF metadata, keywords, ratings, and any adjustments you've made to the images. Aperture does not touch your original iPhoto Library; it simply copies or references the images and data.

Importing an iPhoto Album

When you import an album from an iPhoto Library, Aperture offers all of the same selection and metadata options as when you import images from a disc.

1 Select the Library in the Projects panel, and then choose File > Import > Images.

The Import dialog opens, with the source end of the Import arrow tailing from Local Files in the Import panel and the destination end pointing at Library in the Projects panel. Your computer's directory structure appears at the top of the dialog in column view, and the Browser at the bottom of the dialog shows thumbnails of the selected folder.

2 Navigate to the APTS_Aperture_book_files > Lessons > Lesson02 > iPhoto Library and select URUGUAY.

URUGUAY is an iPhoto album. We can import the entire album or selected images in it.

NOTE ▸ iPhoto must be installed and have been opened at least once for the album to be available.

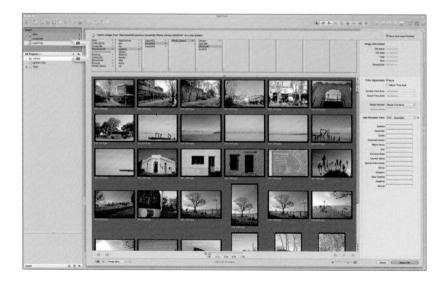

3 Select the first image in the Browser, **DSC_0966.nef**.

4 Look at the Image Information area on the upper right of the Import dialog. The file type is NEF, which is the file extension for Nikon's RAW format.

We're going to import the whole album, but let's add metadata to the images first.

5 Click an empty area of the Browser to deselect all the images.

6 Choose Master Filename from the Version Name pop-up menu.

7 Choose Add Metadata From > IPTC – Expanded on the right side of the Import dialog.

8 Type *Orlando Luna* in the Credit field.

9 Type © *Orlando Luna* in the Copyright Notice field. Remember, press Option-G to create the copyright symbol.

10 Type *Colonia* in the City field.

11 Type *URY* (for *Uruguay*) in the Country Name field.

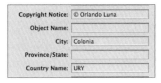

This new metadata will be attached to all the images when they're imported.

Now that you've chosen the album to import and have specified some metadata, you can specify whether the images are managed or referenced.

12 Choose "In their current location" from the Store Files pop-up menu in the Import dialog.

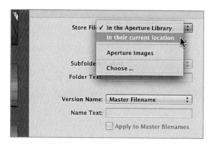

13 Make sure URUGUAY is still selected in the column view of the Import dialog, and that the Import arrow is pointing to the Library. Click the Import Arrow button to begin the import process.

Aperture begins to import the album and creates a new, untitled project for it in the Projects panel.

14 Rename the untitled project in the Projects panel *South America*.

Aperture imports the Uruguay album into the South America project. The metadata we specified is attached to the imported images: A tag icon 🏷 on the lower right corner of each of thumbnail indicates that the image has associated metadata.

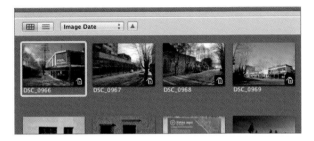

15 Quit Aperture.

As you can see, importing images from iPhoto does not require you to copy images into Aperture. In a referenced workflow, both Aperture and iPhoto can access the digital master file without duplication. Now, it's time to import our third collection of images: photos of South Beach, Florida.

Importing Images from a Memory Card

When you're capturing images on location, it's not uncommon to shoot hundreds or even thousands of images a day. This is sometimes called a high-shot-rate shoot. On some high-shot-rate location shoots, the photographer shoots until the camera's media card is full, and one or more photo assistants swap out the media cards while the photographer continues shooting. Meanwhile, a technician downloads the images and checks them on a computer or laptop. This workflow is efficient but can be expensive.

Another type of location shoot, called a low-shot-rate shoot, is typically in a controlled environment such as a studio and uses a camera that's tethered to a computer. In this workflow, the camera's software controls and downloads the images to the computer's hard disk. This allows you to take advantage of the computer's larger storage space, and images can be examined immediately for exposure, focus, and lighting.

For our Grande Agency gig, imagine that we've just returned from location scouting in South Beach, where we captured the images on our camera's media card—without a big crew or budget. Now, we've brought the media card back to the studio and we're ready to download the images to Aperture.

> **NOTE** ▶ You will learn how to integrate Aperture into a tethered-shot workflow in Lesson 12.

Opening Aperture Automatically

Aperture opens automatically when a supported camera is tethered and active, and when your system senses a media card with images. You checked this preference in Lesson 1. For this exercise, we will use a disk image based on a media card.

1 In the Finder, navigate to APTS_Aperture_book_files > Lessons > Lesson02.

2 Double-click the **sobe.dmg** mounted disk image.

Aperture should open on sensing the mounted disk image.

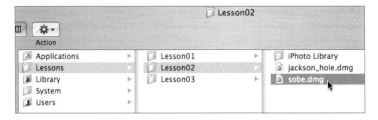

3 Click the Continue button if the Welcome screen appears.

Aperture shows the Import dialog and panel, with the source end of the Import arrow next to the mounted disk image, EOS_DIGITAL.

4 Click the Library in the Projects panel to set it as the destination for your images. This way, Aperture will import the South Beach images into their own project.

> **NOTE** ▸ We'll organize all of the location images in Lesson 3.

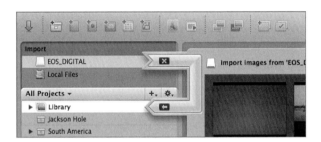

Before we import these images, we have to name them and add metadata. But first, let's explore the auto-stacking feature available in Aperture's Import dialog.

Auto-stacking Images

In traditional photography, photographers sorting through images after a shoot often used a technique called *stacking*, in which they stacked the mounted transparencies according to a particular criterion and placed their favorite on top (or separated it from the stack). The idea is that there is one "hero" image per stack, and the other images are alternatives in case the client wants a different one.

Typically, stacked, or bracketed, images comprise bursts of similar shots during a high-shot-rate photo shoot. *Bracketing* is the technique of shooting images with static content at different exposure levels.

To help photographers organize series of similar digital images, Aperture offers the capability to stack images before or after importing them. When you auto-stack images as they're being imported, Aperture uses the timestamp metadata to group images shot up to one minute apart. Stacking is not permanent and can be undone or edited at any point. Stacking is just a way of grouping images for viewing purposes; it doesn't affect where they are stored within your Aperture Library.

Let's look at Aperture's auto-stack option with our South Beach location images.

1 Drag the Thumbnail Resize slider in the lower right corner of the Import dialog to enlarge the thumbnail images so that they fill the Browser.

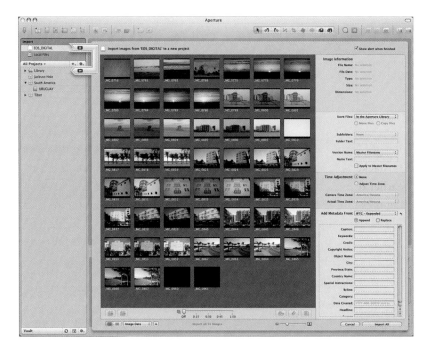

The Auto-Stack slider, at the bottom of the Import dialog, is set to Off by default.

2 Drag the Auto-Stack slider all the way to the right.

With the slider set to 1 minute, too many shots will be grouped in a stack, because typically photographers bracket images no more than a few seconds apart. We want the stacks to match the camera's setting of three images per burst.

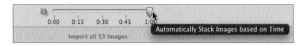

3 Drag the Auto-Stack slider to 0:15.

Now any images that were shot within 15 seconds of each other will be stacked together.

TIP ▶ If you make a mistake or change your mind as you're defining your stacks, click the Unstack All Stacks button, which is the rightmost button just above the Thumbnail Resize slider in the Import dialog.

4 If necessary, drag the Thumbnail Resize slider until most of the thumbnails fit in the Browser.

Aperture creates 15 stacks of three images each, as well as one stack of two images (two black frames), and leaves a handful of images unstacked. (The unstacked images were not bracketed and were shot more than 15 seconds earlier or later than any others.) A thin gray rectangle around the images denotes the stack groupings. The left image in each stack has a small number in the upper left corner. This is the Stack button, and it indicates that this image is the *pick* of the stack. The pick is a representative image for the stack; Aperture defines the pick when you auto-stack images, but you can change the pick later, if desired.

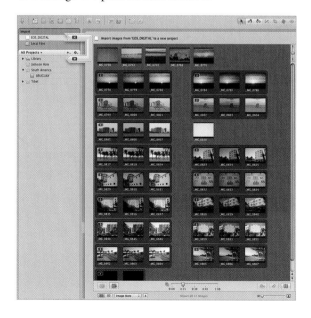

By default, a stack is shown expanded, with all the images displayed, but you can close a stack and open it again whenever you wish. You may want to close your stacks to free up space in the Browser or to reduce the number of images you're looking at when sorting through and selecting final images to edit. When a stack is closed, only the stack's pick image appears in the Browser.

5 Click the Close All Stacks button near the bottom left of the Import dialog.

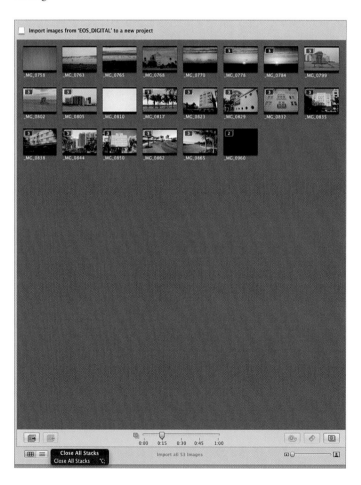

6 Drag the Thumbnail Resize slider to fill the Browser with the closed Stacks. Currently, we're looking at the images in grid view, which displays the image thumbnails, but you can also work with stacks in list view.

7 Click the List View button in the lower left corner of the Import dialog, under the Open/Close All Stacks buttons.

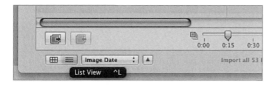

The Browser switches to list view. Stacks are still grouped together and closed, and they can be opened by clicking the disclosure triangle or clicking the Open All Stacks button. The items in the list view can be enlarged by dragging the Thumbnail Resize slider on the lower right.

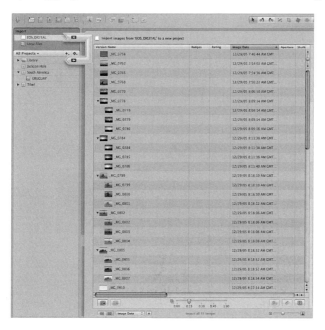

8 Click the Grid View button to go back to a thumbnail view.

Stacking images as you import them is a good habit to get into, but you can do much more with stacks after the images are in Aperture. We'll explore stacks in greater depth in Lessons 3 and 8. Now, let's finish importing the South Beach images.

Naming, Adding Metadata, and Selecting Images to Import

Generally speaking, you don't want to delete images from a media card or camera until after you import them. You can make a better decision about the quality of the images after you've closely scrutinized them in Aperture. But

sometimes there are images you obviously don't want—photos of the inside of your camera bag, for example, are not likely to win any awards—and you can opt not to import those images in the first place.

1 In the Metadata area of the Import dialog, choose Version Name > Custom Name with Sequence.

2 Type *SoBe_2005* (for *South Beach, 2005*) in the Name Text field.

3 Choose Add Metadata From > IPTC – Expanded.

4 For Credit, type *Orlando Luna.*

5 For Copyright Notice, press Option-G to create a copyright symbol, and then type *Orlando Luna.*

6 For the City, Province/State, and Country Name fields, type *South Beach, FL,* and *USA,* respectively.

> **NOTE ▶** Technically, the city is Miami Beach, but it's South Beach to us locals.

Now that you've entered the metadata you want applied to the images that you import, select the images.

7 Click in the Browser, then press Command-A to select all the images.

8 Command-click the image **_MG_0810** to deselect it.

9 Command-click the image **_MG_0960** to deselect it.

As you can see, **_MG_0960** is actually a closed stack that contains two images. When stacks are selected or deselected, all the images within the stack are affected. Be careful when you delete stacks, especially if they are closed and you cannot see all of the images they contain. These two images we know to be black frames, so they're OK to delete.

Now we're ready to import the images.

10 Click the Import button in the lower right corner of the Import dialog.

Notice that the Import button has been updated to reflect the number of images you selected (50).

As Aperture imports the images, it creates a new, untitled project under the Library in the Projects panel. When it's finished, it shows the Import Complete window.

Aperture now asks whether you want to erase the imported images from the media card. It's better to erase media cards using the erase function on your camera rather than using Aperture or other software on your computer. Media cards are formatted for specific camera models, and the camera will do a better job than a computer of completely erasing the card.

11 Click the Eject Card button in the Import Complete window.

12 Rename the untitled project *South Beach* in the Projects panel.

Importing images from a media card or camera is something you'll need to do on a daily—or more frequent—basis. You can see how easy it is to do in Aperture.

13 Quit Aperture.

NOTE ▸ If Aperture is still creating previews of the imported images, a Warning dialog may appear if you attempt to quit Aperture. You can choose Continue Processing or Stop Processing and Quit. If you choose Stop Processing, processing will continue when you reopen Aperture.

In this lesson, you imported images from three different sources into Aperture, naming them and adding metadata along the way. In Lesson 3, you'll organize the images a bit more, send them off to Grande Agency, and continue to prepare for the fashion location shoot.

Lesson Review

1. What is the Import arrow and how does it work?
2. What is the difference between managed images and referenced images?
3. Can you import images from iPhoto without duplication?
4. What is stacking?

Answers

1. The Import arrow allows you to choose the source and destination of your imported images. Aperture displays the Import arrow from the source location in the Import panel to the destination in the Projects panel. You can point the arrow to existing projects or albums, or you can create a new, untitled project as your destination by pointing to the Library.

2. Managed images are stored inside the Aperture Library. Referenced images are stored outside the Library. As long as the referenced images are made available to Aperture, you will see no difference in their behavior.

3. Yes, images can be imported from iPhoto without duplication. Choose "In their current location" from the Store Files pop-up menu in the Import dialog.

4. Aperture offers the capability to stack images before or after importing them as a way to organize series of similar digital images. You can auto-stack images while importing them, or stack automatically or manually afterward. When you auto-stack images while importing them, Aperture uses the timestamp metadata to group images that are shot up to one minute apart. Stacking is just a way of grouping your images for viewing purposes; it doesn't affect where they are stored within your Aperture Library.

Keyboard Shortcuts

Command-I	Open Import dialog
Shift-I	Show Import panel
Command-A	Select all
Command-Shift-A	Deselect all
Option-G	Copyright symbol ©

3

Organizing and Rating Images

Organizing images is one of the most time-consuming and important tasks of professional photography. You need to be able to quickly and easily find the image you need for a particular client or job. The larger your image collection, the greater the challenge.

Another critical task is evaluating images—judging not only their composition and aesthetic value but also the quality of the shots, including focus, lighting, and exposure.

The two tasks go hand in hand, because it's natural and intuitive for a photographer to want to somehow identify or flag "hero" or "keeper" images (or duds) while sorting and organizing them.

With Aperture, it's easy to organize and rate images in a seamless process. For example, you can organize similar images into intuitive stacks, choose the pick of a stack as your favorite in a group, and apply star ratings to individual images as you evaluate them in the Viewer. In this lesson, we'll explore some of Aperture's organization and rating features as we continue preparing the potential fashion-shoot location images for our client, Grande Agency.

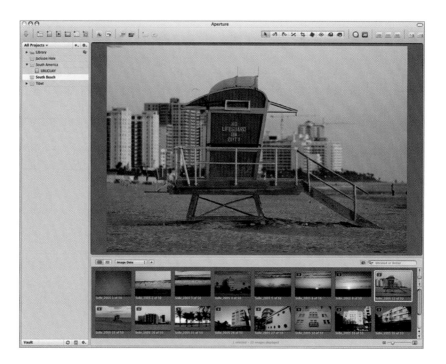

Working with Stacked Images

In Lesson 2, you auto-stacked the images of South Beach as you imported them. Aperture gives you many more ways to use stacks after your images are imported.

1 Double-click the Aperture icon in the Applications folder to open Aperture. The Jackson Hole, Colonia, and South Beach images are part of your Library and appear in the Projects panel.

2 Select the South Beach project.

3 Choose the Maximize Viewer layout (Command-Option-V), then press
 Shift-W to rotate the Browser to the left. Press D to display the control bar.
 This offers a terrific view for working with stacks in the Browser while still
 keeping the Viewer open.

 The stacked images appear in the Browser, and the pick image of the first
 stack is displayed in the Viewer.

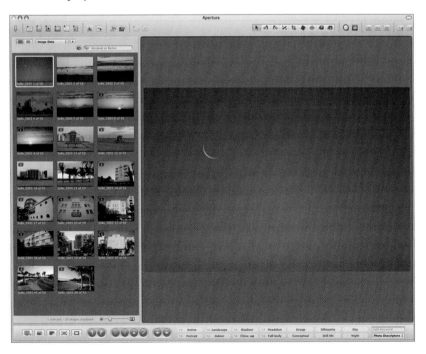

Currently, the stacks are closed, because we closed them in the Import dialog. You can open and close stacks in the Aperture main window just as you can in the Import dialog.

4 Choose Stacks > Open All Stacks (Option-') to open the stacks in the Browser. Drag in between the Browser and Viewer and adjust the panels until each stack occupies a row.

TIP ▶ Press Option-; to close all stacks, and press Shift-K to open or close selected stacks.

In addition to opening or closing all the stacks at once, you can open and close stacks individually by clicking the appropriate Stack button. Let's try that now.

5 Click the Stack button on the stack of **SoBe_2005 15 of 50** in the Browser.

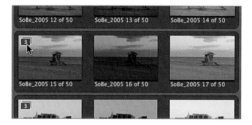

Another useful stacking feature is choosing the pick of the stack. When you auto-stack images during the import process, Aperture by default sets the first image of the sequence as the pick. Quite often, of course, this won't be the best image in the stack. Let's choose different picks for some of the South Beach stacks.

6 Select the **SoBe_2005 8 of 50** image—the last of the first set of three sunset images—in the Browser. It offers a little bit more detail in the shadow areas over the water than the other two images in the stack.

7 Choose Stacks > Pick, or press Command-backslash (\) to make it the pick of the stack.

Aperture updates the stack with the new pick at left. You can also define a pick by dragging an image to this location.

8 Drag the image **SoBe_2005 40 of 50** from the center to the left of the stack. When you see a green bar appear, release the mouse button. This image is the new pick.

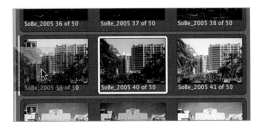

Now that you have a better understanding of how to control stacks and choose picks, let's organize the three collections of images we imported in Lesson 2.

NOTE ▶ You'll learn more about stacking in Lesson 8, "Advanced Organization and Rating."

Organizing Imported Images

There are many ways to organize the images of Jackson Hole, Wyoming; Colonia, Uruguay; and South Beach, Florida, depending on personal preference and work style. Aperture is flexible. We could group the images as albums within one project, for example, since they're all for one job. Or we could group them under a more general heading, such as Travel Images, and organize them within that heading by location. Or both.

Organizing a Collection Using Folders

Since we've already imported our images into location-based projects, we'll leave them that way and simply put them all in an umbrella folder called Travel. You'll learn other ways to organize images in the advanced lessons in this book.

1 Click the Basic Layout button that you added to the upper right corner of the main window in Lesson 1. Press V to hide the Viewer.

When you're organizing projects, hiding the Viewer gives you more room to work in the Browser and the Projects panel.

2 Select the Library in the Projects panel and then choose File > New Folder.

A new, untitled folder appears under the Library in the Projects panel. The name is highlighted and ready for you to edit.

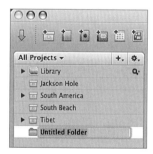

3 Rename the untitled folder *Travel*.

4 Drag the Jackson Hole project to the Travel folder. A circle with a horizontal line will appear indented below the Travel folder, indicating that the project is inside the folder.

5 Select the South America project and drag it to the Travel folder, making sure that the circle and horizontal line are aligned with the Jackson Hole project, so that all of the projects are on the same hierarchical level inside the Travel folder.

6 Select the South Beach project and drag it to the Travel folder as well.

Now that the images are organized, experiment with what you can see in the Browser.

7 Select the Jackson Hole project.

Aperture displays the Jackson Hole project images in the Browser.

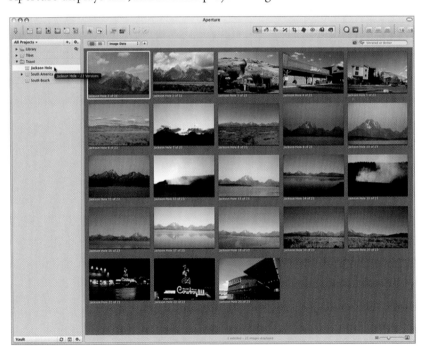

8 Select the Uruguay album inside the South America project.

Aperture displays the Uruguay album images in the Browser.

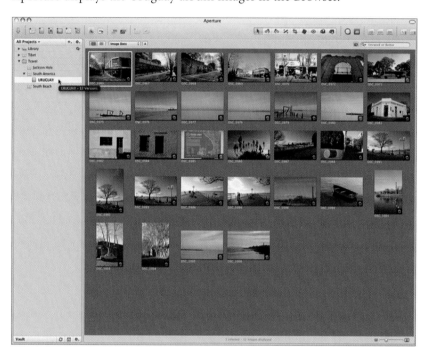

Note that since there are no other images in the South America project, the contents of the Uruguay album and South America project are identical. If the South America project contained other images—in the project itself or in other albums or folders in the project—they would have all appeared in the Browser when you selected the South America project. With this particular file structure, you could create albums of images of other countries in South America and organize them all within the South America project.

9 Select the Travel folder. Aperture shows the contents of all three nested projects in the Browser.

TIP Drag the Thumbnail Resize slider at the bottom of the Browser, if necessary, to see all of the thumbnails.

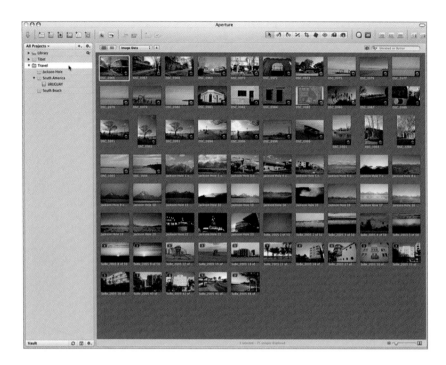

Excellent. Now that our images are organized in the Projects panel, let's create an album of some of the choice images from each location to send to the client.

Creating an Album

Albums come in two flavors, standard and Smart. A standard album is one to which you manually add images. A Smart Album changes dynamically according to metadata criteria that you define. We'll create a Smart Album later in this lesson. For now, let's create a standard album for the images we want to share with Grande Agency. The album will consist of a few images that convey the flavor of each location. These images may not necessarily be the most artistic or attractive photographs, but they'll be a representative sample that Grande can evaluate.

1 Select the Travel folder in the Projects panel.

2 Choose File > New > Album (Command-Option-L).

3 Name the newly created album *Locations,* and then press Return.

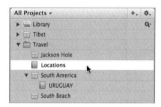

Now add your selected images to the album.

4 Select the Jackson Hole project in the Projects panel to see thumbnail pre-
 views of its images in the Browser.

5 Drag **Jackson Hole 1 of 23** from the Browser to the Locations album in
 the Projects panel.

The green plus-sign icon indicates that you're adding the image to the
Locations album. Notice that the image is still in the Browser for the

Jackson Hole project because the image has not actually been moved; the album contains a pointer to the image in the Jackson Hole project.

6 Select the Locations album in the Projects panel.

The **Jackson Hole 1 of 23** image appears in the Browser, and it is the only image in the album so far. Let's say you've just decided you don't really want to include this image in the album.

7 Control-click the **Jackson Hole 1 of 23** image in the Browser and choose Remove From Album from the shortcut menu.

NOTE ▸ The Remove From Album command removes the image from the album without affecting the image anywhere else it appears in your Library. The Delete Version command removes that version of your image from your Library and will remove the digital master image if no other versions exist.

8 Select the Jackson Hole project in the Projects panel.

9 Click to select **Jackson Hole 2 of 23**, then Command-click to add **Jackson Hole 11 of 23** and **Jackson Hole 21 of 23**, and drag them from the Browser to the Locations album.

10 Select the South America project in the Projects panel, close all the stacks, and drag **DSC_0966**, **DSC_0976**, and **DSC_1006** from the Browser to the Locations album.

11 Select the South Beach project in the Projects panel and drag **SoBe_2005 8 of 50**, **SoBe_2005 12 of 50**, and **SoBe_2005 24 of 50** from the Browser to the Locations album.

12 Select the Locations album in the Projects panel to view the images in it. The album should contain the nine images you selected.

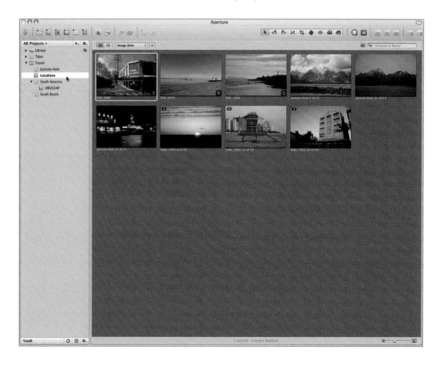

Now that we've collected the desired images into one album, we can easily email it to the client from within Aperture.

Emailing Images from Aperture

Email is often the easiest way to send files to a client or colleague. Aperture offers a straightforward way to compress and send images via your preferred email application. It even allows you to add a watermark to images when you send them to someone via email, to ensure that the images won't be reproduced without your permission.

Specifying Your Email Application

Let's first specify the email application we want to use, and then we'll add a watermark to the images before sending them to Grande Agency.

1 Choose Aperture > Preferences.

2 From the "Email images using" pop-up menu in the Output area of the Preferences dialog, choose your preferred email program.

3 Click and hold the Email Export Preset pop-up menu.

Aperture offers several export presets, three of which are designed for emailing images. They allow you to email small, medium, or large JPEG images.

4 Release the Mail Export Preset pop-up menu button.

We'll customize one of these presets now to speed the downloading process and to include a watermark.

Adding a Digital Watermark

You'll add a watermark to these images using a Photoshop file that we've created for you.

1 Click the Edit button next to the Mail Export Preset pop-up menu. The Export Presets dialog appears, with the presets listed on the left.

2 Choose the Email Small – JPEG preset.

The right side of the Exports Presets dialog displays the customizable parameters for this preset. These include options for changing the image format, adjusting the image quality, attaching a color profile, and adding a watermark.

3 Click the Add (+) button in the lower left corner of the Export Presets dialog.

Aperture duplicates the selected Email Small – JPEG preset and names the new preset Email Small – JPEG Copy.

4 Rename the Email Small – JPEG Copy preset *Email 480 – JPEG (wtrmmrk no Meta)*. The meaning of this name will become clear as you customize the preset.

5 With the new preset selected, make sure that Image Format is set to JPEG and the Image Quality slider is at 6.

6 Deselect the Include Metadata checkbox. You don't always need to send metadata with your images. The client doesn't need to know, for example, what shutter speed you used to capture your images.

7 Choose Size To > Fit Within (Pixels), and set both Width and Height to *480*.

The Fit Within (Pixels) option scales the image proportionately to the largest specified dimension. Sizing the images to a maximum of 480 by 480 pixels speeds the downloading process and reduces the file size so that the images cannot be reproduced effectively.

Now add the watermark and specify the watermark options.

8 Select the Show Watermark checkbox.

This allows you to superimpose an image on the exported images and protect them against unauthorized reuse.

9 Choose Position > Top Right, and set the Opacity slider to *0.4*.

10 Click the Choose Image button to choose an image to use for the watermark.

11 Navigate to the APTS_Aperture_book_files > Lessons > Lesson03 folder and select the **luna_wtr_mrk_h240.psd** file. Then click Choose.

A preview of the image appears above the Choose Image button in the Export Presets dialog. The watermark will be embedded in the emailed images.

TIP ▶ To create your own watermark image in Photoshop, use a transparent background and save the image as an RGB (not grayscale) PSD file. Aperture preserves the transparency of imported PSD images. If you make changes to the original image and want the changes to be reflected in your Aperture watermark, you must update the preset by reselecting the edited image in the Export Presets dialog.

12 Click OK to close the Export Presets dialog.

13 Close the Preferences dialog.

That's all there is to it. Now you can email the images.

Emailing the Images

When you email images from within Aperture, it automatically uses the email application you specified in Preferences.

1 Select the Locations album in the Projects panel and click in an empty area of the Browser to deselect all the images in the album (which actually selects all the images for inclusion).

2 Choose File > Email (Option-E).

Aperture jumps to your selected email application and creates a new email message with the album attached. In the real world, you would enter the recipient's email address, add text to the body of the message, and click Send. Since the Grande Agency isn't real, you don't have to do that for this book, but you can email the images to yourself if you're the kind of person who likes to see things through to completion. Otherwise, simply quit and return to Aperture for the next exercise.

3 Quit your email application.

Rating Images

As a photographer, you're constantly evaluating the quality of the images you shoot. Ratings in Aperture allow you to tag individual images according to their quality, from excellent (five stars) to poor (one star). You can also leave images unrated, or rate images with the dreaded Reject tag. This allows for a total of seven ratings.

Rating images is an area where Aperture really shines. You rate images in the Viewer, where flexible controls and tools enable you to closely inspect your images. You use the buttons conveniently located in the control bar at the bottom of the main window.

Imagine we've heard back from Grande Agency. The art director can't decide where he wants to hold the photo shoot. He wants to let his client make the decision, so he wants you to send him more shots of all three locations, including shots that show a wider variety of scenery.

So your next task is to select images for the retailer. To do so, we'll use Aperture's rating feature to identify five-star "selects" that we want to send, and then we'll make a Smart Album that contains the selected images.

Making Selects

For this task, we'll keep it simple: a Select rating means we're sending the image to the fashion retailer; any other rating (or lack of rating) means the image is out of the running. We'll start with the images of Colonia, Uruguay.

NOTE ▸ You'll learn more about rating images in Lesson 8, "Advanced Organization and Rating."

1 In Aperture, select the South America project in the Projects panel.

2 Press W, then press V, then Shift-W. Press D if the control bar is not visible. You should end up with a layout similar to the following screen shot.

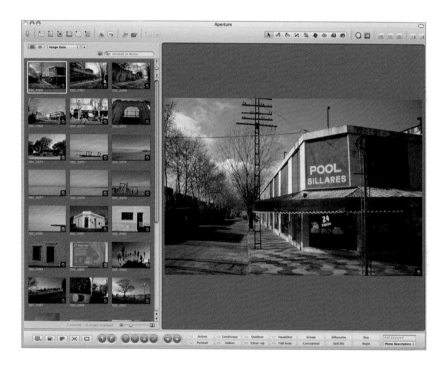

3 With the first image, **DSC_0966**, selected, Command-click **DSC_0975** and then Command-click **DSC_0999** to select and show all three images in the Viewer.

4 Click the **DSC_0975** image in the center of the Viewer to make it your primary selection.

Notice the metadata icon in the lower right corner of the images in the Viewer. Because ratings are a type of metadata in Aperture, the metadata display must be on for you to see the star ratings we're about to apply.

5 If the icon does not appear on the three images in the Viewer, press the Y key to display it.

Before continuing, let's quickly adjust the workspace to better accommodate the three landscape images in the Viewer.

6 Press Shift-W. Aperture rotates the workspace, moving the Browser below the Viewer. Now, our selected images appear larger in the Viewer, and we're ready to start rating them.

7 Click the Select button (the green checkmark) on the control bar below the Browser.

Five stars appear on each of the selected images in the Viewer, as well as on the images' thumbnails in the Browser. The problem is that we wanted to apply the five-star Select rating only to the primary selection.

8 Choose Metadata > Unrated to remove the Select rating you just applied
 to the three images.

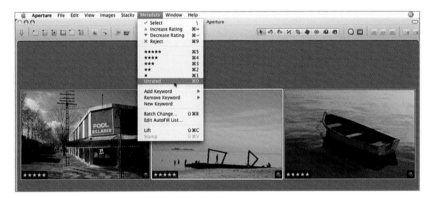

9 Click the Primary Only button on the control bar. This allows you to
 make changes to the metadata of the primary selection only.

 When you toggle on the Primary Only button, the two images in the
 Viewer on either side of the primary selection become deselected.

10 Click the Select button to apply a five-star rating to just the primary
 selection.

 The Primary Only button is useful when you want to view multiple images
 but rate only the primary selection. Now let's continue rating the
 images from Uruguay, learning our way around the Viewer as we go.

Exploring the Viewer

The Viewer displays a detailed view of images selected in the Browser so that you can make adjustments, compare images, and inspect images at full resolution. You can set the Viewer to display one image or multiple images at a time, which is especially helpful when you're rating images. You can select an image to compare others against, and then display other similar or related images next to it for inspection.

Now let's explore ways to select images and manage the appearance of the Viewer.

1 Click in an empty area of the Browser to deselect all the images, and then press Command-Option-V to switch to the Maximize Viewer layout, which hides the control bar and reduces the Browser to a single row of thumbnails.

2 Press Command-A to select all the images in the Browser.

Most of the images appear in the Viewer. Images that could not fit are indicated by *and* n *more…* in the lower right corner. The number will vary depending on your screen size and resolution.

3 Press Command-Option-S to change to the Basic layout. Aperture restores the Projects panel and the control bar to the main window, and because we have large number of images in the Viewer, it made the Viewer as large as it could to display as many of the selected images as possible.

4 Position the cursor between the Viewer and Browser until it changes to a resize icon, and then drag up to make the Browser bigger and the Viewer smaller. The images in both the Browser and the Viewer are scaled accordingly.

Let's make a few more adjustments to the layout before we continue rating our images.

5 Press the W key to hide the Projects panel.

6 Drag the Thumbnail Resize slider until you can see two rows of thumbnails in the Browser. Press D to display the control bar; the keyword buttons occupy the right side.

7 Select the image in the lower right corner of the Viewer and then press the right arrow key three or four times.

When the last image in the Viewer is the primary selection, you can use the arrow keys to change it in this way: As you press the right arrow key, the primary selection changes to the next image in the Browser. Pressing the left arrow key cycles back through the Browser hierarchy, changing the primary selection accordingly.

8 Scroll through the Browser and select the last image.

9 Click the Viewer Mode button on the control bar and choose Main Viewer > Primary from the pop-up menu.

The Primary Viewer mode displays only the primary selection in the
Viewer. You can see the other selected images in the Browser.

10 Use the arrow keys to navigate to the image **DSC_0986** in the Browser and
 make it your primary selection.

 This is another good shot to send to the fashion retailer, so let's select it.

11 Make sure the Primary Only button is selected, then click the Select button
 in the control bar to tag the new primary selection with a five-star rating.

12 Click the Viewer Mode button again and choose Main Viewer > Multi to
 restore all of the selected images in the Viewer.

 NOTE ▶ The Secondary Viewer items on the Viewer Mode pop-up menu
 are available when more than one display is connected to your computer.
 We'll learn about using multiple displays in Lesson 10, "Advanced Output."

Now that you know how to navigate through and select images to display in the Viewer, let's learn some keyboard shortcuts to make it even easier to rate our Uruguay and South Beach images.

Making Selects Using Keyboard Shortcuts

Using keyboard shortcuts is an excellent way to speed up the process of giving images a five-star Select rating. The shortcut for the Select command is the backslash (\) key. Pressing the backslash key gives a five-star rating to an image or to groups of images. Let's use keyboard shortcuts now to get good close-up looks at potential selects in the Viewer and rate them.

1 Use the arrow keys to navigate to the **DSC_0980** image in the Browser.

2 Press Option-R to switch to the Primary Viewer mode.

Yes, this is a good shot to send to the retailer.

3 Press the backslash (\) key to rate this image as a select.

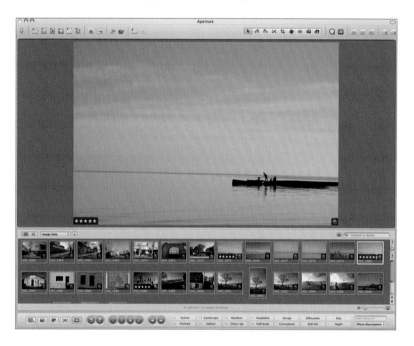

4 Press Option-U to return to the Multi Viewer mode.

5 Use the arrow keys to navigate to the **DSC_0982** image in the Viewer.

6 Press Option-R to switch to the Primary Viewer mode.

Yes, now that we can see it larger, we can appreciate the atmosphere that this image conveys. Let's select it.

7 Press the backslash key (\) to rate this image as a select.

8 Press Option-U to return to the Multi Viewer mode.

9 Rate the following additional South America images as selects: **DSC_0966**, **DSC_0976**, **DSC_0979**, **DSC_0999**, and **DSC_1006**.

Now that we have chosen images from the South America project, let's choose images from the Jackson Hole locations.

Evaluating Images at Full Resolution

One of Aperture's strengths is its capability to display images at full resolution, showing you every pixel and providing the finest level of detail possible. This is a tremendous asset when you're evaluating images for focus, detail, and lighting.

Two features are of particular use when you want to evaluate images at full resolution: the Zoom feature and the Loupe tool. Let's evaluate the images from Jackson Hole, Wyoming, using Zoom and the Loupe to get a better look at them.

Using the Zoom Feature

A full-resolution image shows every pixel of an image. You can set your image to appear at full resolution even though the image may not fit within the Viewer.

1 Press W to open the Projects panel, select the Jackson Hole project, and then press W to close the Projects panel again.

2 Click to select **Jackson Hole 1 of 23** in the Browser.

3 Position your cursor over the white-capped mountain in the center of the image and then press the Z key. Aperture zooms in on the image, using the location of your cursor to center it.

You are viewing the image at a full 1:1 ratio. Viewing the full-resolution image allows you to make decisions based on actual pixels instead of a scaled view. When an image doesn't fit within the area of the Viewer, a small gray box appears on the image with a red rectangle inside, showing the portion of the image that is currently visible in the Viewer. You can drag the red rectangle within the gray box to see other parts of the image. This is known as *panning*.

4 Drag the red rectangle in the gray box to pan around the image onscreen.

At 100 percent, we can see that this image is out of focus, so let's move on.

5 Press the right arrow key to move to the next image, **Jackson Hole 2 of 23**.

Aperture displays the next image at the same zoom level, 100 percent.

Like **Jackson Hole 1 of 23**, this image doesn't completely fit in the Viewer at full resolution. You can pan the image as described in step 4, or use the following technique.

6 Press the spacebar while dragging the image in the Viewer.

TIP If you have a scrolling mouse you can use the scroller to pan images in the Viewer. Just hover the scroller over the panning rectangle. Multidirectional scrolling mice such as the Apple Mighty Mouse can scroll up and down as well as left to right. Scrolling mice also work in the Browser: when you hover the scroller anywhere in the Browser, all of the thumbnails scroll.

This image is OK, but let's keep looking.

7 Select the **Jackson Hole 11 of 23** image in the Browser.

This one's pretty good.

8 Press the backslash key (\) to tag this image as a select.

9 Click the Zoom Viewer button (Z) to fit the image in the Viewer.

The Loupe tool works well when you want to look at the details in a portion of an image. Let's explore it now as we continue to choose images from Jackson Hole.

Using the Loupe Tool

Using the Loupe tool is a convenient and effective way to view portions of an image up close in the Viewer or the Browser. There are two types of Loupes. The default Loupe looks like a magnifying glass with a second lens on the handle. The Centered Loupe is a lens with a draggable lower right extension as well as a pop-up menu. You will use the Centered Loupe more in Lesson 7.

1 Select the **Jackson Hole 15 of 23** image in the Browser.

2 Click the Loupe icon to select it in the toolbar or press the accent grave (`) shortcut key.

3 Position your cursor, which appears in the small lens in the handle of the Loupe, over the bird flying through the mist in the Viewer. The area under the small lens (the source view) appears zoomed to 100 percent in the large lens (the zoomed view).

4 Press Option-Shift-hyphen (-) twice to reduce the size of the Loupe and home in more closely on the bird.

TIP ▶ Press Option-Shift-hyphen to reduce the size of the Loupe; press Option-Shift-= to enlarge the size of the Loupe.

Let's increase the Loupe's magnification to get an even closer look at the bird.

5 Press Command-Shift-= to increase the zoom level to 200 percent.

The bird looks pretty sharp. This image is a winner.

6 Press Shift–accent grave (`) to release the position of the Loupe, then click
the Select button in the control bar, or press the backslash (\) key, to rate
this image as a select.

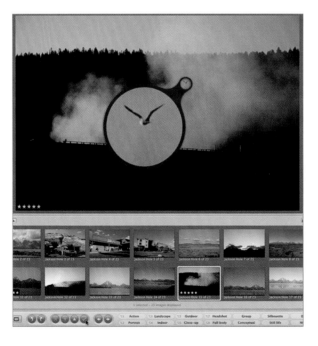

Let's inspect another Jackson Hole image with the Loupe. You don't need
to select it; you can simply position the handle of the Loupe over the
image in the Browser.

7 Press Shift–accent grave (`), then place the source area of the Loupe tool
over the **Jackson Hole 21 of 23** thumbnail in the Browser. Try to hover
over the top of the neon sign.

8 Press Option-Shift-= three times to enlarge the Loupe.

TIP You can press the Loupe magnification keyboard shortcuts repeat-
edly to increase or decrease the tool's size or magnification level by multi-
ple increments. For example, press Command-Shift-= once to zoom in at
200 percent, press it twice to zoom in at 400 percent, and press it three
times to zoom in at 800 percent.

Let's rate this one as a select also.

9 Click to select the **Jackson Hole 21 of 23** image in the Browser and press
the backslash (\) key.

The Loupe returns to your last-used settings when you select it next, so
return it to 100 percent.

10 Press Command-Shift-hyphen to return the Loupe's magnification level to
100 percent.

11 Press the accent grave (`) key to hide the Loupe.

Now that you've learned some ways to get a closer look at your images, let's look at how we can quickly maneuver around the Browser to view and select images.

Navigating the Browser

Depending on your workspace configuration, display resolution, and the number of images you're evaluating, their thumbnails may not all fit in the Browser. There are a couple of ways to scroll through the images. Let's reorient our view and take a look at them.

1 Press Shift-W to rotate the Browser from the bottom to the left side of the main window.

2 Drag the Thumbnail Resize slider in the Browser if necessary so that you can see two columns of thumbnails.

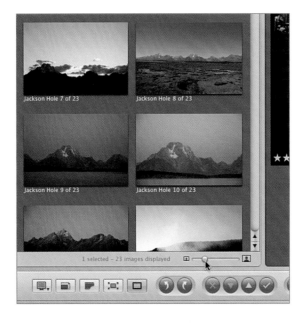

This allows us to see larger thumbnails and a large image in the Viewer for these landscape photos.

3 Drag the scroller to the right of the Browser all the way down.

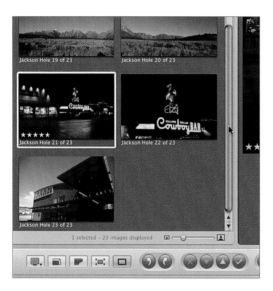

4 Drag the Shuttle control, located above the Browser scroll bar, up and down. Aperture shuttles continuously through the images in the Browser.

5 Use the left and right arrow keys to navigate to images outside the Browser area. The newly selected images appear.

6 Scroll to the bottom of the Browser and select the **Jackson Hole 19 of 23** image.

This is a nice shot, so let's use a new way to define it as a select for the retailer.

7 Control-click the image in the Viewer and choose five stars from the Rating shortcut menu (Command-5).

8 Control-click the **Jackson Hole 17 of 23** thumbnail in the Browser and choose five stars from the shortcut menu.

9 Using any of the techniques you've learned in this lesson so far, give the
 following images a five-star rating for the client: **Jackson Hole 2 of 23**,
 Jackson Hole 7 of 23, **Jackson Hole 8 of 23**, and **Jackson Hole 9 of 23**.
 This gives you a total of nine five-star Jackson Hole images.

 These images not only have individual merit but together tell a complete
 visual story about the location. It's OK that some of the images need crop-
 ping or exposure adjustments or have slanted horizon lines; we'll correct
 those problems in the next lesson.

 Zooming in at full resolution in the Viewer can give you a much
 better sense of the content of your images, allowing you to more criti-
 cally evaluate them. It's also important to be able to quickly navigate
 through images in the Browser so that you can work with large groups
 of images efficiently. Now that we've made selects for the South
 America and Jackson Hole images, let's move on to rating our South
 Beach images.

Rating Stacked Images

Rating stacked images, such as our South Beach images, isn't much different
from rating unstacked images.

1 Press the W key to reveal the Projects panel, select the South Beach project,
 and then press W again to close the Projects panel.

 You can open the stacks and rate other images that are not picks, but
 remember, the idea with stacks, especially stacks of bracketed images,
 is that you are choosing the best image of the series as the pick of
 the stack.

2 Drag the Thumbnail Resize slider so that all the closed stacks fit within the Browser.

3 Select the **SoBe_2005 36 of 50** image.

4 Press the backslash key (\) to make this image a select.

5 Select **SoBe_2005 12 of 50** in the Browser and press the backslash key (\)
to make it a select.

6 Navigate to and rate the following seven South Beach images as selects:
**SoBe_2005 3 of 50, SoBe_2005 4 of 50, SoBe_2005 8 of 50, SoBe_2005 24
of 50, SoBe_2005 27 of 50, SoBe_2005 40 of 50,** and **SoBe_2005 48 of 50.**

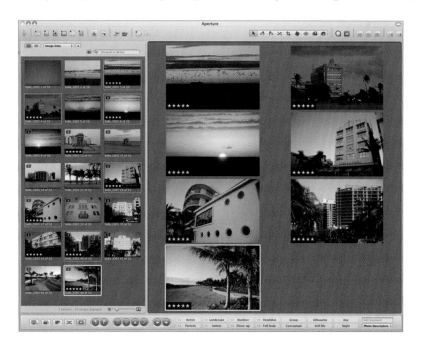

Now that you have rated the images, you can use a filter to display only the five-star images. We'll do that next.

In addition to basic search filters, you should know that a Query HUD is available when you need to perform more advanced search and rating operations.

The Query HUD (*HUD* stands for *heads-up display*) is an easy-to-use panel that lets you search for images. Using the Query HUD, you can search images by text, rating, keyword, date, IPTC information, EXIF information, or a combination of any of these criteria. You can also use the Query HUD to filter what you are viewing in the Browser based on image metadata. You'll learn more about filtering and querying in Lesson 8, "Advanced Organization and Rating."

Managing Multiple Projects

We've chosen the select images from all three locations, and now we're going to use a filter to view just the five-star images. Before we send them to the retailer, however, let's take a quick look at two more organizational features in Aperture: tabbed panes and split panes.

Working with Projects in Tabbed and Split Panes

Putting projects, folders, and albums in tabbed and split panes is a great way of accessing them quickly without having to select them in the Projects panel. Tabbed and split panes are also useful when you're working with more than one project at a time.

1 Press Command-Option-B to switch to the Maximize Browser layout.

2 Select the Travel folder in the Projects panel.

 All the images in the Jackson Hole, South America, and South Beach projects appear in the Browser, with the stack picks indicated.

3 Click the magnifying glass icon in the Filter field on the upper right of the Browser. Choose five stars.

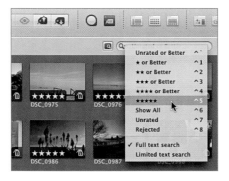

The Browser displays only the five-star select images. The filter criterion affects only the Travel folder; it can be changed to display different Travel folder images. Later in the lesson you will create a Smart Album using the same criterion.

4 Option-click the Jackson Hole project to open it in a tabbed pane in the Browser.

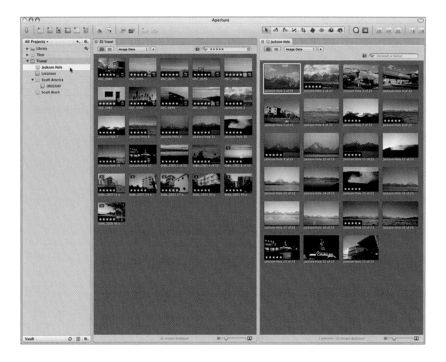

The contents of the Travel folder appear in the left pane of the Browser, and the contents of the Jackson Hole project appear on the right; the Jackson Hole tab is active.

5 Command-click the South America project to open it in a tabbed pane on the right pane of the Browser next to the Jackson Hole tab.

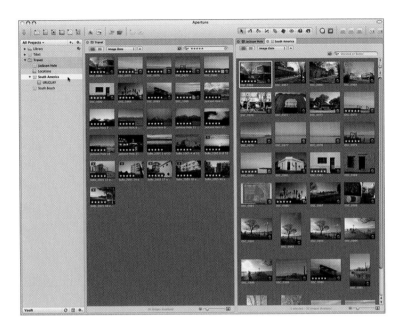

6 Command-click the South Beach project to open it as a tabbed pane next
to the other two projects.

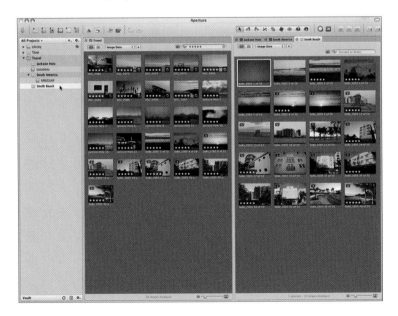

Now that you have set up split panes and multiple tabs, let's put them to use.

Organizing Images Using Split Panes

With split planes, we can select certain images to view in one pane, change ratings or other metadata, and view the results in another pane. Let's take a look at how this works.

1 Click the Jackson Hole tab in the right pane.

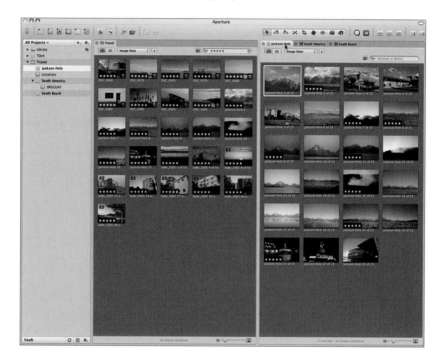

2 With the Jackson Hole tab open in the right pane, select the **Jackson Hole 2 of 23** image. We rated it as a select earlier, but now, on second thought, let's not send it to the retailer.

3 Press Command-0 to remove the rating from **Jackson Hole 2 of 23**.

The rating disappears from the image in the Jackson Hole project tab and the image disappears from Travel folder tab, because the Travel folder is filtered to display only five-star select images.

4 Select the **Jackson Hole 6 of 23** image and press backslash (\) to make it a select. The image is added to the filtered Travel tab.

5 Close the project tabs in the right pane of the Browser, leaving only the Travel tab open.

6 Click the X on the right side of the Filter field to reset the filter and display all the images from the Jackson Hole, South America, and South Beach projects.

Split panes are a great tool for viewing multiple folders, projects, and albums at once. Just be careful not to get too close to the monitor, as prolonged close-up viewing of split panes has been known to cause splitting headaches!

Creating a Smart Album

Earlier in this lesson you manually added images to a standard album that you exported via email. To make changes to a standard album, you have to manually add or delete images. Next, you filtered the Travel folder temporarily to view only five-star images.

Smart Albums, like filtered Browsers, are updated dynamically according to metadata criteria that you define. When you change the criteria associated with a particular Smart Album, the contents of the Smart Album change automatically. We will create a Smart Album now that contains all of the five-star images that we want to send to the retailer.

> **TIP** ▶ Aperture comes with a selection of Smart Albums already set up in the Library. For example, there are Smart Albums that gather all the images taken in the previous week, and all the images taken in the previous month. Click the Library disclosure triangle to see the preset Smart Albums that Aperture has created for you. Select any Smart Album to see its contents in the Browser.

1 Make sure the Travel folder is selected in the Projects panel and then choose File > New Smart > Album (Command-Shift-L) or click the New Smart Album button on the toolbar.

A new, untitled Smart Album appears along with a Query HUD (located next to the magnifying-glass icon) for setting the criteria for this Smart Album.

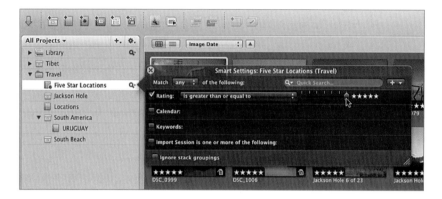

2 Rename the untitled Smart Album *Five Star Locations* and then press Return.

The Query HUD, as mentioned earlier, lets you specify your search criteria.

3 Make sure the Rating box is checked and that the Rating pop-up menu is set to "is greater than or equal to." Then drag the Rating slider all the way to the right to specify five-star images.

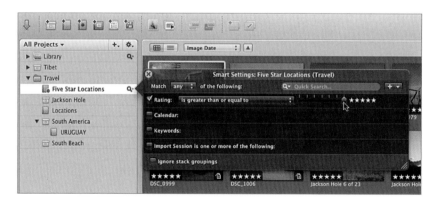

4 Click the circled X in the upper left corner of the Query HUD to close it.

The images matching the search criteria appear in the Browser. You can work with these images in the same way as you can work with the images in any project or standard album. If you change the search criteria, Aperture will update the Smart Album so that it comprises all the images in the Travel folder that meet the new criteria.

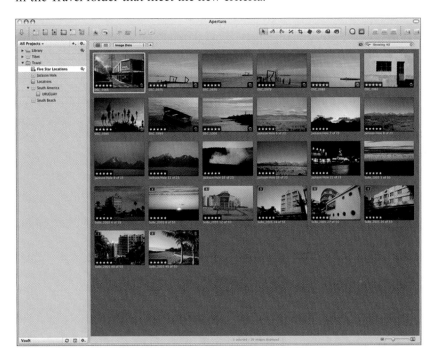

In this lesson, you've learned how to organize images in folders and albums (both standard and Smart), how to navigate through and select images in the Viewer and Browser, and how to rate images as five-star selects.

In the next lesson, we'll edit some of the images in the Smart Album to clean up a few glaring problems before we post them as a web journal for the retailer to evaluate.

Lesson Review

1. Describe two ways to open and close stacks in Aperture.

2. If you auto-stack images as you import them and don't like the pick that Aperture defines automatically, how can you change it?

3. Describe two useful features for evaluating images in the Viewer.

4. What's the difference between a standard album and a Smart Album?

Answers

1. To open all stacks in the Browser of the main window, choose Stacks > Open All Stacks or press Option-'. Press Option-; to close all open stacks. To open or close individual stacks, click the Stack button of a particular stack.

2. To manually define a pick image in a stack, select it in the Browser and choose Stacks > Pick or press Command-backslash (\). Or, drag the image that you want to be the pick to the leftmost position in the stack.

3. The Zoom feature and the Loupe are two useful tools to use when you're evaluating images in the Viewer. Aperture allows you to view images at full resolution, so you can see every pixel of an image. To see an image at full resolution in the Viewer, select it in the Browser and choose View > Zoom to Actual Size, or press the Z key. The Loupe lets you inspect images even more closely: Select it in the toolbar and position the small lens of the Loupe over an image in the Viewer or Browser; the large lens shows a magnified view of the pixels in the selected area. Press Command-Shift-= to zoom in at 200 percent; press the keyboard shortcut twice to zoom in at 400 percent, and so on. The Loupe is useful for making quick checks for dust specks and flaws.

4. A standard album is one to which you manually add images. Smart Albums are updated dynamically according to metadata criteria that you define. When you change the criteria associated with a particular Smart Album, the contents of the Smart Album change automatically.

Keyboard Shortcuts

Option-' (apostrophe)	Open all stacks
Option-;	Close all stacks
Shift-K	Open/close a selected stack or stacks
Command-Option-L	Create a new album
Command-Shift-L	Create a new Smart Album
Option-E	Email selected images
\ (backslash)	Apply a Select (five-star) rating to an image
Command-backslash (\)	Make a selected image the pick of the stack
Command-5 or backslash (\)	Apply a five-star rating to an image
Command-0	Tag an image as unrated
Y	Show/hide a metadata icon on images in the Viewer and Browser
S	Toggle the Primary Only button in the Viewer
Option-R	Switch to the Primary Viewer mode
Option-U	Switch to the Multi Viewer mode
Z	Zoom to 100 percent or fit to Viewer
` (accent grave)	Show/hide the Loupe tool
Command-click an item in the Projects panel	Open the item in a tabbed pane in the Browser
Option-click an item in the Projects panel	Open the item in a split pane in the Viewer

4

Time This lesson takes approximately 75 minutes to complete.

Goals Use the Rotate, Straighten, and Crop tools to frame images

Automatically adjust an image's exposure and luminance level

Use the Spot & Patch tool to remove sensor dust

Copy adjustments from one image to another using the Lift and Stamp tools

Image Adjustment Basics

After you have imported digital master files to your hard disk, you can make adjustments to them. For example, you can change their exposure, contrast, or saturation, or you can crop, straighten, or rotate them.

When you make adjustments to an image, Aperture stores those modification instructions as a "version" of the master file that includes your adjustments and embedded information; Aperture leaves the master file untouched. There is no need to execute a Save command in Aperture. The version is simply an XML file that stores adjustments to an image as a set of instructions linked to the master image.

When you view a version, Aperture uses the original master file as a resource and applies the linked set of instructions to the image on your display. In this way, all image adjustments made in Aperture are nondestructive. When you export an image, the adjustments are applied only to the exported copy.

In Lesson 3, you created a Smart Album of images of three potential locations for a fashion shoot. Even though the images are only intended for assessing the locations and won't be used in the fashion retailer's advertising, they speak to your professional talents, so you want them to look their best. In this lesson, we will learn the basics of using Aperture's nondestructive editing tools to tidy up and, in some cases, enhance the appearance of these images. You'll learn more about making image adjustments in Lesson 7, "Finishing, Delivering, and Archiving Images," and Lesson 9, "Advanced Editing."

Preparing Images for Adjustments

This lesson picks up where Lesson 3 left off, so there are no media or lesson files to import.

1 Open Aperture.

2 Press Command-Option-S to make sure you're in the Basic layout.

3 Select the Five Star Locations Smart Album in the Projects panel.

Framing Your Images

Aperture offers a number of tools that help you frame images, which is an everyday task for many photographers. These tools, located on the center right of the toolbar, allow you to rotate, straighten, and crop images. Let's use them now to adjust the frames of some of our five-star location images.

Rotating a Single Image

The Rotate tools allow you to change the orientation of your images. You can rotate clockwise (right) or counterclockwise (left) in 90-degree increments. You may need to rotate images, for example, if you held your camera in the portrait position to capture some shots and they were imported without adjustment. All of the images in our Smart Album are correctly oriented, but let's learn to rotate images using one of our South America shots.

1 Click the Rotate Left tool to select it.

2 Click the image **DSC_0986** in the Browser.

The image rotates 90 degrees counterclockwise.

TIP ▶ Aperture uses the standard keyboard shortcut Command-Z to undo an action. If you make a mistake in rotating the image, just press Command-Z. Press Command-Z multiple times to step backward through the most recent actions.

3 Press the R key to switch to the Rotate Right tool. The R key is the keyboard shortcut for both Rotate tools. If the Rotate Left tool is already selected, pressing R switches you to the Rotate Right tool.

TIP ▶ Pressing Option temporarily switches between the Rotate Left and Rotate Right tools.

4 Click the image **DSC_0986** in the Browser. The image rotates 90 degrees clockwise, back to its original position.

5 Press the A key to switch to the Selection tool.

It's a good habit to switch to the Selection tool whenever you are done using an adjustment tool on the toolbar. This helps prevent accidental changes to images.

Rotating a single image is straightforward. You can also rotate a single image in the Viewer.

Rotating a Group of Images

Things get a bit tricky when you want to rotate multiple images at once, as you'll see now.

1 In the Browser, select the first image in the Smart Album, **DSC_0966**, and then Shift-click the fifth image, **DSC_0980**.

The five images appear in the Viewer, and the last image is your primary selection.

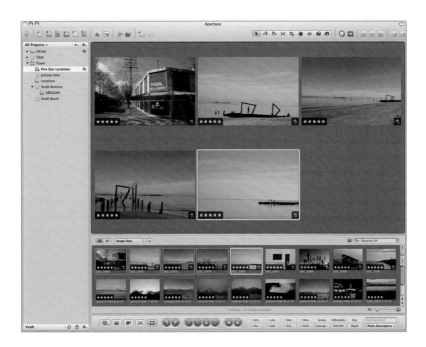

2 Make sure the Primary Only option is off. You can tell it's off because the background of the Primary Only button is light gray and the nonprimary images in the Viewer are outlined with a thin white frame.

3 Select the Rotate Left tool and then click the second of the five images in the Viewer. Only the image that you click rotates.

4 Press Command-Z and then turn on the Primary Only option. The Primary Only button's background turns a darker shade of gray and the white outline surrounding the nonprimary images in the Viewer disappears.

5 Click the third of the five images in the Viewer. Once again, only the image that you click rotates.

Using the Rotate tool, you can rotate only single images, regardless of the Primary Only setting. There is a way, however, to rotate multiple images at once, as you're about to see.

6 Press Command-Z, then press the A key to switch to the Selection tool.

7 Press the left bracket ([) key. The primary selection, **DSC_0980**, rotates 90 degrees counterclockwise, because the Primary Only mode is on.

8 Press the right bracket (]) key to rotate the primary selection 90 degrees clockwise, returning the image to its original orientation.

9 Turn off the Primary Only mode by pressing the S key and then press the right bracket (]) key.

All five images rotate 90 degrees clockwise.

10 Press the] key again. Now all of the images are upside down.

11 Press the [key twice to return the images to their original, upright positions. Then, click in the background of the Browser to deselect all the images.

To rotate a group of selected images, you must have the Primary Only mode off and you must use the [and] keys or the Rotate buttons in the control bar, not the Rotate tools in the toolbar, in the Viewer. Once you know the secret, it's easy. You can, for example, Command-click to select discontiguous images in the Browser and then use [or] to rotate them. Who ever knew rotating could be this much fun!

Using the Straighten Tool

Now let's perform some needed corrections, starting with a slanted horizon line in one of our Jackson Hole images. We'll use the Straighten tool, which offers an innovative way of adjusting horizon lines: The tool automatically crops the image as necessary. It is primarily a corrective tool, as in our project, but it can also be used to create Dutch angles for those times when you purposefully frame an image on a slant to create a feeling of disorientation.

1 Select the **Jackson Hole 8 of 23** image in the Browser.

The horizon line is just off enough to drive a perfectionist photographer crazy. A slight adjustment will work wonders.

2 Select the Straighten tool from the toolbar, or press G.

3 Drag the cursor close to the center. As you drag, a grid appears to help you adjust the horizon so that it's perfectly level, and the image rotates around the center crosshair of the grid. Don't worry about getting the horizon perfect yet.

Dragging near the center crosshair is a little like turning a steering wheel. The rotation is very sensitive and becomes more difficult to control, the closer you drag to the crosshair.

4 Drag the cursor toward the edge of the image frame and adjust until you are satisfied.

Dragging further away from the center crosshair allows you to adjust the rotation in smaller increments.

5 Select **Jackson Hole 9 of 23**. This image doesn't need to be straightened, but practice using the Straighten tool on the image to skew it.

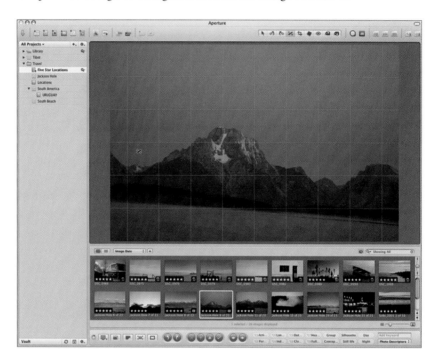

6 Choose Window > Show Adjustments or press Control-A to open the Adjustments Inspector.

7 Click the Adjustments Inspector's Action button and choose Remove Selected from the pop-up menu.

The Remove Selected command removes the adjustment performed by the currently selected tool. The Remove All Adjustments command, meanwhile, removes the effects of all the adjustments applied to an image regardless of which tool is currently selected. These are two useful commands to know, but we do want to level this horizon line.

8 Use the Straighten tool to adjust the horizon line in any images that you think require straightening in the Five Star Locations Smart Album, then press the A key to switch to the Selection tool when you are done.

Clients are not likely to compliment you on your wonderfully level horizon lines, but they will certainly notice if your horizons are askew.

Using the Crop Tool

Cropping images is a basic task that photographers perform regularly. You can use cropping to remove an unwanted element from a frame or to create a dynamic shift in composition. In either case, you use Aperture's Crop tool.

1 Press I to close the Adjustments Inspector.

2 Select the **SoBe_2005 12 of 50** image in the Five Star Locations Smart Album in the Projects panel. It appears in the Viewer. This is a nice image, but there's a small bit of kite, or a flag, in the upper left corner that's a

little distracting. And there's a bystander on the beach who interferes with the overall serenity of the image. So let's crop this image to remove those two unwanted elements.

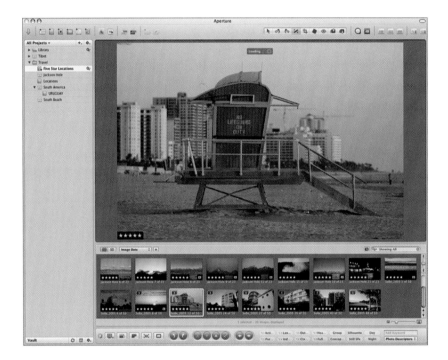

3 Select the Crop tool in the toolbar, or press C.

The Crop HUD appears, offering options for constraining the crop action to a specific aspect ratio. We'll learn how to do that in the next task. Right now, we want to freely crop the image.

4 Leave the Constrain box unchecked and drag the Crop HUD out of the way.

5 Starting in the upper left corner, below the yellow flag, drag diagonally across the image in the Viewer to the lower right corner. Keep the bystander in the background in the shot for now.

The area outside the selection appears darker; this is the area that Aperture will crop out of the image. Aperture provides eight crop handles on the selection, which you can drag to adjust the crop area. Let's do that now to remove the man standing by the water on the right side of the image.

6 Drag the lower right corner handle up and to the left, releasing when the cursor is at the bottom of the lifeguard stand's stairs.

7 Drag the center left handle inward until the leftmost building is out of the frame.

8 Drag the upper center handle to the top edge of the frame.

When you're ready to apply the crop adjustment, simply press Return.

9 Press Return to accept the crop and switch to the Selection tool.

Good work! You've successfully cropped two distracting elements from the image.

Cropping to a Specific Aspect Ratio

Many times when you crop an image, you must preserve its aspect ratio or you must crop it to a specific aspect ratio for a certain type of output. You can use the Crop HUD to crop to a specific aspect ratio.

1 Select the **SoBe_2005 3 of 50** image.

2 Press the C key to select the Crop tool.

3 In the Crop HUD, select the "Constrain cropping tool to" checkbox and then choose Common Sizes > 11 x 8.5.

4 Drag diagonally across the image from the upper left corner to the lower right corner.

Cropping to an 11 x 8.5 aspect ratio results in a narrower image. That's OK for this shot though, because we won't lose any important content.

5 Drag inside the cropping frame to the left and right to reposition it until you are happy with the composition.

6 Press Return to accept the Crop adjustment.

Choosing an aspect ratio when cropping an image is an effective way to prepare the image for a specific type of output, such as an 11-x-8.5-inch print.

Making Automatic Adjustments

Aperture offers a number of automatic adjustment tools that make it easy to perform routine editing tasks, such as adjusting an image's exposure or levels. Located in the Adjustments Inspector, these tools analyze the data of the image in the Viewer and make the selected adjustment accordingly. Automatic

adjustments are designed to let you make quick changes to individual images and are not meant for mission-critical image editing. Since our Five Star Location images are simply for judging possible locations, they are excellent candidates for a few automatic adjustments.

Auto Levels – Combined BW

Auto Exposure Auto Levels – Separate

1 Press Command-Option-V to switch to the Maximize Viewer layout. Aperture closes the Projects panel and control bar. Press Control-A to display the Adjustments Inspector.

2 Select the **Jackson Hole 17 of 23** image in the Browser. This image is overexposed and rather washed out. It would benefit from an Exposure adjustment.

3 Click the Auto Exposure button below the histogram in the Adjustments Inspector.

Aperture adjusts the image's exposure. A checkmark appears in the Exposure checkbox in the Adjustments Inspector, the value changes in the Exposure slider (click the Exposure disclosure triangle to see the slider), and the image darkens in the Viewer.

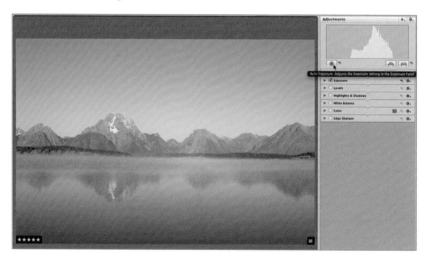

You can also tell that an adjustment has been applied from the badge that appears on the image's thumbnail in the Browser.

Now let's automatically adjust the levels of a different Jackson Hole image.

4 Select **Jackson Hole 9 of 23** in the Browser. The image is a bit dark and could use a bit more punch to make it more dramatic.

5 Click the Auto Levels – Combined button.

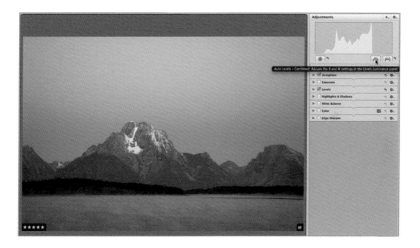

Big change. The Auto Levels – Combined button applies a luminance adjustment to the black and white points of the combined RGB channels of the image in the Viewer. It is a good adjustment if you want to maintain the color balance of your image while adjusting its overall exposure and contrast.

If you don't like the result of the Auto Levels – Combined adjustment, you can undo it easily. Let's see how the Auto Levels – Separate adjustment works instead.

6 Click the Reset button to the right of the two Auto Levels buttons, or press Command-Z to undo the adjustment.

TIP You can undo an Auto Exposure adjustment by clicking the Reset button next to the Auto Exposure button, as well.

7 Click the Auto Levels – Separate button.

This time, Aperture applies different adjustments to the black and white points of each individual color channel in the image instead of adjusting the average of the three channels. This method may alter the color balance of the image, but in our case, the adjustment is a good one. The contrast of the foreground imagery and colors is much more pronounced using this adjustment.

As you can see, Aperture's automatic adjustments are a convenient way to make quick corrections to an image's exposure or color balance. For those times when you want to study or understand the content of your image data more closely, you can use the histogram in the Adjustments Inspector.

Analyzing Image Information with the Histogram

A histogram analysis is a tool found in many imaging applications and camera LCD readouts. It is a graph that plots the brightness values of an image from the blackest to the whitest. By looking at a histogram, you can tell such things as where the pixels are concentrated in an image (in the shadows, midtones, or highlights), whether the overall tonal range is smooth, and whether the shadows or highlights are clipped. Knowing how to read a histogram is critical to making informed decisions about an image at every stage of production, from capture to output.

In Aperture you can view five types of information in the histogram: luminance, combined RGB channel data, and separate red, green, and blue channel information. Even though our Five Star Location images don't need heavy-duty image analysis—that's more important for final shots—the histogram is an important resource, and we can use it to help us make some additional image adjustments.

1 Select the **SoBe_2005 4 of 50** image in the Browser.

This image, shot before sunrise, captures the ethereal quality of natural light at dawn combined with artificial light in the windows of the hotel. Because most of the image's pixel values are quite dark, they are concentrated on the left side of the luminance (default) histogram at the top of the Adjustments Inspector.

2 Choose Histogram Options > RGB from the Adjustments Action pop-up menu.

The histogram is updated to show the RGB image data so that you can see not only the three individual color channels but also where their channel information overlaps.

Let's apply an automatic adjustment to make the image look as though it had been taken after sunrise rather than before, and then see how the histogram reflects that change.

3 Click the Auto Exposure button.

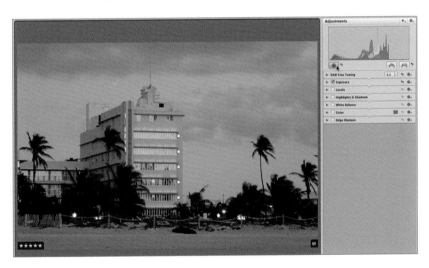

Aperture brightens the image, and the values in the histogram shift to the right, toward highlights.

Comparing Images with the Histogram

Another productive way to use the histogram is to compare data in different images.

1 Click **Jackson Hole 9 of 23** and then Command-click **Jackson Hole 11 of 23** in the Browser to select them both.

Since we previously adjusted the **Jackson Hole 9 of 23** image, its histogram should be quite different from the histogram of **Jackson Hole 11 of 23**.

2 Using the Adjustments Action pop-up menu, switch the Histogram view to Luminance. This will allow you to focus on the luminance values of the images.

3 Alternately click the two images in the Viewer and notice the differences in the histograms. The **Jackson Hole 11 of 23** image has far fewer bright values.

Jackson Hole 9 of 23 and its histogram

Jackson Hole 11 of 23 and its histogram

4 Command-click **Jackson Hole 9 of 23** to deselect it. Apply the Auto
Levels – Combined adjustment to the **Jackson Hole 11 of 23** image.
Compare the before and after histogram by selecting and deselecting the
checkbox next to Levels.

The Auto Levels adjustment nudged the values in the image toward the
brighter areas without significantly altering the image color, just as it's
supposed to do.

The histogram is your main source for analyzing image data in Aperture. The
secondary histogram in the Levels area of the Adjustments Inspector shows
unadjusted values, so you can compare data. (Click the Levels disclosure
triangle to reveal or hide the secondary histogram.) You will learn more
about the Levels controls group and both histograms in Lessons 7 and 9.

Using the Spot & Patch Tool

The Spot & Patch tool is designed to magically eliminate small unwanted ele-
ments of an image, such as dust or skin blemishes. Let's use this tool to remove
some sensor dust on the Jackson Hole images.

NOTE ▸ The image sensor on a digital camera is susceptible to dust. This dust can be eliminated with proper care and cleaning of the protective glass of the sensor, but sensor dust is often not detectable by looking through the camera and goes unnoticed until the images reach the post-production stage.

1 Press Shift-W to rotate the Browser to the left side of the main window. Select **Jackson Hole 6 of 23** through **Jackson Hole 19 of 23** in the Browser.

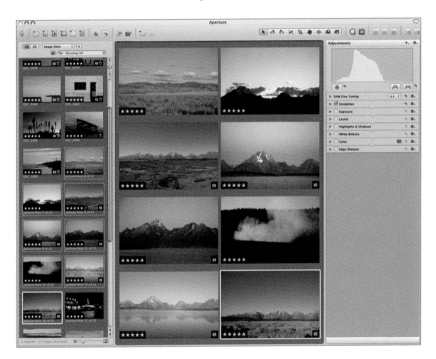

2 Press the S key to turn the Primary Only option off, if necessary. All of the nonprimary selections should have a white border in the Viewer.

3 Click the first image, **Jackson Hole 6 of 23**, in the Viewer and press Option-R to switch to the Primary Viewer mode to focus on this first image.

4 Position the mouse cursor over the sensor dust located near the top of the image, just left of center, and then press the Z key to zoom in on the area.

The sensor dust appears as a small dark blotch on the image. Sensor dust is often easier to detect in relatively flat color areas such as skies.

NOTE ▸ Pressing the Z key to zoom may deselect images, as Aperture will adjust the number of selected images to fit the size of your Viewer. This is true even if you are in the Primary Viewer mode.

5 Click the Spot & Patch tool or press the X key to select it.

The Spot & Patch HUD appears, letting you set the Radius before you click the area that you want to eliminate in the image.

6 Drag the Radius slider in the Spot & Patch HUD to 26.0. A circle previewing the Radius size appears around a target crosshair when you position the cursor over the image.

7 Click the sensor dust with the Spot & Patch tool.

A yellow circle appears to indicate that you applied a Spot & Patch correction. The Spot & Patch tool replaces the spot using pixel values from the area around the selection.

8 Press Return to accept the Spot & Patch results. Press Z to zoom back out. Press Option-U to return to the Multi Viewer mode.

That's all it takes to remove sensor dust from an image. Now, let's clean up the dust on some other Jackson Hole images.

Using the Lift and Stamp Tools

Very often, similar adjustments must be applied to multiple images. Aperture allows you to easily copy an adjustment from one image and apply it to another image or group of images using the Lift and Stamp tools. Many of our Jackson Hole images have sensor dust in the same location. Instead of using the Spot &

Patch tool on each image, let's use the Lift and Stamp tools to apply the cleanup from the last image to all of the affected images.

1 Make sure **Jackson Hole 6 of 23** through **Jackson Hole 19 of 23** are selected in the Browser.

2 Click the Lift tool in the toolbar (the second tool from the right) or press O to select it. The Lift & Stamp HUD appears.

3 Drag the Lift & Stamp HUD over the Browser so you can see all of the images in the Viewer.

4 Using the Lift tool, click the **Jackson Hole 6 of 23** image, which you adjusted using the Spot & Patch tool.

Clicking the image selects it and lifts, or copies, the adjustments of the image to the Lift and Stamp tools' memory. When you click, the tool automatically changes from the Lift tool to the Stamp tool (from an up to a down arrow), ready to apply the lifted adjustments to another image or group of images. The tool has lifted not only the image's adjustments but also its ratings and metadata. Since we only care about copying the Spot & Patch adjustment, let's disable the other items.

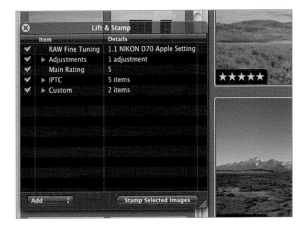

5 Click the Adjustments disclosure triangle in the Lift & Stamp HUD to see the Spot & Patch item. Then, deselect all the RAW Fine Tuning, Main Rating, IPTC, and Custom information items.

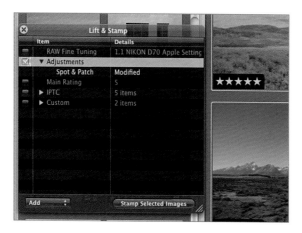

6 Close the Lift & Stamp HUD, then select **Jackson Hole 7 of 23**. Press Option-R to show only the primary image in the Viewer. Click the Stamp tool. Since the image was shot on the same shoot on the same camera, the sensor dust is in approximately the same location at the top of the image, just left of center.

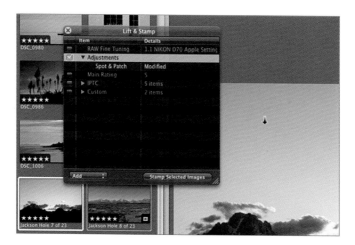

7 Position the cursor near the sensor dust and press Z to zoom in on the image in the Viewer.

8 Click the image with the Stamp tool. The sensor dust disappears, this time because we copied the adjustment from the first image.

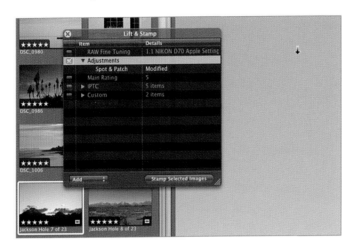

A third image, **Jackson Hole 17 of 23**, also needs to have sensor dust removed, but zooming in on **Jackson Hole 7 of 23** in the Viewer caused **Jackson Hole 17 of 23** to become deselected. Fortunately, we can stamp the adjustment on an image in the Browser by simply clicking in it.

9 Click the **Jackson Hole 17 of 23** image in the Browser to apply the Stamp tool correction to it.

10 Press Z to zoom back out of the Viewer, and then press Option-U to return the Viewer to the Multi Viewer mode. Some of the Jackson Hole images are still selected. Hold down the Shift key and press the right arrow key several times until **Jackson Hole 6 of 23** through **Jackson Hole 19 of 23** are selected.

11 Click the Stamp Selected Images button in the Lift & Stamp HUD. This copies the Spot & Patch adjustment to all the selected images; images that have already undergone the Spot & Patch adjustment are unchanged. There is no additive effect.

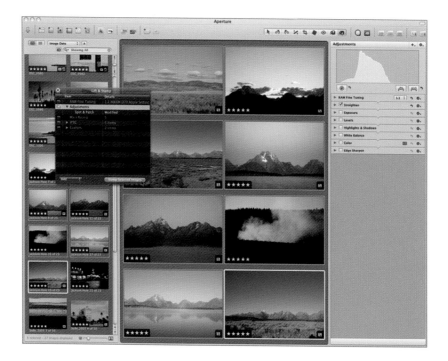

TIP You can also apply the Lift & Stamp adjustment to multiple images by clicking the first image of a selection and then Shift-clicking the last image of a group. Simply clicking an image within a selection does not apply the adjustment to multiple images.

12 Close the Lift & Stamp HUD by clicking the circled X or pressing the A key to switch to the Selection tool.

The Spot & Patch adjustment worked well on all the images except for the **Jackson Hole 9 of 23** image. Next, we will blend the adjustment and make it less obvious.

Adjusting Spot & Patch Options

Many of the tools in Aperture, including the Spot & Patch tool, offer basic options in their respective HUDs but make additional options available in the Adjustments Inspector after the adjustment has been applied. Let's use these additional options to fine-tune the Spot & Patch adjustment on the **Jackson Hole 9 of 23** image.

1 Click the **Jackson Hole 9 of 23** image in the Browser or Viewer to make it the primary selection.

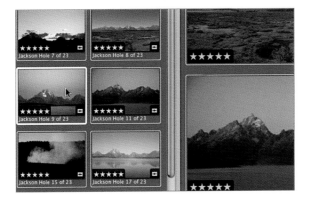

2 Press Option-R to switch the Viewer to Primary Viewer mode.

3 Position the cursor close to the sensor dust area and press the Z key to zoom in.

The Spot & Patch adjustment did not simulate the digital noise pattern on the image, so the shape of the correction is noticeable. But we can adjust the tool's parameters to blend the patch better.

4 Click the Spot & Patch disclosure triangle in the Adjustments Inspector to reveal the Spot & Patch controls group.

5 Drag the Radius slider to 40, or double-click in the numerical entry box, type *40*, and then press Return.

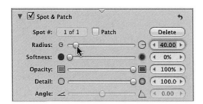

This made the patch lighter, but it is still not quite blending in.

6 Set Softness to 20%, Opacity to 90%, and Detail to 5.00.

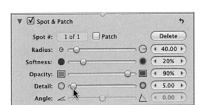

These adjustments do a much better job of blending the patch into the sky. Increasing the softness feathers the edge of the selection; reducing the opacity adjusts the density of the pixels included in the patch area; and the much lower value for Detail reduces the amount of detail blended into the patch area.

7 Press the Z key to zoom back out. The sensor dust is gone, and the patch isn't noticeable.

Removing sensor dust is only one way to use the Spot & Patch tool. You can also use it to clone pixels from one area of an image to another. The good news is your images are nice and clean and ready to ship out. The great news is that we never touched the original master image.

Comparing an Adjusted Image to the Master Image

Remember, after making all of these changes, your original master images are untouched. The instructions are only "baked" into exported images from versions (which you'll do in Lesson 7). At any time, however, you can compare your adjusted image to the original master file. Here's how.

1 Press Command-Option-S to switch to the Basic layout.

2 Select **SoBe_2005 12 of 50** in the Browser.

This is the image we cropped at the beginning of the lesson.

3 Press the C key to choose the Crop tool.

The original crop area appears. Let's adjust it.

4 Drag the top center handle until it just clears the tips of the antennas over the lifeguard stand. (You may need to deselect the Constrain checkbox in the Crop HUD.)

5 Press Return to accept the change. Remember, the original master file is untouched.

6 Choose View > Show Master Image, or press the M key.

The Viewer shows the master image instead of the cropped version. You have not undone your changes; you are viewing the original digital master file. A floating tag tells you that you're viewing the master image.

7 Choose View > Show Master Image (or press M) to switch back to the cropped image in the Viewer.

You can toggle the master image in the Browser as well as in the Viewer.

8 Select the **Jackson Hole 9 of 23** image in the Browser.

9 Press the M key several times to switch between the Master and Version views. This is a great way of doing a before-and-after comparison of an adjustment. On this image we can really see how the adjustment enhanced the image.

NOTE ▶ You may experience a slight delay as you switch between the Master and Version views in the Browser. Make sure you allow time for the image to completely appear before making any critical evaluations.

In Aperture, you can make as many changes to a version as you like, and as many versions of an image as you'd like. The original master image remains intact. When you are ready to export, you can export the master or a version with the adjustments you have made. You'll learn more about creating multiple versions of an image in Lesson 9.

Photographers are perfectionists. We are constantly trying to get the most out of our tools to achieve the best possible results. A subtle change in exposure or depth of field during a shoot can mean all the difference between a "Wow!" versus an "Eh" from the client. Making adjustments to digital images is no different: A few subtle changes and corrections go a long way toward turning an average picture into a stunning image.

Lesson Review

1. How does Aperture apply changes to image files nondestructively?

2. How does the Straighten tool work?

3. Name two types of automatic adjustments in Aperture and explain how to make them.

4. What is a histogram and what kind of information does it show in Aperture?

Answers

1. When you make adjustments to an image, Aperture creates a "version" of the master file that includes your adjustments and embedded information; Aperture leaves the master file untouched. Versions do not actually exist as independent image files. Adjustments to an image are kept as a set of instructions linked to the master image. When you view a version, Aperture uses the original master file as a resource and applies the linked set of instructions to the image on your display. In this way, all image adjustments made in Aperture are nondestructive.

2. The Straighten tool allows you to straighten uneven images: for example, to make a horizon line level. As you drag with the tool, a grid appears to

help you make the adjustment, and the image rotates around the crosshair in the middle of the image.

3. Aperture allows you to automatically adjust the exposure and levels of images. You do so by selecting an image in the Browser so that it appears in the Viewer, and then click the Auto Exposure or Auto Levels button in the Adjustments Inspector.

4. A histogram is a graph that plots the brightness values of an image from the blackest to the whitest. By looking a histogram, you can tell such things as where the pixels are concentrated in an image (in the shadows, midtones, or highlights), whether the overall tonal range is smooth, and whether the shadows or highlights are clipped. In Aperture you can view five types of information in the histogram: luminance, combined RGB channel data, and separate red, green, and blue channel information.

Keyboard Shortcuts

R	Select the Rotate tool
Command-Z	Undo last action
A	Select the Selection tool
[Rotate the selected image(s) 90 degrees counterclockwise
]	Rotate the selected image(s) 90 degrees clockwise
G	Select the Straighten tool
C	Select the Crop tool
M	Show/hide the master image view in the Viewer
X	Select the Spot & Patch tool
O	Select the Lift tool

5

Time This lesson takes approximately 1 hour to complete.

Goals Create a web journal album

Design webpages in the Webpage Editor

Preview web journal images in a slideshow

Export a web journal to HTML

Publish a web journal to a .Mac account

Lesson **5**

Creating Web Output

Images in your Aperture Library would not be particularly exciting if you could not share or display them. One of the best ways to share your images is with a web journal album. A web journal album is a type of album whose images you arrange in the Webpage Editor and publish on the web as a web journal. The web journal displays images with titles, captions, and other descriptive text. It is a flexible way to assemble webpages, and it's particularly useful for sharing location shots, such as those we took in Uruguay, South Beach, and Jackson Hole. In this lesson, we will create a web journal that clients can view online at their convenience. We'll preview the images in the journal as a slideshow, and then export the web journal pages to HTML and publish them to a .Mac account. But before we get started, let's organize the Projects panel, which has become relatively cluttered.

Organizing the Projects Panel Using Favorites

As your Aperture Library grows to include more projects and folders, the Projects panel can become crowded and it can be hard to find the items you need for any given work session. For example, our Library contains (among other items) a standard album, a Smart Album, and the Tibet project. But all we need to create our web journal album is the Travel folder and the Five Star Locations Smart Album, so let's make them easier to access by making them "favorites."

> **NOTE ▸** This lesson picks up where Lesson 4 left off, so there are no media or lesson files to import.

1 Open Aperture if it's not already open.

2 Press Command-Option-S to make sure you're in the Basic layout. Press Shift-D to turn off the keyword controls in the control bar if they are visible.

3 Select the Travel folder in the Projects panel and then click the disclosure triangle to view its contents.

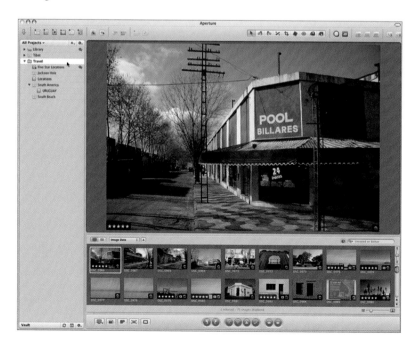

4 Choose Add To Favorites from the Project Action pop-up menu. This sets
the Travel folder as a favorite.

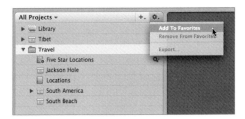

5 Choose Show Favorites from the All Projects pop-up menu at the top of
the Projects panel.

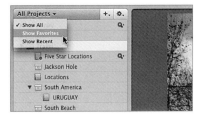

The Projects panel now displays only folders, projects, and albums that
you have designated as favorites—in this case, the Travel folder. The proj-
ects and Smart Album inside the Travel folder do not appear because we
haven't designated them as favorites. You need to select each individual
item that you want to designate as a favorite.

NOTE ▶ The Projects panel always shows the Library and the default
Library Smart Albums.

6 Choose Show All from the All Projects pop-up menu to show all of the Library contents in the panel again.

7 Select the Five Star Locations Smart Album and choose Add To Favorites from the Projects Action pop-up menu.

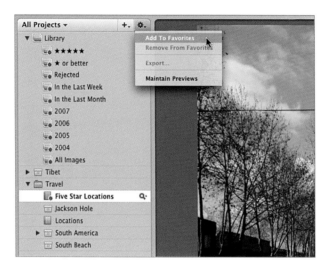

8 Choose Show Favorites from the All Projects pop-up menu to show only your favorites.

9 Click the Library's disclosure triangle to hide its default Smart Albums.

Using favorites is an excellent way to control what you are viewing in the Projects panel as the number of organizational elements in the panel increases. Aperture offers you two types of web output: the web gallery and the web journal. You will create a web journal.

NOTE ▶ A web gallery is a type of website you can create in Aperture that is like an online contact sheet of images. It offers fewer options and less control over webpages than a web journal. You will create a web gallery in Lesson 10.

Now you're ready to create a web journal of your location images to share with Grande Agency and its client.

Creating a Web Journal

A web journal is basically a collection of webpages that feature images with
extended captions. It can have one or more index pages that display thumb-
nails of images; viewers can click a thumbnail to see the image in detail. You
can control the size and the grouping of the images on the index pages, as well
as of the accompanying text. Our web journal will have an opening index or
title page, as well as an index page for each location, for a total of four pages.
We'll use the text to explain the logistical issues of shooting in each location.

1 Control-click the Five Star Locations Smart Album in the Projects panel
 and choose New From Selection > Web Journal.

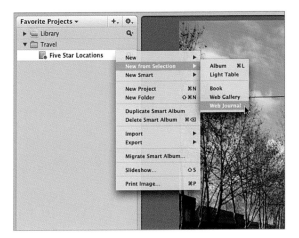

A window appears asking whether you want to create the web journal
from the first selected image in the Browser or from all of the images in
the Smart Album.

2 Click Create With All Images.

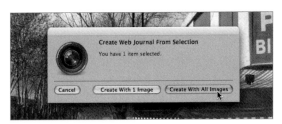

TIP ▶ You can also create a web journal album by selecting images in the Browser and then choosing New Web Journal From Selection from the Projects panel Add to Library pop-up menu.

A new, untitled web journal album appears in the Projects panel, and the Webpage Editor appears in place of the Viewer.

NOTE ▶ Any item you create while the Projects panel is displaying favorites—including our new web journal album—automatically becomes a favorite, too.

3 Name the untitled web journal album *Locations Journal* and then press Return.

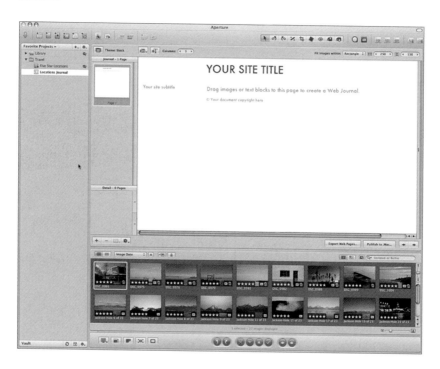

4 Press Command-Option-V to switch to the Maximize Viewer layout, which hides the Projects panel and control bar, reduces the Browser, and provides a large space to work in the Webpage Editor.

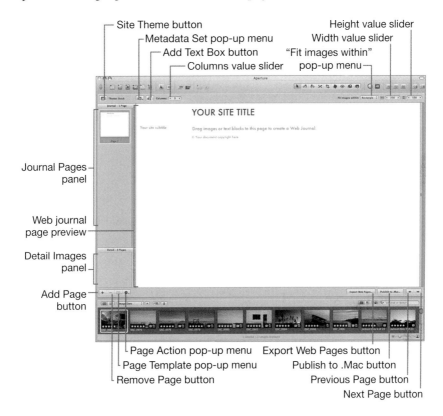

The Webpage Editor has numerous panels and controls for creating pages and working with images in a web journal album. So let's get started using it.

Adding Images and Pages

You can add individual images to a web journal manually or use automated functions to add images and pages. We'll start by adding images manually to the main index page of the journal, which will showcase one image from each of the three locations. Then we'll add additional linked pages to the journal.

1 Drag **DSC_0976** from the Browser to the Webpage Editor preview area, releasing the mouse button when a green line appears across the center of the area.

The image appears below the YOUR SITE TITLE text.

2 Position the cursor over the image in the preview area. Notice the buttons that provide different functions.

Detail button

YOUR SITE TITLE

Remove photo box
Remove image from photo box

© Your document copyright here

3 Drag **Jackson Hole 11 of 23** from the Browser to the preview area, releasing the mouse button when a green line appears below the **DSC_0976** image.

YOUR SITE TITLE

© Your document copyright here

This creates a new photo box, which holds an image. A photo box is simply a container for an image or a group of images. You can also drag an image on top of an existing image to replace it, or drop an image to the right or left of an image to add to an existing row of images.

4 Drag **SoBe_2005 48 of 50** below the second image.

The three images appear in the web preview area in a column. In the Browser, the added images are selected and tagged with a small 1 in the upper right corner. This indicates the number of times the image is used on the site—so far, just once.

Now that you've manually added images to the title page, let's add three pages to the web journal—one for each location.

5 Click the Show Unplaced Images button, then select all of the images in the Browser.

You will use the selected images to automatically create additional pages, sorted by city.

6 Choose New Page For Each City from the Page Action pop-up menu at the left side of the Webpage Editor, below the Detail Images panel.

Aperture adds three pages to the web journal, one for each city identified in the City metadata field in our Five Star Locations Smart Album. The pages appear with image thumbnails in the Journal Pages panel. The Colonia page appears in the preview area because it's first alphabetically, and Aperture adds page numbers to the top of the pages to allow navigation.

Choosing a Site Theme

With the basic skeleton of the web journal in place, let's change the look of the pages to reflect a preset theme. By default, Aperture applied the Stock theme, which uses a white background, but let's use something more dramatic.

1 Click the Site Theme button in the upper left corner of the Webpage Editor. The Choose Web Theme window appears, offering a selection of preset templates for creating standard HTML webpages.

2 Select the Stock Black theme and then click the Choose button to apply the new theme and return to the Webpage Editor. Aperture returns to page 1 of the site when you apply a new theme.

You have now created the structure of your web journal and given it a theme, or style. Now, you need to customize the text.

Customizing Text

Aperture applied some placeholder titles when we created the web journal, but they're completely customizable. Let's edit the existing text as well as add new text.

1 Click the "YOUR SITE TITLE" text and replace it by typing *PROPOSED LOCATIONS.*

2 Replace the "Your site subtitle" text with *Grande Agency/Luna Studio.*

3 Replace the "Your document copyright here" text with © *Orlando Luna*.

That was easy. This header, subtitle, and copyright text will appear on all of the site's index pages.

TIP ► You can define web copyright info in Aperture Preferences. Aperture will automatically fill in the Preferences web copyright data to all newly created web galleries and web journals.

Aperture displays caption information under the images. Since there is no caption metadata, let's add some now. Instead of manually writing a caption for each image, however, we can automate the process by using the Batch Change feature.

4 Click the Show All Images button, then press V to hide the Webpage Editor and enlarge the Browser.

5 Select all of the Uruguay images, which all begin with *DSC*.

6 Choose Metadata > Batch Change.

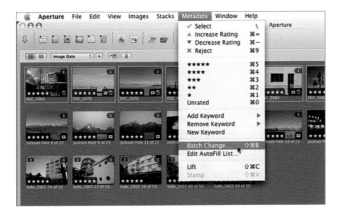

The Batch Change dialog appears.

7 Choose Add Metadata From > Caption Only.

8 In the Caption field, type *Colonia June 2005* and then press Tab.

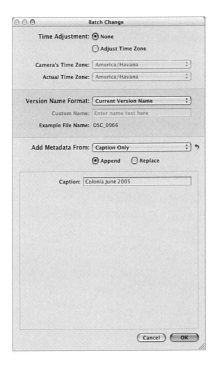

9 Click OK to apply the caption to all of the selected images.

10 Repeat steps 5 through 9 for the Jackson Hole and South Beach images, selecting them in turn and specifying a caption of *Jackson Hole Sept 2005* and *South Beach Dec 2005,* respectively. Then press V to return to the Webpage Editor.

Make sure Caption is chosen in the Metadata Set pop-up menu. The captions you entered using the Batch Change command are displayed under each image.

11 Click to select the Colonia page in the Journal Pages panel.

The captions are identical for all of the Colonia images; they need to be customized so that the client can reference specific images.

12 Select Enable Plate Metadata from the Metadata Set pop-up menu.

Aperture adds an image number caption to each thumbnail.

13 Click to select Page 1 in the Journal Pages panel.

The index pages now contain a custom header and captions. You will add some text to the main index page in a minute, but let's quickly customize the text on the image detail pages first. A detail page appears whenever a user clicks on a thumbnail on an index page.

14 Click Detail Page 1 in the Detail Images panel, in the lower left corner of the Webpage Editor. If necessary, use the arrow buttons on the right side of the Detail Page panel to navigate to Detail Page 1.

The first image in the journal and the image-capture metadata appear in the preview area. The clients don't need to know the lens aperture, camera shutter speed, and other capture information for the image, however; they do need to see the caption and image number.

15 Choose Caption Only from the Metadata Set pop-up menu.

Now, only the Caption metadata that we edited earlier in this exercise will appear on all of the image detail pages.

16 Select Page 1 in the Journal Pages panel.

Excellent. The next task is to add text about the different locations. To do that, we need to create text boxes.

Adding Text

The default text fields got us off to a good start, but sometimes you need additional text on a webpage. Not to worry. You can create additional boxes as needed.

1 Click the Add Text Block button. A text box appears at the bottom of Page 1. You may need to scroll in order to view the text.

2 Place the cursor over the text to see a frame appear around it.

3 Click the left T in the upper right corner of the text box.

The placeholder text changes to a subtitle style in a larger point size.

4 Click the placeholder text and type *Additional Images on Pages 2 thru 4*, and then press Tab.

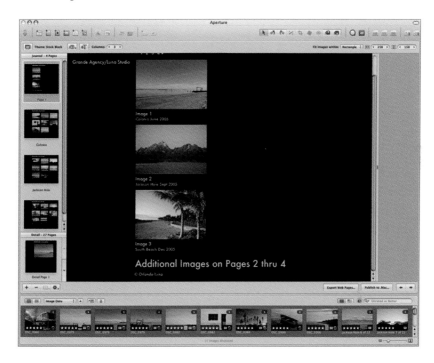

The main index page is complete. Now it's time to add text to the three city index pages (pages 2 through 4 of the web journal).

5 Select the Colonia page in Journal Pages panel. It appears in the preview area.

6 Click the Add Text Box button.

A text box is added to the bottom of the page. For the city index pages, let's move this text box to the top of the page and use it to identify the location.

7 Position the cursor over the top center of the text box (over the grid of dots) and drag it up, releasing the mouse button when you see a green line above the eight thumbnail images.

8 Click the T in the text box to change the text to the Subheading style. Then select the text and type *Colonia, Uruguay, photographed June 2005*. Press Tab when you finish entering the text.

You now have a location title at the top of the page. Next, let's add some notes at the bottom of the page regarding the logistics of a shoot in Colonia, Uruguay.

9 Click the Add Text Box button.

10 Click the text and type *Local producer available to handle equipment and location arrangements*. Then press Tab to exit text-editing mode.

11 Select the Jackson Hole page in the Journal Pages panel.

12 Repeat steps 6 to 10 to add a subhead that says *Jackson Hole, Wyoming, photographed Sept 2005* at the top of the page and a note at the bottom of

the page that says *Great location, may be too snow covered and cold in the winter to shoot.*

13 Select the South Beach page in the Journal Pages panel.

14 Repeat steps 6 to 10 to add a subhead that says *South Beach, Florida, photographed Dec 2005* and a note that says *Largest variety of locations for a winter shoot.*

TIP ▶ To check your spelling, Control-click the text inside the text box and choose Spelling from the contextual menu.

The web journal is almost done. Let's just make a few small adjustments to the size and position of the images on the pages.

Sizing and Positioning Images

In Aperture, you can adjust the size and positions of the thumbnails on index pages as well as the size of images on detail pages. And as you saw when you edited the caption metadata, you can also conveniently jump to the Viewer to inspect or edit images while you're working with them in the Webpage Editor. Let's make a few tweaks to the images in our web journal.

1 Click Detail Page 1 in the Detail Images panel.

TIP ▶ Click the up and down arrow buttons on the right side of the Detail Images panel to preview other image detail pages in the web journal.

The image on the detail page could be slightly larger than the default value.

2 Drag the Width value slider to 700 or type *700* into the field.

Aperture updates the image size in the preview area. The good news is that Aperture applies the new size to all of the detail page images. You

can't resize them individually. The image aspect ratio remains untouched, and the image sizes itself to the smaller of the two values.

3 Select the South Beach page in the Journal Pages panel.

You can also resize images on index pages as well as control the number of columns that appear and the size of the thumbnails. The default image size and three-column layout look pretty good for our web journal, but let's rearrange the order of the images.

4 Drag Image 27 (**SoBe_2005 3 of 50**) to the upper left corner of the web-page, releasing the mouse button when a green line appears to the left of Image 20. **SoBe_2005 3 of 50** becomes Image 20 and Aperture renumbers the other images accordingly.

SoBe_2005 3 of 50 works in the first position, but as you may recall from Lesson 4, we cropped it slightly for printing purposes. Now, in the web journal, it seems out of place compared with the other images.

5 With Image 20 (**SoBe_2005 3 of 50**) selected, click the "Show Viewer for this Browser" button on the upper left of the Browser.

The Webpage Editor is hidden and the selected image appears in the Viewer.

6 Press C to select the Crop tool. Make sure the Constrain checkbox in the Crop HUD is deselected.

7 Drag the right edge of the crop area to include the rightmost cluster of birds, and pull the bottom handle up slightly. Then, press Return to accept the adjustment.

8 Click the "Show Viewer for this Browser" button again to return to the Webpage Editor.

The adjusted image appears in the preview area and it now more closely matches the other images on the webpage.

9 Drag Image 23 (**SoBe_2005 8 of 50**) to the last position on the page.

Nice. Now the sunset shots frame the other images on the page. The other index pages look pretty good, so now is a good time to kick back and preview all of the images in the web journal. You can do that by watching a slideshow.

Previewing Images in a Slideshow

Slideshows are an excellent way to showcase your work. You can use them to create a presentation for clients, to display event images, or to run in the background at an event. They're also one of the best ways to preview your images.

Let's create a slideshow now of the images in the web journal to gauge the impression they'll make.

1 Choose File > Slideshow or press Shift-S.

The Run Slideshow window appears.

The slideshow displays all the images in the current album or project. In this case, the slideshow displays all of the images in our web journal album, which is based on the Five Star Locations Smart Album.

2 Choose Slideshow Preset > 4-Up Slow. This preset displays four images on a grid, showing them for three seconds each. Then the first image is replaced with the fifth in a two-second cross fade, and so on.

3 Click the Start button to begin the slideshow.

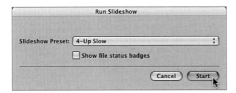

The slideshow begins, with the images appearing one at a time until four of them are onscreen. Then, the images successively cross-fade new images into place. The slideshow will continuously loop.

4 Press the Esc key to end the slideshow.

The presets are wonderfully designed, but there are number of options available when you create your own preset.

5 Press Shift-S to open the Run Slideshow window again, and then choose Slideshow Preset > Edit. The Slideshow Presets window appears.

6 Select 4-Up Slow from the Presets list on the left and click the Add (+) button in the lower left corner to create a new preset based on 4-Up Slow.

7 Name the new preset *2-Up Slow* and press Return.

8 Drag the Columns slider to 1 and the Padding slider to 4 pixels, and then click OK.

After these changes, the images appear in a single column in the slideshow and the space, or padding, between the two images is reduced.

TIP ▶ Using the controls at the bottom of the Slideshow Presets dialog, you can also add music to your slideshow from an iTunes playlist. And using the Quality options in the upper right corner of the dialog, you can choose the Good setting, which loads more quickly onscreen.

9 Click Start to play the 2-Up Slow slideshow.

The slideshow now displays two images at a time onscreen. This allows you to concentrate your evaluation on fewer images at a time.

10 Press the spacebar to pause the slideshow; press the spacebar a second time to resume the slideshow.

A partially transparent triangle momentarily appears onscreen to indicate pause or playback mode.

11 Press the right arrow key to advance the slideshow manually; press the left arrow to move backward through the slideshow.

12 Press Esc to end the slideshow.

As you can see, slideshows are a terrific way to review images. Now that you have previewed the images in your web journal, it's time to export them for the clients to view.

Exporting a Web Journal

When you're ready to publish a web journal, Aperture presents you with two options: You can export the webpages to HTML and save them on your hard disk, after which you can email the pages to a client, manually post them on a website, or make them available on an FTP site for a client to download. Or, you can publish the web journal directly to a .Mac site. We'll learn both processes here.

Exporting to HTML

We'll start by exporting the web journal as a self-contained HTML website.

1 Click the Export Web Pages button in the lower right of the Webpage Editor.

An export dialog appears, letting you specify where you want to save the web journal. Let's use a folder that has already been created for this project.

2 Navigate to APTS_Aperture_book_files > Lessons > Lesson05 > Web Export.

3 Choose Detail Image Preset > Web Detail – JPEG – Best Quality. Leave the Thumbnail Image Preset set to the default High Quality setting.

4 In the Export As field, name the journal *GrandeLocations* (no space), and then click the Export button.

An Exporting window appears indicating how long it will take to generate the web journal. It may take several minutes as Aperture goes back to the original RAW files and processes any adjustments you have made to generate the final webpages.

When Aperture is finished, you can check the results by viewing the pages in a web browser.

5 In the Finder, navigate to the APTS_Aperture_book_files > Lessons > Lesson05 > Web Export > GrandeLocations folder on your hard disk.

6 Double-click index.html.

Your default web browser should open and display the main index page of the Proposed Locations web journal.

7 Click the page links if desired to navigate the site. Click any image thumb-
 nail to view its detail page. When you're finished, you can make the site
 available to the client in any of several ways, including manually uploading
 it to a web server. Check with your Internet service provider for instruc-
 tions. If you have a .Mac account, it's easier to publish the journal to the
 web, as you'll see now.

Publishing to .Mac

If you have a .Mac account, it's much easier to publish the web journal.

1 In the Webpage Editor in Aperture, click the Publish to .Mac button.

NOTE ▶ If your .Mac account is not already set up, you will be prompted to configure it. It's a good idea to have your account configured before you publish a web journal to it.

2 In the dialog that appears, type *GrandeLocations* in the Publish Album As field.

TIP ▶ The name you enter in the Publish Album As field will be part of the site's URL, so avoid using spaces or special characters.

3 Choose Detail Image Preset > Web Detail – JPEG – Best Quality, and leave the Thumbnail Image Preset set to the default High Quality setting.

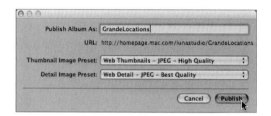

4 Click the Publish button.

An Exporting window appears showing Aperture's progress as it generates the webpages. When it's finished, a Publish Complete window appears, offering you the option to preview the web journal in a browser.

NOTE ▶ There may be an extended pause between the Exporting and Publish Complete windows while the web journal uploads.

5 Click the View in Browser button.

Your default web browser opens and displays the main index page of the
web journal.

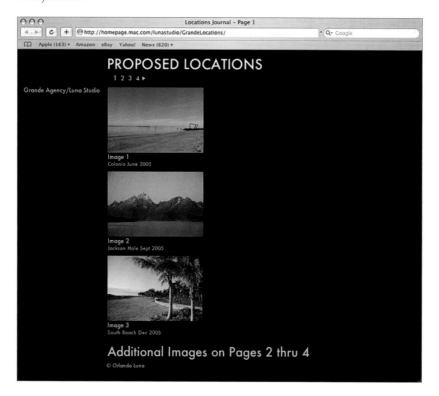

That's it. Now you can email the clients and direct them to your .Mac URL
to view the images.

Congratulations! In this lesson you created and uploaded a web journal. Web journals—and their cousins, web galleries—are an excellent way for clients to review your work. You'll learn how to create a web gallery for an online portfolio in Lesson 10, "Advanced Output."

Over the course of these five lessons, you have done quite a bit of work to your Library. In the real world, now would be an excellent time to back up all the valuable data that you've created so far. However, we'll learn how to back up and archive your Aperture Library and images in Lesson 7, "Finishing, Delivering, and Archiving Images."

Lesson Review

1. What is a web journal?

2. How do you add text to a web journal page?

3. Describe two ways to publish a web journal.

Answers

1. A web journal is a type of album that you publish as a website. It can have one or more index pages that display thumbnails of images, and viewers can click a thumbnail to see each image in detail. Web journal pages also display titles, captions, and other descriptive text. A web journal is a flexible way to share images, and it is particularly useful for sharing location shots.

2. To add text to a web journal page, click the Add Text Box button. Then, drag the text box to the location you desire, such as the top of the page. Click the T icon to change the text style if desired, and select the text and edit it as needed.

3. When you're ready to publish a web journal, Aperture offers two options: You can export the webpages to HTML and save them on your hard disk, after which you can email the pages to a client, manually post them on a

website, or make them available on an FTP site for a client to download. Or, you can publish the web journal directly to a .Mac site. To export as HTML, click the Export Web Pages button in the Webpage Editor; to publish to a .Mac account, click the Publish to .Mac button.

Keyboard Shortcuts

Shift-S	Create a slideshow
Spacebar	Pause/resume playing a slideshow
Right arrow	Move forward one slide in a slideshow
Left arrow	Go back one slide in a slideshow
Esc	Stop playing slideshow

6

Lesson Files	APTS_Aperture_book_files > Lessons > Lesson06
Media	alessandra.dmg
Time	This lesson takes approximately 75 minutes to complete.
Goals	Create a Light Table album and add images to it
	Organize images into groups in the Light Table
	Arrange images within groups in the Light Table
	Learn to use the Centered Loupe
	Evaluate images in Full Screen mode
	Switch interactively between the Light Table and Full Screen mode
	Print images from the Light Table

Lesson **6**

Evaluating Images

All the hard work you did in Lessons 1 through 5 scouting for a location for the Grande Agency fashion shoot has finally paid off: The client chose South Beach. In fact, the commercial shoot is complete, and it's time to take a look at the captured images.

Evaluating images is one of a photographer's primary tasks. You've already learned some features for evaluating images in Aperture, such as maximizing the Viewer, zooming and panning, and using the Loupe. In this lesson, you'll learn how to use the Light Table and the Full Screen mode to help you evaluate the quality of the images from the Grande photo shoot, sort them, and choose two hero images for the catalog. Then, in Lesson 7, we will make some adjustments to the hero images and then deliver and archive the photos.

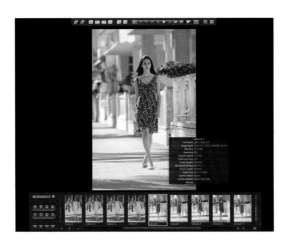

Preparing the Project

We've imported images several times, but it's the foundation of any workflow, so that's where we'll start. Although a fashion shoot can produce hundreds of images, we will work with fewer images to keep our project manageable.

Importing the Images

At the fashion shoot, we photographed two outfits, against different backgrounds, on one model. You could import the two sets of images separately and name them independently, but in this exercise we will import them together and use the Metadata Batch Change option to customize the version names.

1 In the Finder, navigate to the APTS_Aperture_book_files > Lessons > Lesson06 folder and double-click **alessandra.dmg.**

A disk image named EOS_DIGITAL from the camera's media card appears on the desktop. Because we set Aperture as the default capture application in Lesson 1, it opens automatically.

2 If the Welcome screen appears, click the Continue button.

3 In the Import panel, click the Library icon in the Projects panel so that Aperture imports the Alessandra images to a new project.

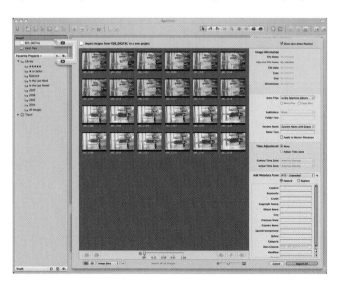

4 In the Image Information area of the Import panel, choose Version Name > Master Filename.

5 Choose Add Metadata From > IPTC – Expanded and then enter the following metadata:

Credit: *Orlando Luna*

Copyright Notice: *© Orlando Luna*

City: *South Beach*

Province/State: *FL*

Country Name: *USA*

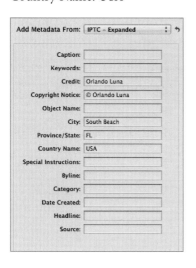

Since you previously entered similar metadata, the information should automatically fill in as you type.

> **TIP** To automate the process of entering repetitive data, you can use presets for the import process. To learn more about import presets, see Lesson 8, "Advanced Organization and Rating."

6 Click one of the images or the background of the Browser area of the Import dialog and then press Command-A to select all of the images.

7 Press the left bracket ([) key to rotate all of the images 90 degrees counterclockwise.

NOTE ▶ If only one image rotates when you press the left bracket ([) key, only the primary selection is active. Press S to deactivate the Primary Selection.

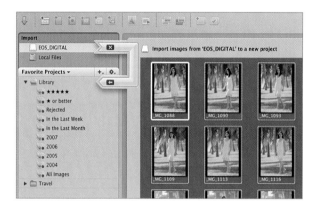

NOTE ▶ Many cameras offer an auto-rotate function, but it wasn't the best choice for this shoot. These images were captured with a Canon EOS 20D digital SLR mounted on a tripod, and the photographer would have had to rotate the camera to view the image upright if the auto-rotate function had been set. To make matters worse, the photo would have been displayed as a small portrait-oriented image on a landscape-oriented camera LCD.

8 Click the Import All button.

9 Click the Eject Card button when the images are all imported.

10 Double-click the new project in the Projects panel, rename it *Grande Fashion*, and then press Return.

Now that the images are in Aperture, you will batch-rename them.

Batch-Changing Filenames

The new project contains two sets of images: one of the model wearing a light-colored dress in a tropical setting, and one of the model wearing a dark-colored dress on a city street. You will use the Batch Change feature to customize the names for the two sets of images.

1 Press V to hide the Viewer.

2 Drag the Thumbnail Resize slider to enlarge the thumbnails until they fill the Browser.

3 Select all the images of the model with the palm trees in the background. Drag to select them or click on the first image of the group and then Shift-click the last image of the group.

> **TIP** ▶ Select the first image of a continuous group and keep pressing Shift–right arrow to add to the selection.

From now on, we'll refer to these as the "tropical" images.

4 Choose Metadata > Batch Change or press Command-Shift-B.

The Batch Change dialog appears.

5 Choose Version Name Format > Custom Name with Index.

6 Type *tropical* in the Custom Name field and then click OK.

A progress window appears as Aperture processes the name change.

NOTE ▶ Entering a name in the Custom Name field changes the name of an image's *version*, not the original name of the master image. When we export versions of these images in Lesson 7, we will keep their new names. This way, when we send a disc of images to the client, the image names will match the names in our Library.

7 Press Command-R to invert your selection; then repeat steps 4 through 6 for the remaining images, using the custom filename *sidewalk*.

We'll refer to this set of images as the "sidewalk" shots.

8 Click in a gray area of the Browser to deselect all of the images.

Now that you have renamed the images, it's time to sort them using the Light Table.

Creating a Light Table Album

In Lesson 3, you used stacks to organize your location images. Another power-ful and flexible way to view and sort images is to use Aperture's Light Table feature. Light Tables in Aperture let you arrange images in a free-form manner, in much the same way you would work with slides on a traditional light table. Using Light Tables, you can drag and position images, resize them on the fly, review selections, check details with the Loupe, and get a feeling for how your images might look together in print or published on the web.

1 Control-click Grande Fashion in the Projects panel and choose New from Selection > Light Table.

A Light Table in Aperture is a type of album.

2 Name the new Light Table album *Grande Light Table* and then press Return.

3 Press Command-Option-V to hide all panels except the Light Table and the Browser.

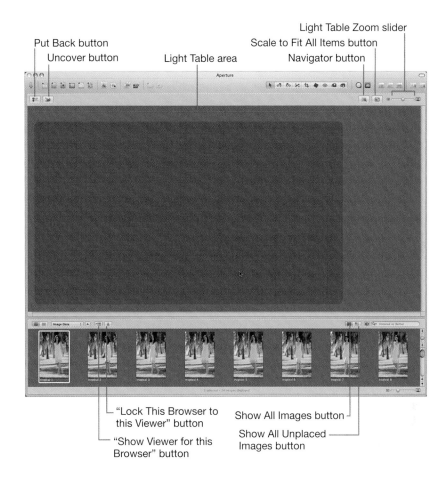

Put Back button

Uncover button

Light Table area

Light Table Zoom slider

Scale to Fit All Items button

Navigator button

"Lock This Browser to this Viewer" button

"Show Viewer for this Browser" button

Show All Images button

Show All Unplaced Images button

Although you will use the Light Table to organize your images, some tasks will be easier to perform in the Viewer. Fortunately, you can toggle back and forth between the Light Table and the Viewer quite easily.

4 Click the "Show Viewer for this Browser" button.

The Viewer appears. Let's stay in the Viewer to take our first look at the images and tag the photos we will not use. In identifying rejects, look for technical issues such as those in out-of-focus images and photos that show awkward body positions or facial expressions like closed eyes and cropped extremities. Images with minor, correctable issues, such as poorly framed backgrounds, should be kept. The most important criterion is "How does the garment look?"

TIP ▶ A good rule for deciding whether a photo should be included is, if you have to think about it, remove it. A great image is one that doesn't cause you to ponder whether it's good. And remember, you can always reimport a rejected image later.

5 Choose each of the following images in the Browser and press Command-9 to tag them with a reject rating:

▶ From the **tropical** set of images: **2**, **3**, and **7**.

▶ From the **sidewalk** set of images: **2**, **4**, and **9**.

As you tag each image as a reject, an *X* appears on its thumbnail; when you select the next image, the rejected thumbnail disappears. This is because the default Query HUD filter for newly created albums is to show images that are unrated or better—in other words, to hide rejected images.

TIP ▶ To keep track of which images have been rejected, you can create a Smart Album that is set to display only rejected images.

6 Press V to hide the Viewer and resize the thumbnails to fill the Browser.

The images you rejected are no longer displayed.

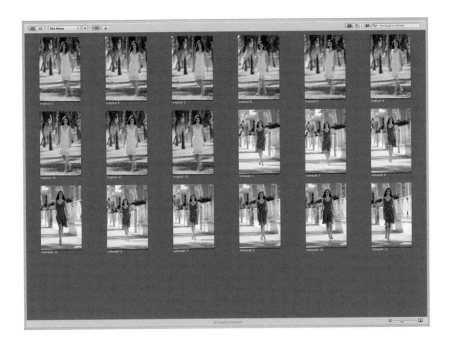

7 Press V to display the Viewer.

8 Click the "Show Viewer for this Browser" button to return to the Light Table.

Now that we have hidden the images we definitely won't use, let's use the Light Table to organize the remaining images.

Adding Images to the Light Table

In the previous exercise, we created the Light Table album, but it's empty. Let's add images to it.

> **NOTE ▶** Due to the dynamic nature of the Light Table, the positions of the images in the Light Table as they appear in this book may not exactly match what you see on your own computer display. Still, use the figures in this book as a guide.

1 Control-click in the Light Table area and choose Minimize Size.

Unlike a traditional light table, the Aperture Light Table is dynamic; it will grow and shrink as needed.

2 Select all of the tropical shots and drag them from the Browser to the Light Table. The number in the lower left of the thumbnail you are dragging indicates how many images are being added to the Light Table.

A small 1 appears in upper right corner of each thumbnail that you dragged to the Light Table. This indicates how many times the image appears in the Light Table; an image can be placed in the Light Table more than once.

TIP ▸ If you are working with two displays, set the Secondary Viewer to Alternate in the Viewer Mode pop-up menu. Any images selected in the Browser will appear on the second display. More on using two displays can be found in Lesson 10, "Advanced Output."

Using the Light Table Navigator

You've only added some of your images to the Light Table, and already the need to resize the view and easily move around in it has become apparent.

1 Drag the Light Table Zoom slider to the right until you have zoomed in on one row.

As you drag, the size of the Light Table increases dynamically. Zooming in on the Light Table is a good way to get a close-up view of a few images at a time. And although you can use the scrollers to navigate to other parts of the zoomed-in Light Table, Aperture's Navigator button is far more efficient.

2 Click the Navigator button in the upper right corner of the Light Table (or press the N key).

The Light Table view zooms out, and the area that was in close-up now appears highlighted. This is the Navigator *hot area*. You can reposition the hot area, and when you release the mouse button, Aperture will automatically zoom back in to that area.

3 Drag the hot area to a different row of images.

The Light Table view zooms in on the images that you defined as the hot area. This is a great way to quickly move to different parts of the Light Table.

4 In the Browser, select one of the tropical images not currently visible in the Light Table.

The Light Table displays the selected image. This is another convenient way to navigate to a desired image.

5 Click the Scale to Fit All Items button or press Shift-A to resize the Light Table to fit all the current images.

The Light Table resizes to show all the images it contains. Now that we know a few tricks for navigating in the Light Table, let's add the rest of our images to it.

Adding More Images

Add the sidewalk shots to the Light Table.

1 Click the Show Unplaced Images button at the top of the Browser.

Only the images that have not been placed in the Light Table appear in the Browser.

2 Select all the sidewalk images in the Browser and drag them to the right edge of the grid of images in the Light Table.

Oops! They overlap. That's not what you want. Fortunately, the dynamic nature of the Light Table comes in handy here.

3 With the sidewalk images still selected, drag them to the right until there is a small gap in between the two groups of images.

The Light Table grid, which underlies the images and helps you position them evenly, grows as you drag the images to the right. Now that all of the images are in the Light Table, let's sort them into two groups.

4 Press Shift-A to resize the Light Table grid and center the images on it.

5 Click the Show All Images button on the right side of the Browser.

You have done the equivalent of spreading your images across your dining room table—but spreading your images across your dining room table has never been this neat. Next, we will sort and group and evaluate the images in the Light Table as we hunt for two hero images for the catalog.

Evaluating Images in the Light Table

One of the more impressive characteristics of the Light Table is the way it lets you select and position images. Photos can overlap and be resized to emphasize selected groups. As you evaluate images, you can naturally and intuitively drag and rearrange them in the Light Table.

But what would a light table be without a Loupe? In this exercise, you will use the Loupe to evaluate the images in the Light Table.

Using the Centered Loupe to Evaluate Images in the Light Table

In Lesson 3 you used the default Loupe. Aperture has a second type of Loupe, called the Centered Loupe, which offers a few extras.

1 Press accent grave (`) to activate the Loupe.

2 Choose View > Use Centered Loupe, or press Shift–Command–accent grave (`) to switch to the Centered Loupe.

3 Position the Centered Loupe over the model's face in the sidewalk group's center image. Use the white highlight circle that appears as a positioning reference.

Once you release the Loupe, the live area zooms to a 100 percent view.

4 Drag the Loupe to the right until the tropical images are uncovered.

5 Choose "Focus on Cursor" from the pop-up menu on the lower right of the Loupe.

The Centered Loupe will now display whatever image portion your cursor moves over.

6 Position the cursor over different images in the tropical group. Spend
 extra time looking over **tropical 5** and **tropical 8**, as these will be the first
 images we sort.

7 Choose "Focus on Loupe" from the Loupe's pop-up menu.

8 Close the Loupe by pressing accent grave (`).

 You will be working with the Centered Loupe throughout the rest of the
 lessons. Feel to activate the Loupe at any point when you need a closer
 look at an image.

Grouping Images

Let's sort our images into groups as we evaluate them and look for hero images.
Although we'll be delivering a number of images to the client, we'll use the

hero images in this project to base our adjustments on, so we need to choose one hero image for each background.

1 Select **tropical 5** and **tropical 8** in the Browser.

The images become selected in the Light Table.

2 Drag these two images to the left side of the Light Table until the grid begins to grow. Keep dragging until you set off these two images from the two larger groups. Remember, the screen shots in this book may appear slightly different from what you see on your own display.

3 Deselect the two images, and then reselect one or both of them and drag them close together. Then, reselect them both.

4 Drag the Light Table Zoom slider to the right until the Light Table is focused on the two selected images.

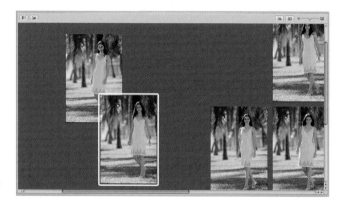

Notice that the Light Table zooms toward the primary selection. Notice, also, that these two images are similar in composition and are both pretty good shots, except that the model's right arm is hidden behind her body on **tropical 8**. We're evaluating images now, so let's just set these two aside and look at some other images. To find the next images we want to study, let's learn a new way to navigate in the Light Table.

5 Press and hold down the spacebar while dragging the mouse to the left. Drag until **tropical 11** is centered in the Light Table.

NOTE ▶ If necessary, press T to view the metadata overlay, which displays the filename.

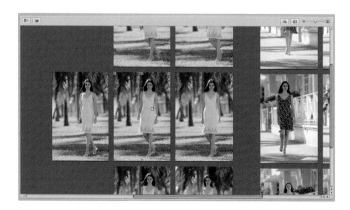

6 Position the cursor over **tropical 11**.

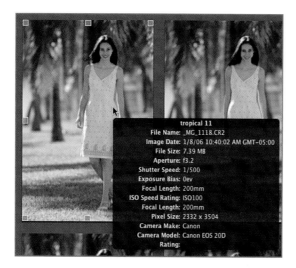

Image resize handles appear.

7 Drag one of the corner handles to enlarge **tropical 11** by about 33 percent. It's OK if the enlarged image overlaps other images.

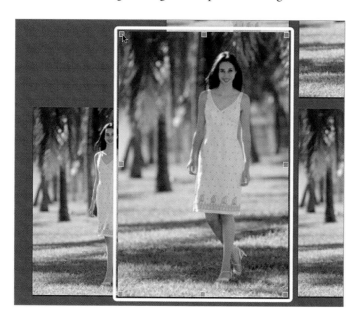

Now you have a better view of the shot. Again, this photo looks pretty good—except for the hair over the model's right shoulder: The ends of a few strands are in shadow. Of course, we could do some work on the image in Adobe Photoshop, but let's see if we can find a better image.

 Use the Loupe for a closer look at **tropical 11** if you wish to see the shadow.

8 Select **tropical 9** and drag it on top of **tropical 11** to group them.

As you can see, you can drag images on top of each other as well as next to each other. Let's organize the tropical shots into three subgroups: We'll drag images around the Light Table to group our favorite shots, the "maybe" shots, and the "probably not" shots.

9 Drag the following tropical images in the Light Table into the groups described below. Don't worry if images in a group overlap. Navigate in

the Light Table using all of the techniques described so far in this lesson as needed.

- ▶ Favorite images: **4**, **8**, and **12**
- ▶ Maybe images: **6**, **10**, and **11**
- ▶ Probably-not images: **1**, **5**, and **9**

Next, make sure the groups have some breathing room.

10 Select the groups and drag to reposition them. Select a group by Shift-clicking the individual images in it or by dragging across the group diagonally. Reposition the groups in a triangle shape as shown in the following figure, with the favorites group on top, the maybe group on the lower right, and the probably-not group on the lower left.

11 Repeat steps 9 and 10 for the sidewalk images, organizing them into the following groups:

▶ Favorite images: **1**, **6**, and **11**

▶ Maybe images: **5**, **8**, and **12**

▶ Probably-not images: **3**, **7**, and **10**

TIP ▶ To remove an image from the Light Table album, select the image and press Delete. The image is removed from the Light Table album but not the original project. To remove an image from the Light Table surface while keeping it in Light Table album, click the Put Back button (or press Shift-P).

12 Press Shift-A to resize the Light Table to fit your new groups.

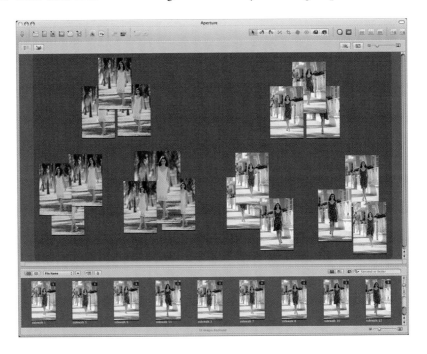

You are now a grouping guru. You can easily move images in and out of groups simply by dragging them.

Arranging Images Within a Group

We narrowed down our favorites from the two groups, but we still have to pick the hero image. Before we can evaluate the images further, we need to arrange the images in the groups so that we can see them clearly. Luckily, Light Tables makes it easy to arrange images within a group.

1 Select the favorites group of sidewalk images and then zoom in on the group using the Zoom slider.

2 Click the Uncover button in the upper left corner, or press Shift-X.

Any images that were overlapping are repositioned so that you have an unobstructed view of the selected shots. However, images that are *not* selected when you use this command may actually become obstructed.

3 Press Shift-X to return to the previous view.

The Uncover function only temporarily rearranges your images. This is a wonderful way to quickly see overlapping images. If you want to permanently reposition them, however, use the Arrange command.

4 With the favorite sidewalk images still selected, Control-click them and choose Arrange from the contextual menu.

The images are neatly repositioned next to one another in the Light Table.

NOTE ▶ Arranging images using the contextual menu or by manually dragging cannot be undone with the Undo command (Command-Z).

Now let's arrange the tropical shots.

5 Press N and then drag the Navigator hot area over the favorites group of the tropical shots.

6 Select all of the images in this group.

7 Control-click the images and choose Arrange from the contextual menu.

Once again, the images are repositioned neatly in the Light Table.

Both groups of favorite images are now neat and orderly. To find one hero image for each of the groups, let's switch to Full Screen mode to view the images in detail.

Evaluating Images in Full Screen Mode

As you have seen, you can zoom in on images in the Light Table and use the Loupe to evaluate images. Another good way to evaluate images is to use Aperture's Full Screen mode.

The Full Screen mode displays images that are in a folder, project, album, or book on a black background. In Full Screen mode, you can view, sort, and stack your images. You can also apply adjustments and keywords. When you've finished working with your images, you can use Full Screen mode to preview and proof your images. Let's switch to it to decide on our hero images.

1 Select the favorite images from the tropical shots.

2 Press F to switch to Full Screen mode.

The three favorite tropical shots appear against a black background, and a filmstrip appears at the bottom of the screen. The filmstrip in Full Screen mode is similar to the control bar in the Aperture main window. You can use the filmstrip's controls to move through, rotate, view, and rate your images. Full Screen mode also has its own toolbar, although you might not see it yet.

3 Position the cursor in the black area at the top of the screen. The toolbar appears. Click the Always Show Toolbar button.

The toolbar is now a fixture on the screen and will not hide when you move your cursor away from it. You do not have to activate the Always Show Toolbar button to use the toolbar. The Full Screen toolbar contains many of the same buttons as the regular Aperture toolbar; however, it cannot be customized.

TIP Tools that are in the regular toolbar but not visible on the Full Screen toolbar are still accessible via their usual keyboard shortcuts.

4 If necessary, press T to display the metadata overlay so that you can see the image filenames. Then, look at the image **tropical 8**.

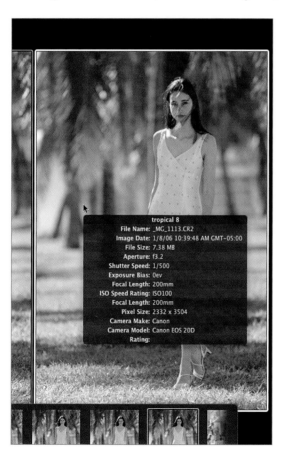

The dress shape looks nice in this shot, but the model's strands of hair across her face are a concern. Let's take a closer look.

5 Select the Loupe or press the accent grave (`) key, then press Shift–Command–accent grave (`) to switch to the Centered Loupe. Drag in the center of the Loupe and position the small white highlighted circle over the model's face in the **tropical 8** image.

On closer inspection, you can see there are quite a few strands of hair streaming across her face. That won't do.

6 Command-click **tropical 8** to deselect the image. Then, click the Loupe button to turn it off, or press accent grave (`).

The image disappears from the Full Screen mode display area but is still in the filmstrip.

7 Click the image **tropical 12** to make it the primary selection.

Let's see it close up.

8 Press Option-R to switch the view to Primary.

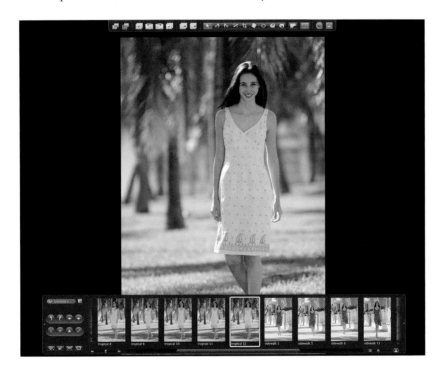

All images except the primary selection close. The filmstrip now covers up part of the primary image, but the bottom is an important part of this image. A quick adjustment to the filmstrip is in order.

9 Click the Viewer Mode button on the filmstrip and choose Avoid from the pop-up menu, or press Control-V.

The image shrinks slightly so that it is not covered by the filmstrip.

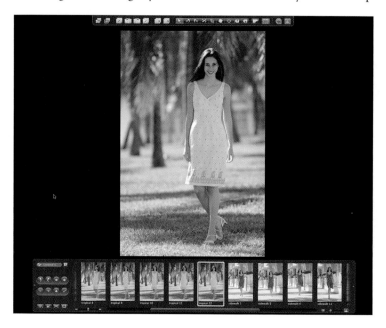

Switching to the Primary view is a great way of focusing on one image. And this one looks excellent. It conveys emotion and shows off the garment nicely—a good combination. This is our first hero image. Let's just double-check for focus using the Centered Loupe.

10 Press accent grave (`) to activate the Loupe, then drag it to the left side of the screen.

11 From the pop-up menu on the lower right of the Loupe, select "Focus on Cursor."

12 Position the cursor over the model's face, then on the garment, to check for focus.

13 Press accent grave (`) to hide the Loupe.

That looked pretty sharp. Let's move back to our Light Table view.

Switching Between Views

Next, go back to our Light Table and make this hero image larger to set it apart. That way, any time we open the Light Table for these images, we'll quickly be able to identify the hero.

1 Press F to switch back to the Light Table and then click the **tropical 12** image to make it the primary selection.

2 Enlarge **tropical 12** so that it's about twice its original size. Don't worry if
the images overlap; you will fix that next.

3 Drag across the tropical-shot favorites group to select all of the images in
it. Any images that are hidden behind the large hero image will also be
selected.

4 Control-click and choose Arrange from the contextual menu. The images
are rearranged into a neat layout. Resize the Light Table, using the Zoom
slider if necessary, so that you can see all of the images in the group.

Now let's go back to Full Screen mode to choose our sidewalk hero image.

5 Press N and drag the Navigator hot area to the right until the sidewalk favorites group is centered in the Light Table area.

6 Select the images in the sidewalk favorites group and then press F.

7 Press Option-U to return to Multi view. You should be looking at the three favorite sidewalk shots in Full Screen mode.

TIP If you accidentally deselect any of the images in the group, press F or Esc to return to the Light Table, reselect your favorites group, and then press F again to return to Full Screen mode.

8 Select **sidewalk 1** and press Option-R to switch to Primary view.

You are looking at your second hero shot. It has a good attitude, and the dress looks fabulous. As we did with our first hero image, let's resize this one in the Light Table.

9 Press F to switch to the Light Table.

10 Drag a handle to resize the hero image to about twice its original size.

11 Select all the images in the sidewalk favorites group and then Control-click and choose Arrange from the contextual menu. You may want to manually adjust both sets of favorites into custom layouts.

The hero image is now set apart and easy to identify.

12 Press Shift-A to fit all of your images in the Light Table.

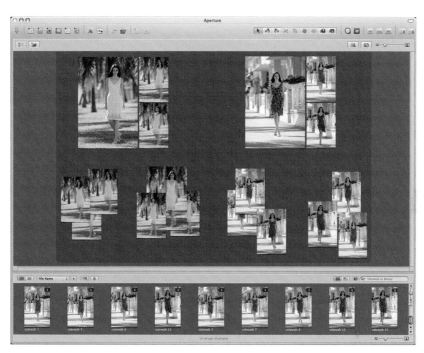

Excellent. You have now selected a hero image for each garment and background, and you've set those images apart in the Light Table. It's always nice to have a hard copy of your work. Let's look at printing options for the Light Table.

Printing the Light Table

You can print images from a Light Table album, and you can choose to print all or part of the actual layout of images you have created in the Light Table. Often, printing a photo can give you a whole new perspective on its quality. Let's print a hard copy of each of the favorites groups for reference.

1 Select the favorites group of the tropical images.

2 Choose File > Print Light Table or press Command-Option-P.

The Print dialog appears with options for printing a Light Table. (Additional options are available when you choose to print individual images.)

3 Choose Orientation > Portrait.

The images will be positioned vertically on the paper.

4 Make sure Paper Size is set to U.S. Letter, the ColorSync Profile is set to System Managed, and the Black Point Compensation checkbox is selected.

Choosing Black Point Compensation adjusts the maximum black level of the image to fit within the capabilities or gamut of your selected printer.

NOTE ▶ If you are working on your production system, you can select the appropriate print size for your printer. The ColorSync profile should be set to the printer profile for your selected printer and paper combination. Be sure to turn off Color Management in the printer driver.

Although the Print dialog offers a preview area, you can get a better idea of how the images will print by viewing them as a Portable Document Format file in the Apple Preview utility.

5 Click the Preview button to create a PDF file and open it automatically in Preview.

To create the PDF file, Aperture starts with the original master image and then "bakes in" any adjustments. This ensures the highest possible output

quality. Once in Preview, you can soft proof, print, cancel, or save the file. Soft proofing allows you to see onscreen how the image will be printed based on the output device profile you chose in the ColorSync pop-up menu in the Aperture Print dialog.

NOTE ► Soft proofing will be covered in greater detail in Lesson 10, "Advanced Output."

6 If you're connected to a printer and want to print the PDF file, click Print. Otherwise, click the Cancel button.

7 Return to the Light Table, and select the images in the sidewalk favorites group.

8 Choose File > Print Light Table.

Aperture remembers the settings from the previous print session. Let's save the current setting as a preset for printing groups of Light Table images in portrait orientation.

9 Click the Save As button.

A window appears on the top of the Print dialog allowing you to name this preset.

10 Enter *Portrait Light Table US Letter* and click the Save button.

The new preset appears in the Preset Name area.

NOTE ▶ In a production environment, you should choose the ColorSync profile for your printer as part of the preset.

11 Click the Preview button.

Aperture opens a PDF file of the grouped images in Preview.

12 Click the Cancel button and click in the Light Table area to return to Aperture.

Congratulations! You have used the Light Table and Full Screen mode to evaluate, sort, and even print your images. Aperture remembers the Light Table configuration, but it's not permanent; you can go back and work in the Light Table at any time. In the next lesson, you will use the two hero shots as resources for image adjustments in preparation for sending the digital files off to Grande Agency for publication.

Lesson Review

1. What is a Light Table album?

2. What is the Light Table Navigator?

3. How do you switch between the Light Table and Full Screen mode, and between the Light Table and the regular Viewer?

Answers

1. A Light Table album is a group of images that you can resize and arrange in a free-form manner, in much the same way you would work with slides on a traditional light table. Using Light Tables, you can drag and position images, resize them on the fly, review selections, check details with the Loupe, and get a feeling for how your images might look together in print or published on the web.

2. The Navigator is a way to quickly move around the Light Table. Clicking the Navigator button in the upper right corner of the Light Table zooms you out in the Light Table. When you use it, the area that was in close-up now appears highlighted. This is the Navigator *hot area*. You can drag to reposition this hot area, and when you release the mouse button, Aperture automatically zooms back in to the newly defined hot area.

3. When you're in the Light Table, press F to switch to Full Screen mode, which displays images against a black background. Press F again to switch back. In the Light Table, click the "Show Viewer for this Browser" button to switch to the regular Viewer configuration; click the "Show Viewer for this Browser" button to return to the Light Table.

Keyboard Shortcuts

N	Choose Navigator
Shift-A	Scale all items in the Light Table
Shift-X	Temporarily uncover overlapping images
F	Switch to Full Screen mode
Esc	Switch out of Full Screen mode
Command-Option-P	Print the Light Table
Command–Option– accent grave (`)	Use the Centered Loupe

7

Lesson Files APTS_Aperture_book_files > Lessons > Lesson07

Time This lesson takes approximately 75 minutes to complete.

Goals Adjust an image in Full Screen mode

Use Levels controls to adjust luminance

Use Exposure controls to adjust tint

Increase the saturation of an image

Match color across multiple images

Print contact sheets

Export versions of an image

Burn a CD

Back up the Library to a vault

Finishing, Delivering, and Archiving Images

Finishing images—applying adjustments to the final images for a client—is often the most critical step of the workflow. Finishing an image or a group of images puts the final polish on the look of a shot.

The images for Grande Agency will be used for print advertising and in-store displays. The color of the garment is, of course, important, but these images are also meant to convey the branding of the apparel company. As a result, we need to make sure that the two groups of photos have the same look and feel.

Once we have adjusted the look of the images, we need to burn the images onto a CD or DVD for delivery. This also involves printing a contact sheet that catalogs the content of the disc for the client.

Finally, after all the hard work you've put into this project, it's a good idea to back up your work. Indeed, backing up is a fundamental part of any workflow. Aperture allows you to back up your Library using a built-in system called a *vault*. In this lesson, you will use a vault to create a backup of your Library.

Preparing the Project

This lesson picks up where Lesson 6 left off. Before starting, make sure that Aperture is open and that you have completed Lesson 6. There are no media files to import. We'll start by making sure we're all viewing the same layout.

1 With the Grande Light Table album selected in the Projects panel, press Shift-A to center and scale the Light Table.

2 Press Command-Option-V to maximize the Viewer.

3 Select the two hero images in the Light Table.

4 Press F to switch to Full Screen mode.

NOTE ▸ If both images are selected but only one appears in the Viewer, make sure the Viewer Mode pop-up menu, located in the filmstrip in Full Screen mode, is set to Multi (press Option-U).

Customizing the Full Screen Mode

As you saw in Lesson 6, Full Screen mode allows you to focus completely on the images you need to evaluate, hiding all other distractions. When it's time to apply adjustments to images, Full Screen mode also offers a number of options to customize the interface to suit the way you work.

1 Click the tropical image in the Viewer to make it the primary selection.

2 Press Option-R to see just the primary selection in the Viewer.

Hiding the Toolbar

We'll be adjusting this image, but before we start, let's rearrange the toolbar and filmstrip to customize the Full Screen mode viewing area for performing adjustments.

1 Click the Always Show Toolbar button. Then, move the cursor away from the toolbar area.

The image scales up to take advantage of the space created by the hidden toolbar. The toolbar is activated with cursor activity at the top of the Full Screen mode Viewer. You can gain access to any of your tools at any time by simply moving the cursor to the top of the screen, and the toolbar will appear. OK, time to customize the filmstrip.

Positioning the Filmstrip

The filmstrip contains many of the tools that are in the Browser, and it can be moved and positioned on the screen.

1 Click a gray area of the filmstrip (but not an edge) and drag it to the left side of the screen.

The portrait-oriented image scales again to take advantage of the newly available space. The filmstrip can be free floating or docked to the edge of

the display area. Depending on the filmstrip's location, the image is centered differently.

2 Drag the filmstrip into the display area so that it is floating.

The image centers in the entire display area.

3 Drag the filmstrip back to the left edge of the display area.

The image centers itself in the space between the right edge of the filmstrip and the right edge of the display area. Whether a single image is centered or not is determined by the Avoid command that is in the Viewer Mode pop-up menu. In addition to being able to move the filmstrip around the Full Screen mode, you can also change the filmstrip's length and increase the width by increasing the size of the thumbnails.

4 Drag the bottom edge of the filmstrip up until only four thumbnails
are visible.

Adjusting the position and the size of the filmstrip gives you more room
onscreen for images in the display area.

5 In the filmstrip, drag the scroller, if necessary, until both hero images
 are visible.

Having both selected images visible in the filmstrip allows you to switch the primary selection without having to use the Viewer Mode pop-up menu.

6 Click the sidewalk hero image, sidewalk 1, in the filmstrip.

The sidewalk image becomes the primary selection.

7 Press the L key to scroll down the thumbnails in the filmstrip. Press the K key when the tropical and sidewalk hero images are centered in the film-strip. If you scroll too far down, press the J key to scroll up, and then the K key once again to stop.

8 Click the tropical hero image, tropical 12, to make it the primary selection.

) The filmstrip automatically scrolls until the selected thumbnail is centered.

9 Use the J, K, and L keys to scroll the filmstrip thumbnails until both hero images are centered in the filmstrip.

 TIP ▶ Press either J or L up to five times to accelerate the scroll. Press the "opposite" letter key to decelerate the scroll, and press K to stop the scroll. Watch the shuttle control to see how fast you are scrolling and where you are in the collection.

You can hide the filmstrip altogether if you want to completely focus on the image.

10 Choose Auto from the Viewer Mode pop-up menu, or press Control-. (period). Then, move the cursor away from the filmstrip.

The filmstrip disappears and the image re-centers in the display area.

You can access the filmstrip at any time by simply placing the cursor over the area where the filmstrip was most recently positioned. When the filmstrip appears, however, the image will re-center itself, which can be a bit distracting. Let's modify that behavior.

11 Choose Avoid from the Viewer Mode pop-up menu or press Control-V to deselect the Avoid command.

12 Move the cursor over and then away from the filmstrip.

The filmstrip will now appear whenever you move the cursor over it and then disappear when you move your cursor away. Since you turned the Avoid command off, the image in the display area does not move as the filmstrip appears and disappears.

Now that you have customized the Full Screen mode, it's time to adjust the first hero image.

Adjusting Luminance

In traditional analog photography, image color and contrast were controlled through specialized processing and the use of filters. In the digital world, you can make the same adjustments with software. An adjustment can be a way of giving a special, stylized "look" to a final image, or—as in the case of our Grande images—adjustments can be a way to simply make the image true to the photographer's vision of the shot.

Making Shadows Darker

Let's make some adjustments to the tropical hero image first, starting with adjusting the shadow areas to give the image a little more punch.

1 Press the H key.

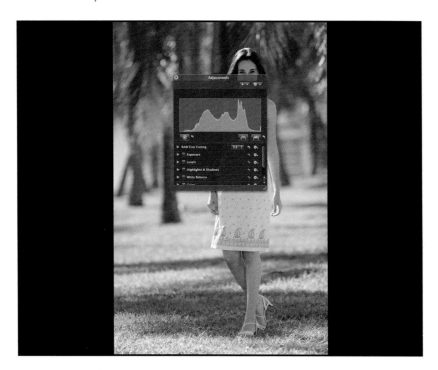

The Adjustments HUD appears. This floating Adjustments HUD offers the same controls as the Adjustments Inspector you used in Lesson 4.

NOTE ► The position and options that are open in your Adjustments HUD may be different from what appear in the screen shots on the following pages, depending on which options you used in previous lessons.

2 Drag the Adjustments HUD to the upper right and make sure it does not cover the image.

Let's start by adjusting the overall luminance of the image in order to darken the shadows. We can achieve this by using the Levels controls in the Adjustments HUD.

3 Click the disclosure triangle next to Levels to reveal the Levels controls if they are not already visible.

4 Choose Show Color Value and Show Histogram from the Adjustments
HUD Action pop-up menu if the color values and histogram are not visible.

Because the Levels controls are directly below the main histogram, it will
be easy to see the effects of the adjustment you are about to make.

5 Reduce the size of Adjustments HUD by dragging the lower right corner
and then use the scroller so that all you can see in the HUD are the Levels
controls group and the main histogram.

6 Click the Quarter-Tone Controls button to activate the Levels quarter-tone controls. The Levels histogram updates with new controls for adjusting four discrete tonal ranges of the image, from black to white, allowing you to make finer adjustments.

7 Choose Luminance from the Channel pop-up menu, then select the checkbox next to Levels.

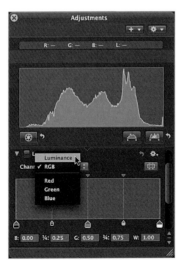

The Levels histogram will now display the Luminance channel, which contains the average of the brightest RGB values in the image. The Levels histogram will now also match the main histogram as we make changes.

8 Drag the leftmost control under the Levels histogram to the right until the B (black point) value is 0.05.

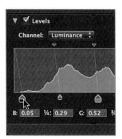

As you drag the black-point control, the Adjustments HUD histogram updates to show the results of the change. The controls under the Levels histogram correspond to the source values. Dragging the black point to the right darkens the shadow areas: The overall image is slightly darkened, but the lower values are affected more. The adjustment results in darker shadows that give the image more depth, but the adjustment also darkens the model's skin tone.

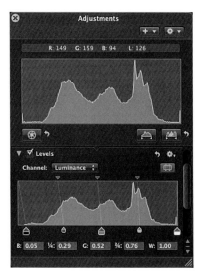

9 Place the cursor over the model's left cheek and look at the RGB values above the main histogram.

The L (luminance) value should be approximately 146, which is low (dark) for this model. Her fair skin should have a luminance value of around 160 on her cheek. The numbers should confirm what you can already see in the image. Let's brighten the model's skin tones next.

Making Skin Tone Lighter

The model's skin should be glowing. For a photographer, glowing skin equates to specific luminance values. The luminance values for the skin tone of this model's cheek should be somewhere in the 155 to 160 range. So now we'll look at the skin tones to evaluate the levels, then adjust the midtones to match our target range of 155 to 160. But first, let's resize the Adjustments HUD.

1 Drag the lower right corner of the Adjustments HUD to enlarge it and then click the disclosure triangle for the Exposure controls group. Click the Tint disclosure triangle within the Exposure controls group.

2 Adjust the size of the HUD until both the Exposure and Levels controls groups are visible.

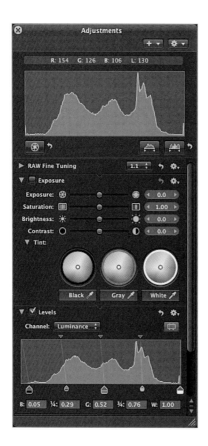

3 In the Tint controls of the Exposure group, click the White eyedropper
 button below the rightmost color wheel.

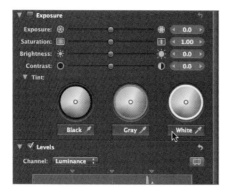

The Loupe appears, allowing you focus on a particular area of the image as you adjust the tint.

The Tint buttons let you choose a neutral value from your image. You can click any of the three buttons since you will be using it only as a guide. You will be using the Tint adjustments later in this lesson; for now you will use the white tint as a guide to view values in the Adjustments HUD histogram.

4 Position the cursor over the model's left cheek while using the Centered Loupe set to "Focus on Cursor."

A vertical yellow line in the Adjustments HUD histogram indicates the luminance values of the model's cheek. The line is to the right of the second histogram peak, indicating that the model's skin tone is just above midtone. This value of the current skin tone will guide us when we adjust the skin tone using Level controls.

5 Press Command-` (accent grave) to turn off the Loupe.

6 In the Levels controls group, Option-drag the center control under the Levels histogram to the right until the value next to the center G (gray)

value is 0.56. Drag the top center control to the right until the center line is just to the right of the vertical, crossing over the peak you viewed earlier.

This pushes the destination pointer for the gray-point adjustment over the area where the histogram line appeared when we chose the white tint, thus affecting the skin tone area more heavily. The skin tone ends up with a darker value. As you drag the center control, all three midtone quarter-value lines move in unison; the black point and white point are unaffected.

7 Position the cursor over the model's left cheek.

The luminance value in the model's cheek now falls in the 155–160 range that the photographer prefers—and as you can see, her skin tone is much brighter. Next, let's adjust the color to fit the photographer's vision.

Adjusting Tint and Saturation

The color values of skin tones vary by subject. In addition, ideal skin tone values are affected by the environment where the image was shot and by any overall aesthetic color considerations that the photographer prefers (such as, for example, going for a sepia-toned image). Our particular model's fair skin should have a blue value just below the midtone value of 128, a green value 10 percent or so above midtone, and a relatively high red value that is closer to three-quarter tone than midtone. This will give her a nice healthy skin tone that is imbued with the warm light of the Florida sun.

1 In the Tint controls of the Exposure controls group, drag the circle in the center of the Gray color wheel up and to the right until it is at about the 2 o'clock position and about three-quarters of the way to the outer edge.

The image color warms up considerably.

NOTE ▶ Dragging the midtone toward the orange/amber area of the color wheel is similar to using a glass or gelatin warming filter on a camera lens.

2 Select and deselect the Exposure checkbox a few times to turn the effect off and on. When you're done, make sure the box is selected.

Sometimes it helps to see a subtle effect by toggling it off and on. Not only can you see the effect on the image as you do so, but the main histogram also updates as you select and deselect the checkbox. This image is almost done; we just need to pump up the saturation a bit to finish it.

3 Drag the Saturation slider to 1.06.

The Saturation adjustment adds a little extra color to the entire image.

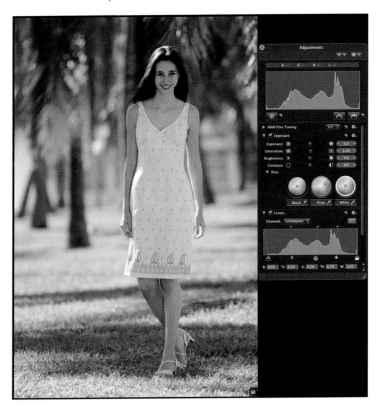

It looks great—the image is finished. The Grande Agency may make other adjustments, but your job is done.

Comparing Images

Before we adjust the sidewalk image, let's quickly see how our adjusted tropical image compares.

1 Press H to hide the Adjustments HUD.

2 Press Option-U to switch the Viewer to Multi mode.

Viewed side by side, the images look as though they were shot in completely different locations many hours apart. In fact, they were shot within an hour of each other. Our next task will be to adjust the sidewalk image to match the changes you've made to the tropical image so that the two are consistent.

Matching Color Between Images

There are many differences between the tropical image and the sidewalk image—location and outfit, to name two obvious ones. However, the model is a consistent element in both images. When matching color between images, the best

aid is a known color. That color, in this case, is skin tone. We will use the model's skin tones from the adjusted tropical image as our guide.

1 Press the C key to select the Crop tool and crop the tropical image so only the model's head and shoulders are in view. (Make sure the "Constrain cropping tool to" checkbox is deselected.) Press Return to accept the crop.

This isn't a permanent change. Temporarily cropping out the background will help us focus on the similar characteristics within the two images.

2 Crop the sidewalk image so that only the model's head and shoulders
appear in that image.

3 Press H to open the Adjustments HUD and drag it so that it's between the
two images.

You are now ready to adjust the sidewalk image, using the tropical image next to it for comparison.

4 With the sidewalk image selected, drag the black-point control under the Levels histogram to the right until its value is 0.06.

The luminance for two images becomes closer. The idea isn't to match the values exactly, but to get the values of the two images in close range of each other.

5 Drag the control in the center of the Gray color wheel toward 2 o'clock as you did for the tropical image, stopping when it is about halfway between the center and the edge of the wheel.

6 Drag the Saturation slider to 1.12.

The color, contrast, and brightness of the images now seem much closer.

7 Deselect the Crop checkbox in the Adjustments HUD to turn off the
crop on the sidewalk image. Resize the Adjustments HUD if the Crop
HUD is hidden.

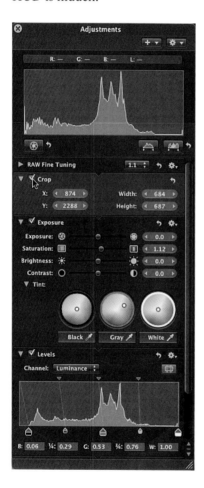

8 Click the tropical image to select it and then repeat step 7 to remove
the crop.

9 Press H to hide the Adjustments HUD.

The two images now have similar contrast and coloring. The images could definitely be placed next to each other for an ad or in a store display. Since you don't know where or how the image will be printed, this is as far as you take the image processing. The agency can tweak the image a bit further depending on the intended use. And since other adjustments may be made down the line, it's not appropriate to perform, say, sharpening.

> **TIP** ▶ If you know how the images will be printed, you can use Aperture's soft-proofing feature. For more on soft proofing, see Lesson 10, "Advanced Output."

Applying Adjustments to a Group of Images

The hero images are done, but we need to apply the same adjustments to the other images in the Light Table album in case the client decides to use them.

1 Press F to return to the Light Table.

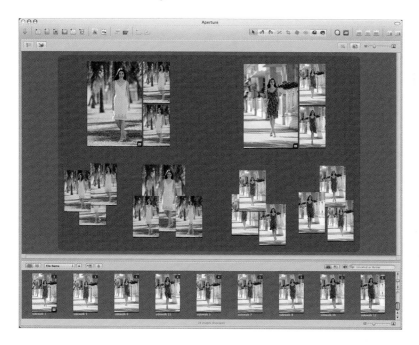

Once we return to the Light Table you will notice the image adjustments we applied to the larger, hero images when compared to the other, smaller images in the Light Table.

2 Select the Lift tool.

The Lift & Stamp HUD appears.

3 Click the sidewalk hero image with the Lift tool.

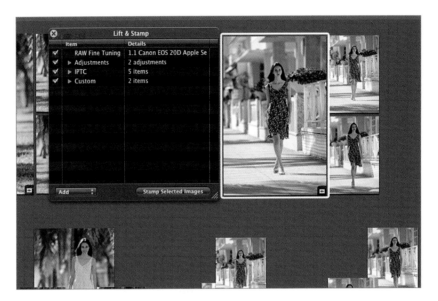

The adjustments we applied to the sidewalk hero image are lifted and then deposited into the Lift & Stamp HUD.

4 Click the disclosure triangle next to Adjustments in the Lift & Stamp HUD.

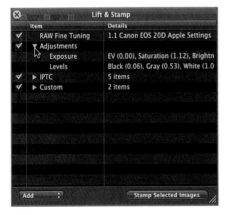

The Levels and Exposure adjustments appear on the Lift & Stamp HUD, as do RAW Fine Tuning, IPTC metadata, and some custom information. The only information we need to stamp, or copy, on the other images is the image adjustments.

5 Click the checkboxes next to RAW Fine Tuning, IPTC, and Custom to deselect them. This ensures they will not be stamped onto any other images.

> **TIP ▶** You can also select the items and press Delete to remove them from the Lift & Stamp HUD altogether.

6 Drag to select all the sidewalk images in the Light Table.

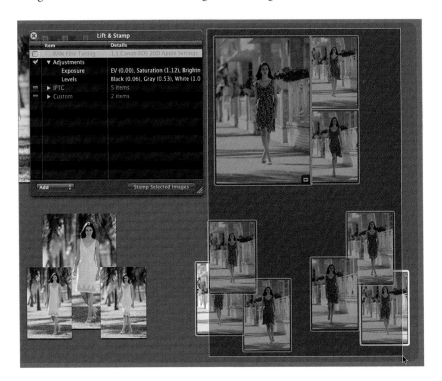

We'll be sending the clients only the hero images and the other favorites, but it's a good idea to adjust all of the images in case the client wants to see them.

7 Click the Stamp Selected Images button in the Lift & Stamp HUD.
The resulting action is highly processor intensive and may take a few moments.

After a few moments the images update with the adjustments applied to them. Note the adjustments badge on the lower right of each image.

Now, let's lift and stamp the adjustments on the tropical images.

8 Option-click the hero image from the tropical group.

Option-clicking in an image replaces the existing Lift settings with parameters from the image you Option-clicked.

9 Select all the tropical images.

10 Click the Stamp Selected Images button.

The selected images update with the new adjustments.

11 Close the Lift & Stamp HUD.

All the images are now adjusted. You could simply select and export the two favorite image groups, but a better solution is to create a Smart Album. A Smart Album will allow you to change your mind by altering the ratings for individual images.

Creating a Smart Album

In Lesson 3 you created a Smart Album for the location shots. You will create one for the delivery shots as well. You will start by rating the images.

1 Select the two groups that contain the hero images.

2 Choose Metadata > Five Stars or press Command-5 to rate the images with five stars.

3 Select the "maybe" group of tropical images.

4 Choose Metadata > Three Stars or press Command-3 to give the images a three-star rating.

5 Select the "maybe" group of sidewalk images and give them a three-star rating.

6 Select the remaining two groups of images (on the lower left of each of the groupings) and give them each a one-star rating (Command-1).

One star may seem harsh for images that made the cut, but by distributing the ratings across the spectrum, you have a lot of flexibility to increase or decrease the ratings of any image at any time.

Your work is done in the Light Table, so let's switch to the Maximize Browser layout to create a Smart Album.

7 Press Command-Option-B.

8 Control-click the Grande Fashion project icon in the Projects panel and choose New Smart > Album.

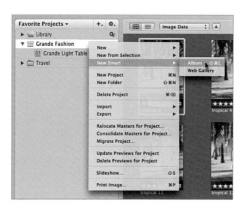

9 Name the new album *Grande Favorites* and press Return.

10 Drag the Ratings slider to five stars and then close the Query HUD.

The 6 five-star images you will be delivering should be visible in the Browser.

11 Drag the Thumbnail Resize slider in the Browser to enlarge the thumbnails until you see two rows of three.

The images are ready to be burned to a CD for the client, but before we do that, let's print a contact sheet to go along with it.

Printing Contact Sheets

Printing contact sheets has been part of the photography process for some time. A contact sheet serves two purposes: It shows the client all of the images you're delivering at a glance, and it provides a reference for you

so that you can track what you delivered. Let's create two contact sheets, one for each purpose.

1 Select all the images in Grande Favorites, then Control-click the Grande Favorites Smart Album and choose Print Images from the contextual menu.

The Print dialog appears.

2 Choose Sample Contact Sheet Preset, on the left side beneath Preset Name.

The preview area displays results of the Sample Contact Sheet Preset settings. We could customize these settings, but let's create a new preset instead. It will be for a contact sheet that includes metadata for your internal reference.

3 Choose New Contact Sheet Preset from the Print dialog Action pop-up menu.

TIP The Printer Selection area of the dialog should reflect settings for the printer or lab that will print your contact sheets. If you are using a service bureau or photo lab, you can click the Save as PDF button to create a PDF file. Make sure you have an ICC profile to manage the color of the printing.

4 Name the new preset *Contact Single Page Photo Info – EXIF* and press Return.

5 Click Save.

Each time you make a change to a preset, the Save button activates. When you have finished customizing your preset, click Save before exiting the Print dialog.

6 Choose Photo Info – EXIF from the Metadata pop-up menu and then click Save again.

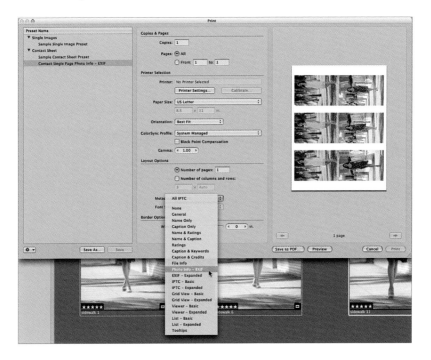

The Metadata pop-up menu allows you to specify what metadata text appears next to the images on the contact sheet. Choosing Photo Info – EXIF prints the filename and technical information next to the images. This is a great setting for your internal reference.

7 Drag the Width value slider under the Border options to *0.10* and then click Save.

Increasing the width creates a little more space between the thumbnails on the contact sheet.

8 Click the Preview button to create a PDF of the contact sheet and to open it in Preview.

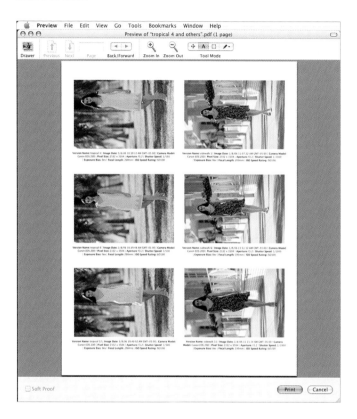

That's a fine contact sheet for your use. Next, let's adjust the preset to create a contact sheet appropriate for accompanying the CD.

9 Quit Preview and click the Aperture application icon in the Dock to return to Aperture.

10 Click the Grande Favorites album and press Command-P to open the Print dialog.

11 Choose the Contact Single Page Photo Info – EXIF preset from the Preset Name area of the Print dialog.

12 Choose IPTC – Basic from the Metadata pop-up menu in the Layout Options area.

This preset will display only the filename, credit, and copyright notice next to each thumbnail. This is a better preset for the client, who mainly needs to use filename information as a reference.

13 Click the Save As button.

14 In the Save Preset As field, name the new preset *Contact Single Page Photo IPTC – Basic*, and then click Save.

15 Back in the Print dialog, click the Preview button to view the contact sheet.

Looks good. This contact sheet will accompany the CD that you send to Grande Agency.

16 Quit Preview.

Time to author the CD.

Authoring a Disc of Final Images

Delivering the images to a client is the culmination of postproduction. The images are sorted and adjusted and it's time to put the project to rest.

Authoring a CD is straightforward: you can use Mac OS X's built-in Burn command. The process for authoring a DVD is identical.

1 Insert a blank CD into your Mac's optical disc drive.

The CD icon appears on your desktop.

NOTE ▶ The behavior that occurs when you insert a CD is user-definable. The first time you insert a blank CD, you are prompted with some choices. This exercise presumes that Open Finder is your default action. To view and change the default behavior, open the System Preferences and choose CDs & DVDs.

2 In Aperture, click an image inside the Grande Favorites Smart Album.

3 Press Command-A to select all of the images in the Browser.

4 Choose File > Export > Export Versions or press Command-Shift-E.

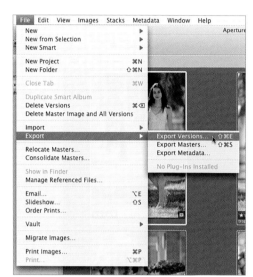

The Export dialog appears. As with printing, you can create an export preset to use regularly in your workflow. Let's do so now.

5 Choose Edit from the Export Preset pop-up menu.

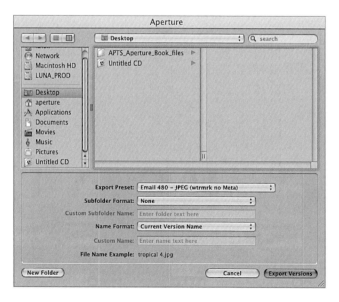

The Export Presets dialog appears.

6 Select PSD – Original Size (16-bit) in the Export Preset Name pop-up menu. Then click the Add (+) button to create a new preset based on the one you have selected.

7 Name the preset *PSD – Original Size (16-bit) 300dpi no meta* and press Return.

The delivery format should be agreed upon with your client. In this case, Grande has requested 300-dpi, 16-bit color images in the Adobe Photoshop format, PSD.

NOTE ▸ The term *dpi* (dots per inch) is used in printing and does not affect image file size.

8 Deselect the Include Metadata checkbox, enter *300* in the DPI field, and choose Adobe RGB (1998) from the ColorSync Profile pop-up menu. Adobe RGB (1998) is the profile used by the digital camera. There is no need to attach metadata.

9 Click OK.

10 Back in the Export dialog, navigate to the CD on your desktop.

11 Make sure that the Export Preset is PSD – Original Size (16-bit) 300dpi no meta, and that the Name Format is Current Version Name.

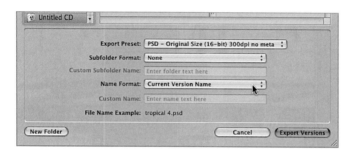

12 Click Export Versions.

Aperture applies your adjustments using the original RAW files to create new 16-bit PSD files of the images. Your original RAW files are never touched. When it finishes, you can burn the CD.

13 In the Finder, name the CD on the desktop *Grande CD*.

14 Control-click the disc icon and choose Burn Disc from the contextual menu.

15 In the window that appears, confirm the disc name is Grande CD (change it if necessary), and make sure that the Burn Speed—which will depend on your drive—is low. Lower speed burns are advisable for critical data because they are more reliable and less susceptible to media inconsistencies.

16 Click Burn.

The Burn window appears and shows the progress of the burn.

17 When the CD is burned, open at least one of the files on the disc to check it.

NOTE ▶ Many photographers like to open all the files on an authored disc to verify there are no problems with file integrity.

18 Eject the CD.

Congratulations. You can send the disc to Grande—but you're not quite finished with the project. The final step in the workflow is backing up your images.

Backing Up the Library

Backing up data is not a new concept for anyone who has been using a computer. Backing up becomes even more important when you are dealing with your valuable images.

Aperture allows you to back up your Library to an optimized data package called a *vault*. A vault includes all your original images, all the versions you create, and image metadata. It preserves the structure of your Projects panel, including all projects, albums, folders, web galleries, web journals, books and Light Tables. You should back up your Library to a vault periodically—starting right now.

NOTE ▶ For more on backup strategies and creating multiple backups, see Lesson 11, "Advanced File Structure and Archiving."

1 In Aperture, press Command-Option-S to switch to the Basic layout.

2 Drag the Thumbnail Resize slider to reduce the thumbnails in the Browser.

3 Choose Add Vault from the Vault Action pop-up menu at the bottom of the Projects panel.

The New Vault Contents dialog appears, indicating the number of managed files that will be included in the vault. Click Continue.

The Add Vault dialog appears. For the purposes of this exercise you will save your vault on your internal hard disk. In reality, you should save the vault on a separate, external hard disk.

4 Navigate to the APTS_Aperture_book_files > Lessons > Lesson07 > Library Backup folder.

5 In the Vault Name field, type *Backup Vault*, and then click the Add button.

The Backup Vault appears below the Projects panel. You can click the
Show or Hide Vaults button to view or hide the vault list. You created the
vault, but it is empty at the moment. Next, we need to update it with the
contents of the Library.

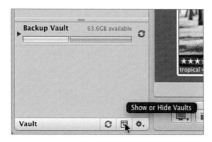

6 Click the Update button.

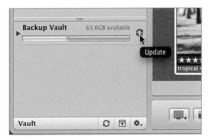

A dialog appears asking you if you would like to update the vault.

7 Click the Update button.

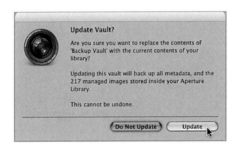

A progress indicator appears. Since this is the first time we are updating, the entire Library is being duplicated to the vault. Future updates will be incremental, only copying the changes since the previous update, and thus will be speedier.

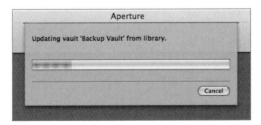

Notice that the Update button is now grayed out. This indicates that the vault is in sync with the Library. As soon as we make changes to a project, the button will turn red, indicating that we need to sync the vault.

The project is delivered and archived. Take a break, and then get ready for Part II, the advanced lessons of this book.

Lesson Review

1. Can the toolbar in Full Screen mode be customized?

2. Describe two ways to control the appearance of the filmstrip in Full Screen mode.

3. How do you adjust the luminance of an image in Aperture?

4. What is a vault in Aperture?

Answers

1. Unlike the regular toolbar, the toolbar in Full Screen mode cannot be customized. However, you can hide it and access the tools using keyboard shortcuts.

2. The filmstrip can be positioned as a floating panel in Full Screen mode, or docked to the side of the Full Screen interface. In addition, you can resize the filmstrip to show more or fewer thumbnail images. The smaller the filmstrip, the more room there is in the Viewer to display images.

3. To adjust the luminance of an image—by making shadows darker for the stronger colors in an image, for example—adjust the levels in the Adjustments HUD or Inspector. If increasing the black point makes skin tones too dark, you can return the glow to a subject's face by raising the midtone level in the Adjustments HUD.

4. A vault in Aperture is an archive of your entire Library. A vault includes all your original images, all the versions you create, and image metadata. It preserves the structure of your Projects panel, including all projects, albums, folders, web galleries, web journals, books and Light Tables.

Keyboard Shortcuts

H	Open the Adjustments HUD
J	Scroll up the thumbnails in the filmstrip
K	Stop scrolling thumbnails in the filmstrip
L	Scroll down the thumbnails in the filmstrip
Control-V	Choose the Avoid command, which will automatically fit the filmstrip and image onscreen

Advanced Features

8

Lesson Files	APTS_Aperture_book_files > Lessons > Lesson08
Media	Lesson08 First Import
	Lesson08 Second Import
Time	This lesson takes approximately 2 hours to complete.
Goals	Create and edit stacks
	Create keywords and keyword groups
	Apply keywords to images
	Edit metadata in batches
	Define picks and promote/demote alternates in a stack
	Apply star ratings to images
	Define album picks
	Filter images using the Browser Search field and the Query HUD

Lesson 8
Advanced Organization and Rating

In Lesson 3, you learned the basics of several of Aperture's organizational features, including stacks, ratings, and albums. In this lesson, we'll explore those features more deeply and learn, among other things, how to manually create and edit stacks, how to add and edit keyword metadata so that you can search for images quickly, and how to apply star ratings to images. All of these techniques will make short work of organizing not just the photos in your archives but also the hundreds of photos that you acquire on heavy shooting days.

To learn about these features, we're going to use Aperture to organize images from an event shoot of the Pickle Family Circus, a San Francisco–based performing arts company. We photographed a rehearsal to capture some images for a printed program that provides a behind-the-scenes look at the production. The client asked specifically for images with a documentary, or "found," look. Because many of these shots were action shots of circus performers, we captured a lot of burst sequences. We'll use Aperture's stacking features to organize the images and the keyword and rating features to further sort and filter them.

Preparing the Project

Before we can begin working with our circus images, we need to import them. Aperture provides many options for importing images. You can import them directly from your camera or media card, from files that are already on your hard disk, or from Aperture project files. But Aperture not only lets you choose where you want to import images *from*, it also gives you options for where the imported images will be *stored*.

As discussed in Lesson 1, you can import images into Aperture's Library, which copies the files, called *managed images*, into the Library location you've specified in the Preferences dialog. You can also choose to import images as *referenced images*. Choosing whether to use referenced images is not a global choice. You can make the decision on an image-by-image basis.

What Happens When You Import an Image?

When you import an image into your Aperture Library, the image is copied from its original location to the Aperture Library package, which is a special kind of folder. By default, the Library package is kept in the Pictures folder inside your Home folder. (In Chapter 11, you'll learn how to move the Aperture Library.)

When you import an image as a reference, the original image file is left in its original location. Aperture builds a thumbnail-size image of the file and stores that in its Library, along with a large preview image, which is also stored in the Library. You can import a reference from an image stored on an external hard disk, CD or DVD, or network server. Even if you take the original volume offline, you'll still see the image in your Aperture Library, because Aperture has the preview image that it built, safely tucked away in the Library.

Importing an image as a reference is analogous to making an alias of a document in the Finder. The reference is simply a pointer to the original image data.

In Chapter 11, we'll explore some of the reasons you might choose to import files as references, rather than into your main Aperture Library. For now, we'll practice importing using both techniques.

Importing the First Batch

Three days of rehearsal shooting yielded around 1,200 images. These pictures were shot in RAW format using an 8-megapixel Canon EOS 20D. We've pared the shoot down to a selection of 53 images, which we'll import in two batches, one now and one later in this lesson. In Lesson 2, you learned how to turn on auto-stacking when importing bracketed, or burst, images. You could do that with these images, but instead we'll create the stacks manually in Aperture so that we can explore a few other organizational features first.

The first batch of images that we'll use in this lesson has been saved in the Lesson08 folder, in a subfolder called Chapter 8 Part 1.

1 Insert the *APTS_Aperture1.5* DVD. Open it and navigate to Lessons > Lesson08.

2 Open the folder called Lesson08 First Import. Inside, you'll find 46 images, plus a folder containing an additional 7 shots of a juggler.

We're going to import these images directly from the DVD as referenced images to demonstrate the power of referenced import. In addition, we're going to use the "Import Folders as Projects" command to preserve the folder structure of the original folder.

1 Open Aperture.

2 Choose Window > Layouts > Maximize Browser, or press Command-Option-B to change to the Maximize Browser view.

 This provides a large Browser, which makes it easier to view lots of thumbnails at once.

3 In the Projects panel, click the Library to select it. We're going to let Aperture create a new project name for us, so we want to select the Library to indicate that the new project should not be created inside another, existing project.

4 Choose File > Import > Folders as Projects, or press Command-Shift-I.

5 Navigate to the APTS_Aperture_book_files > Lessons > Lesson08 > Lesson08 First Import folder on the Aperture DVD.

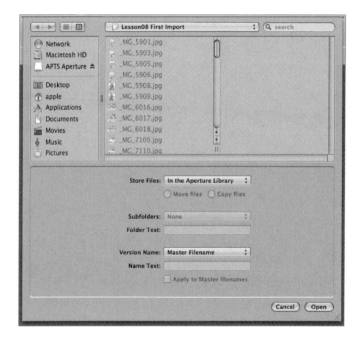

6 Change the Store Files pop-up menu to "In their current location." This tells Aperture to leave the files where they are, and to import a reference to them.

Let's also tell Aperture to give the imported files names that are more meaningful than the camera-generated names.

7 In the Version Name pop-up menu, choose "Custom Name with Index" and then enter *Pickle Circus* into the Name Text field. This will name each image *Pickle Circus* with a sequential number.

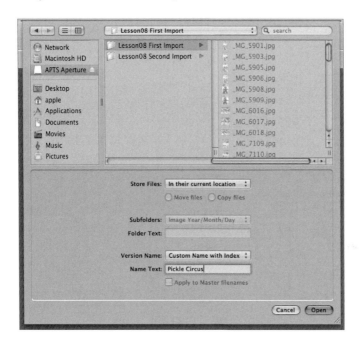

8 Click Open. Aperture will begin importing the images into a new project called Lesson08 First Import.

The project will automatically be selected, allowing you to see the thumbnails as they are imported.

9 When the Import Complete dialog box appears, click OK.

Even though Aperture has successfully imported everything and is showing you thumbnails, it's most likely still doing some processing in the background. Let's take a look at what it's up to.

1 From the Window menu, choose Show Control Bar, or press D.

On the left end of the control bar, you should see a progress indicator spinning.

2 Click the progress indicator to open the Task List window. You can also open it by selecting Window > Show Task List.

This window shows any tasks that Aperture might be performing in the background. It should have at least one entry that says "Processing previews."

Task Name		% Complete
Image Manager	Processing previews (17 remaining)	

This indicates that Aperture is building preview images for your imported files. Because these images are being imported as references, Aperture builds a preview image that it uses for display. This way, even if you take the original file offline (which you could do simply by ejecting the DVD), Aperture can still show you the image.

Preview images are full-resolution—that is, they have the same resolution as your original file. They're stored inside your Aperture Library as a JPEG image. If the original image is available (in this case, it is, because the DVD is still mounted in your computer), then the original image is shown. If the file goes offline, then the preview image is shown.

If you're working with a large number of very high-resolution images, it may take a while for Aperture to build all the preview images. Fortunately, Apple has very intelligently given preview building a low priority, so you can

continue to work with Aperture without experiencing a big slowdown. We'll discuss preview images more in Chapter 11.

Images that have been imported by as references show a small badge, very similar to the alias indicator in the Macintosh Finder.

Finally, note that Aperture has automatically created two albums within our project. The first album contains the 46 images that were in our selected folder, while the second album contains the 7 images that were in the subfolder.

The "Import Folders as Projects" command automatically turns subfolders into albums.

Configuring the Browser

By now, you're familiar with Aperture's Browser and Viewer, and the application's different layout configurations. As you know, thumbnails of your images are displayed in a grid or list view in the Browser. By default, however, Aperture spaces all thumbnails evenly whether they're in portrait or landscape orientation. This can result in gaps that reduce the total number of thumbnails you can see at once. With a large collection—such as our 53 Pickle Family Circus

shots—it helps to turn on proportional spacing for the Browser display. This is an option in Aperture's Preferences.

1 Choose Aperture > Preferences.

2 Select the checkbox "Use proportional spacing for images in Grid View."

Aperture packs the images more closely together, rather than aligning them all to a fixed grid.

Now, you can see more thumbnail images onscreen in the Browser.

Arranging Images in the Browser

In addition to using stacks and ratings to organize images in Aperture, there are a few convenient ways to organize images directly in the Browser: You can use the Sort pop-up menu, and you can freely drag to reposition images in any order. The Sort pop-up menu, by default, organizes images in the Browser by Image Date, but you can change that.

1 If it's not already selected, click the Lesson08 First Import project. This will display thumbnails of all of the images in the project.

2 Click the Sort pop-up menu at the top of the Browser and choose Orientation. Aperture rearranges the images in the Browser so that all of the portrait images are together and all of the landscape images are together.

3 Choose Image Date from the Sort pop-up menu.

Dragging images in the Browser is a good way to group images by subject or content or string them together into a narrative.

4 Select this group of images:

5 Drag the selected images next to the other images of the ballet acrobats.

Notice that after you drag the images in the Browser, the Sort pop-up menu at the top of the Browser changes to Custom.

6 Choose Image Date from the Sort pop-up menu. Aperture rearranges the images by the date and time they were captured.

7 Choose Custom from the Sort pop-up menu.

Aperture remembers your custom arrangement, and you can switch back to it at any time by choosing Custom from this menu.

8 Choose Image Date from the Sort pop-up menu. We want to view the images in the order they were shot.

NOTE ▶ Custom arrangements are lost when projects are exported, but you can preserve a custom arrangement by placing the images in an album. Album order is remembered when a project is exported.

Now that you've imported the project and have learned some tricks about arranging images in the Browser, let's get to work stacking our Pickle Family Circus images.

Creating and Editing Stacks

As you've probably already noticed, most of the images in this project are burst sequences of various performers in action. Our primary organizational goal will be to select the best image from each of these bursts. We'll begin by

stacking our images, which will allow us to use Aperture's comparison tools to quickly pick the best image from each burst.

1 With the Lesson08 First Import project selected, choose Stacks > Auto-Stack. Aperture opens the Auto-Stack Images HUD, which offers the same Auto-Stack slider that's available in the Import dialog.

2 Drag the Auto-Stack slider to *0:15*.

When you move the slider, Aperture groups images together according to the specified time interval. When you release the mouse at 0:15, all images shot within 15 seconds of each other will be grouped into a separate stack.

3 Close the Auto-Stack Images HUD.

4 Click an empty area of the Browser to deselect all images, or press Command-Shift-A.

Auto-stacking did a good job of creating our basic stacks, but let's do some fine-tuning.

Rearranging Stacks

You can rearrange stacks in the Browser just like you rearrange thumbnails: by dragging them. Stacks must be closed for you to rearrange by dragging in the Browser, however. Let's organize our stacks to group them together by subject.

1 Choose Stacks > Close All Stacks or press Option-;.

2 Select the stack of the ballet dancer balancing on the acrobat's head
 (**Pickle Circus 31**).

3 Drag the stack next to the similar stack titled *Pickle Circus 21*.

 NOTE ▸ If you drag an image in an open stack to another location in the
 Browser, you will move it out of the stack.

 After you reposition a stack, you can open it again to see its contents.

4 Press Option-' (apostrophe) to open all the stacks again.

Combining Stacks

A few of our Pickle Family Circus images weren't correctly stacked by the
Auto-Stack command. Luckily, Aperture lets you add images to a stack,
combine stacks, and split stacks so that you can get the exact grouping
that you need.

1 Press Option-' to open all stacks.

2 Look through the images in the Browser to find these two stacks:

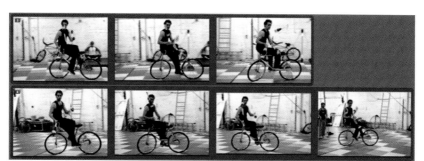

There was a delay between shooting these two bursts, so the Auto-Stack command created two stacks. We only need one pick of the juggling bicyclist, however, so let's combine these two stacks into one.

3 Click the first image in the second stack (**Pickle Circus 39**) and then Shift-click the last image to select all four images in the stack.

4 Drag the selected stack over the first stack so that the green positioning bar is at the end of the first stack. Be sure the bar is positioned just as it is shown in this image. Then, release the mouse. This combines the stacks while keeping the images in shooting order.

When you release the mouse, all of the juggling bicyclist images should be inside the same stack. You'll know you combined the stacks because the stack number changes from 3 to 7. If you make a mistake, press Command-Z and try again.

Adding Individual Images to a Stack

Balancing ballet dancers, juggling bicyclists. We also captured several images of an acrobat balancing on a ring. Aperture grouped four of these images in one stack and left the fifth image unstacked; let's add the fifth image to the stack of four. You might be able to guess how to add an individual image to a stack: simply drag it into the stack.

1 Scan the Browser until you find these images. Depending on the size of your display and your zoom setting, they may not appear in the same row, but they should be adjacent to each other.

The first image belongs in the stack with the other four.

2 Drag the unstacked image into the stack, placing it between any two images.

Once again, you'll know you added the image to the stack successfully because the stack number will change from 4 to 5.

Creating Stacks Manually

You don't have to use the Auto-Stack feature to create stacks; you can also create them manually by simply selecting images and using the Stack command. This is a good way to organize stray images that fell outside the specified Auto-

Stack time interval, or to create stacks of images that contain related subject matter but that might have been shot at different times.

1 Locate these two images in the Browser and select them both. They should be adjacent, so you can either Shift-click or Command-click to select them.

2 Choose Stacks > Stack or press Command-K. Aperture groups the two images into a stack. The Stack command is very useful. You can use it to create a stack from any number of images, as well as to merge stacks or add images to a stack.

3 Leave the two images in the stack selected, and find the image of the same performer stretching and reading, this time with his leg extended in front of him.

We could add this third image to the stack by dragging it, but then we'd have to fuss with clicking and deselecting and dragging. Instead, here's an easier way.

4 Command-click the third image of the performer (**Pickle Circus 25**) to
 add it to the selection, and then press Command-K to add it to your exist-
 ing stack.

> **NOTE** ▶ Images added to an existing stack in this way are placed at the
> end. If you wanted the image in a different position in the stack, you could
> drag it to change its location.

Our stacks are really coming together now, but editing stacks isn't a one-
way street: You can also split stacks and remove images from stacks if they
don't belong.

Splitting a Stack

Just as you can add images to a stack by dragging them into an existing stack
or by using the Stack command, you can also remove images from a stack by
dragging them away from the stack, and you can break up stacks using the
Split Stack command. Let's try it.

1 Locate the stack of the five images of the ballet dancer balanced on the
 acrobat's head.

Notice that in the first image, the acrobat is holding the ballerina's ankle, but in the other images his arms are extended. Let's remove this first image from the stack so that the stack contains only images of the dancer balancing.

2 Click to select the second image in the stack. Aperture will split the stack at the point *to the left of* the selected image.

3 Choose Stacks > Split Stack, or press Option-K.

Aperture splits the stack, leaving only four images in it. You can also use Split Stack to break one stack into multiple stacks.

TIP ► You can also drag the first image to an empty area of the Browser to remove it from the stack or select it and choose Stacks > Extract Item (Option-Shift-K).

4 Click to select the third image in the stack, and then press Option-K.

Aperture splits the single stack of four into two stacks of two. We don't need such fine delineation of these images, however.

5 Press Command-Z to restore the stack of four images.

NOTE ► If you decide that you don't want a set of images stacked, you can of course drag out each image to disassemble the stack. An easier way is to simply select an image in the stack and then choose Stacks > Unstack. Unstacking completely dissolves the stack, leaving all of the images as separate, individual images.

Editing Stacks During Import

Most of the stacking features that you've seen in this lesson in the main window are also available in the Import dialog. We need to import some more images from the Pickle Family Circus shoot—images captured on a different day, onstage—so let's practice editing our stacks as we import these additional images.

1 Select the Lesson08 First Import project in the Projects panel.

2 Choose File > Import > Images, or press Command-I.

3 At the top of the Import dialog, navigate to the APTS_Aperture_book_files > Lessons > Lesson08 > Second Import folder.

4 Press Command-A to select all of the images in the folder.

Now let's enter some metadata that we'll need later in this lesson.

5 In the Add Metadata From menu of the Import dialog, choose IPTC – Expanded and then enter the metadata as shown in the following figure.

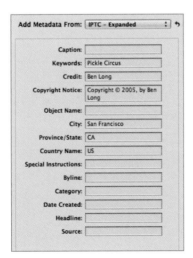

NOTE ▶ Aperture remembers the metadata information you enter here and will automatically complete these entries in the future. For example, after entering *San Francisco* here, if you type *San* into any metadata field in Aperture, it will automatically fill in the full text for you. With this autofill function, adding metadata becomes quicker as you build up a database of autofill responses.

Now, let's create our stacks.

6 Set the Auto-Stack slider to approximately 8 seconds.

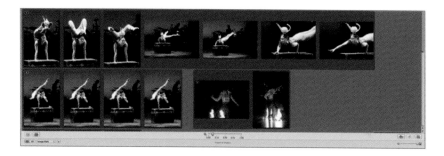

7 With all of the stacks open (press Option-' if necessary to open them), drag the Thumbnail Resize slider so that you can see all of the images onscreen at once. Our goal now is to determine if our stacks need any editing.

Indeed, the first stack—a seven-image stack showing a man tossing a girl into the air—actually contains two different bursts. We'd be better off with each burst in its own stack.

8 Select the fifth image from the left, which should be the first image of the second burst.

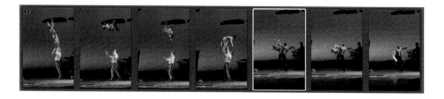

9 Click the Split Stack button or press Option-K.

NOTE ▶ Undo does not work in the Import dialog. If you accidentally split a stack in the wrong place, you'll need to join it and then split it again in the proper location. To join a stack, click the Join Stack button, which has an icon of a roll of tape and is next to the Split Stack button.

10 Using the Split Stack command, split the stack of the teapot acrobat performer into three stacks as shown in the following figures.

Original stack of seven images

Split stacks of three, two, and two images each

11 Change the Store Files pop-up menu to In the Aperture Library. This will tell Aperture to copy the images into the Aperture Library, rather than importing them as references, as we did last time. As you can see, we can

freely combine managed and referenced images within the same project. Now we're ready to start importing.

12 Click in the gray area to deselect any images, then click the Import All button to begin importing your images. You can also start the import operation by clicking the Import Arrow button at the end of the Import arrow.

The Import progress indicator appears next to the project name in the Projects panel. Aperture imports the images in the background, allowing you to continue work on other images or projects.

TIP ▶ If you want more information about the import operation or if you need to interrupt the import, use the Task List. Just choose Window > Show Task List to see a list of all currently running processes. This window gives you a more accurate readout than the progress indicator in the Projects panel. If you need to cancel the import, click the task name (Image Import) and then click the Cancel Task button. Your import will be stopped, but any images already imported will remain in your Library.

13 When the import has finished, click OK to close the Import Complete window.

NOTE ▶ You can also import images by dragging them from the Finder to a project name in the Projects panel. When you do this, however, you can't define stacks or assign metadata.

Now you know all of the ins and outs of organizing stacks in the Aperture main window and Import dialog. There's still more to learn—about choosing picks and alternates, for example—but first let's turn our attention to keywording.

Using Keywords

With all of our images imported and organized into stacks, we're ready to start adding keywords. Keywords—descriptive words about the subject matter of an image—are added to image versions and saved as metadata. They provide an automated way to filter, select, and organize images. You can add keywords at any time and will often refine your keywords while you work. It may seem strange that we're applying keywords before making our selections and rating our images, as we will end up applying keywords to images that we may never use or may even discard. However, since we don't know which images we'll want to keep, and because it's ultimately more efficient to apply keywords in large batches, we're going to apply keywords to all our images now, so that no matter which images we end up selecting as our final picks, they will be properly tagged.

Identifying Keywords

You may not have noticed, but the images in the Lesson08 First Import project had *Pickle Circus* assigned as a keyword. You also assigned this keyword in the Import dialog when you imported the second batch of Pickle Circus images. Let's start by double-checking that the keyword is properly assigned to all of the images in the project.

1 With the Lesson08 First Import project selected in the Projects panel, press Command-Option-B to switch to the Maximize Browser layout. Then, open all stacks by pressing Option-`.

2 Click the Show Metadata button in the toolbar or press Control-D to open the Metadata Inspector.

3 Adjust the Thumbnail Resize slider so that all images are visible onscreen in the Browser.

4 Select one of the rehearsal shots—any one of the images from the initial project that you imported.

5 In the Metadata Inspector, make sure the Metadata pop-up menu is set to Metadata: General and then click the Keywords button at the bottom of the panel. You should see a list of the basic metadata tags that are attached to the selected image.

The Keywords field should show that the image is tagged with a single keyword, *Pickle Circus*.

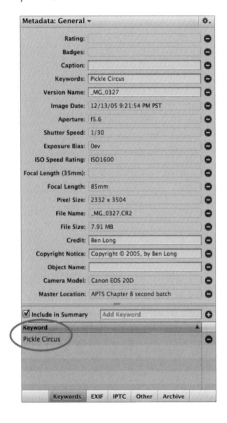

6 Now select one of the performance images—any image from the batch that you imported using the Import dialog. The Keyword summary area should show *Pickle Circus* attached to all of your performance images.

7 Notice the Delete (−) button to the right of the *Pickle Circus* keyword. You can click this button to remove a keyword from an individual image (but

don't do that now). You can also add keywords to individual images by entering them in the Include in Summary field and then clicking the Add (+) button. For keywording "touch-ups" or for those times when you only need to keyword a single image, these two options are all you need. To define keywords for collections of images, however, Aperture offers more powerful tools, which we'll explore now.

Defining Keywords

For the sake of efficiency, it's best to assign keywords to groups of images. And the first step of that process is determining what words to use. The goal is to create keyword tags that will let you perform useful searches, both inside the project and within your entire Aperture Library. So you need to think about how you might want to search. In terms of this project, for example:

▶ Let's assume we'll continue to work with this client; images from other shoots, however, will probably be organized in other projects. So we want to be able to search our entire Library for circus images. Because all of our images are already tagged with the *Pickle Circus* keyword, we're already set up for that search.

▶ In this project, we have two basic types of images: rehearsal and performance shots. We'll want to be able to search for either of those.

▶ Another logical grouping is types of acts: acrobats, aerialists, fire, and juggling. Those will make good keywords as well.

▶ Differentiating between shots of solo performers and groups of performers can make things simpler if the client asks specifically for either type of shot.

▶ Finally, some of our rehearsal shots are candid shots, rather than circus work. We'll make this distinction, as well.

Note that the images don't have to conform to only one of these categories. You can apply as many keywords to an image as you like. So let's begin.

1 Make sure you're in the Maximize Browser layout and the Metadata Inspector is open.

2 Choose Window > Show Keywords HUD, or press Shift-H. You use the
Keywords HUD to set keywords.

The Keywords HUD contains a number of predefined keywords organized
by category, such as *Wedding*. You should also see the *Pickle Circus* key-
word that you added earlier.

TIP ▶ You don't have to use the predefined keywords and, in fact, you
can delete them. For example, if you never shoot weddings, you can delete
the Wedding category by selecting it and then clicking the Remove
Keyword button at the bottom of the HUD.

You can group keywords hierarchically in the Keywords HUD. This allows you
to keep your keywords organized by subject. Note that the *Pickle Circus* key-
word does not have a disclosure triangle next to it. This is because it doesn't
have any subordinate keywords attached to it. Now we'll define the keywords
we discussed earlier, but we'll include them all as subordinates of the *Pickle
Circus* keyword, to keep our Keywords HUD tidy.

1 With the *Pickle Circus* keyword selected, click the Add Subordinate
Keyword button at the bottom of the Keywords HUD. *Pickle Circus*
becomes a keyword group, with one subordinate keyword: *Untitled*.

Clicking the Add Keyword button always adds a keyword at the same level as the currently selected keyword. Clicking the Add Subordinate Keyword button always adds a new keyword as a child of the currently selected keyword.

2 Change the untitled keyword to *Performance*.

3 With *Performance* still selected, click the Add Keyword button. This will add another *Untitled* keyword at the same level as *Performance*.

4 Rename the new keyword *Rehearsal*.

We're on a roll. Let's keep going.

Adding Keywords and Groups

Now let's add another layer of specificity to our keyword scheme. There are four types of acts in our Performance shots: acrobats, fire, juggling, and aerialists. We'll put these in their own groups.

1 With *Pickle Circus* selected, click the Add Subordinate Keyword button to create a new, untitled subordinate keyword. Rename it *Acts*.

2 With the *Acts* keyword selected, click the Add Subordinate Keyword button to create a subordinate keyword below *Acts*.

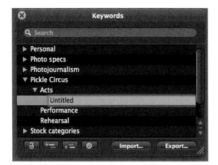

3 Rename the new keyword *Acrobats*.

4 With *Acrobats* selected, click the Add Keyword button three times to create three new keywords at the same level as *Acrobats*. Rename these *Aerialists, Fire,* and *Juggling.* When you're finished, your keyword group should look like the following figure.

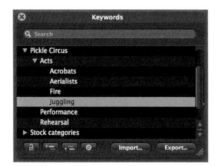

Note that it doesn't matter in what order you add the keywords. Aperture automatically alphabetizes them in the Keywords HUD.

5 Select the *Rehearsal* keyword and use the Add Keyword button to create three new keywords.

6 Rename the new keywords *Group, Solo,* and *Candids.* We can use these to provide a little more detail about the content of a shot.

TIP ▶ Open and close the keyword groups by clicking their disclosure triangles. Closing them gives you more room to work in the HUD but, obviously, doesn't let you see what's inside the group.

When you're finished, the Pickle Circus keyword group should look like this:

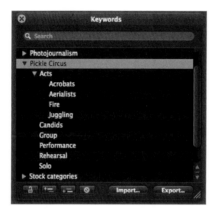

These should be all the keywords that we'll need for this project. Of course, we can always add more later, either to the Keywords HUD for batch application, or to individual images using the Metadata Inspector. It's important to understand that the hierarchical structure shown in the Keywords HUD is for organizational purposes only. Keywords don't actually have a hierarchical relationship. Now let's apply these keywords to some images.

Assigning Keywords to Images

Aperture provides several ways to assign keywords to images. Although they all have their strengths, you'll probably find yourself settling in to one or two methods that you prefer. For the sake of example, we're going to switch between all of the different methods in this lesson, so the workflow we use here may be a little more convoluted than what you'd normally use. However, you'll learn all of Aperture's keyword-assigning techniques.

Dragging and Dropping Keywords

The first way to assign keywords to images is to drag them directly from the Keywords HUD to the image or images.

1 Make sure you're still in Maximize Browser layout (Command-Option-B), that all stacks are open (Option-'), that the Metadata Inspector is open (Control-D), and that the Keywords HUD is open (Shift-H).

2 Choose Image Date from the Sort pop-up menu at the top of the Browser.

3 Choose Window > Show Control Bar (D) to display the control bar.

The first stack in your project should contain four images of a man tossing a girl into the air.

4 Select all of the images in this stack by clicking the first image on the stack and then Shift-clicking the last image.

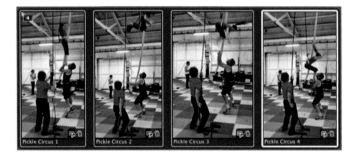

Note that while all of the images have a white selection boundary, the last image has a thicker white selection boundary, showing that it's the primary selection.

5 In the control bar, make sure that the Primary Only button is on.

We want to attach three keywords to the primary selection in this stack: *Group, Aerialists,* and *Rehearsal.*

6 Click *Group* to select it in the Keywords HUD, then press the Command key
and click the other two keywords to select them. When all three are selected,
drag them to the primary selection (the image with the thick border).

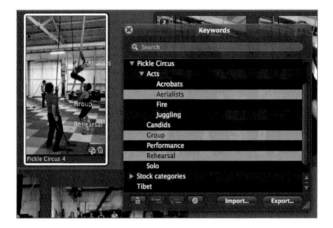

In the Metadata Inspector, you can see that all three keywords were added
to the image.

7 If necessary, click the Keywords button at the bottom of the Metadata
Inspector to reveal the Keyword summary area. The Keyword summary
area should look like this:

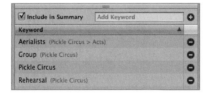

The Keyword summary area shows the keywords that are attached to the
current primary selection.

8 Now click one of the other selected images in the stack. In the Keyword
summary area you should see only the *Pickle Circus* keyword.

Because Primary Only was on, the keywords were applied only to the
image that you dropped them onto.

Applying Keywords to a Group of Images

Let's now apply keywords to all the selected images in a stack.

1 Press S to turn off the Primary Only option. It should not be highlighted in the control bar.

2 With the same four-image stack selected, drag the keywords indicated in step 6 of the previous exercise to any image in the stack.

3 Select each image individually and examine its keywords in the Metadata Inspector. You should see the same keywords for each picture.

Why does Aperture work this way? After all, if I select multiple images, don't I want to perform an action to all of them? Not necessarily. Remember that if you were in the Basic layout—or any other layout that included the Viewer—you might select multiple images in order to view them all side by side. However, you might not want to assign the same keywords to all of those images. By pressing the S key to toggle the Primary Only option on or off, you can immediately change between applying keywords or ratings to *all* of the currently selected images, or just one.

Creating Keyword Buttons

If you want to add keywords to just a few images, dragging from the Keywords HUD is easy enough. If you're working with large batches of images, though, you'll probably find it easier to use Aperture's keyword buttons.

1 Switch to the Basic Layout by pressing Command-Option-S.

2 Select Show Keyword Controls from the Window menu, or press Shift-D.

The control bar will show special keyword buttons and controls on the right side.

3 Notice that you can see the Keywords in the Metadata Inspector.

You can use the keyword buttons to assign keywords with a single mouse click or keyboard shortcut. However, Aperture's keyword buttons are initially configured with a set of default keywords, not the ones we defined in the Keywords HUD. So we have to create a custom keyword button set with our Pickle Circus keywords before we can apply them.

NOTE ▶ You can edit the keyword buttons regardless of what images are open in the Browser or what layout you're using.

1 In the control bar, click the Select Preset Group pop-up menu and choose Edit Buttons.

The Edit Button Sets window opens, allowing you to create groups, or sets, of keyword buttons. You can define as many keyword groups as you want and freely switch between them to perform different keywording chores.

2 Click the Photo Descriptors button set in the left column to select it. The contents of this set—the keyword buttons it contains—appear in the middle column. The right column shows all of your currently defined keywords (your Keywords Library).

3 Click the Add (+) button in the lower left corner of the window to create a new keyword preset group.

4 Name the new keyword preset group *Pickle Circus* and press Return. The Contents column will be empty, because the new preset group does not have any keywords in it yet.

5 In the Keywords Library column, click the disclosure triangle next to *Pickle Circus* to see all of the keywords that you defined earlier.

To add keywords to the preset group, you simply drag them from the Keywords Library column to the Contents column. The number of buttons that will fit in the control bar will vary depending on the size of your display. However, Aperture will always be able to show at least eight buttons, and it can assign the number keys 1 through 8 as shortcuts for the buttons, so it's best if your first eight keyword choices are the eight that you'll use most frequently.

> **TIP** ▶ If you have a particularly large Keywords Library, you can use the Search field at the top of the Keywords Library column to find the keyword you'd like to add to your new set.

6 Select the keywords shown in the following image and drag them to the Contents panel.

You can rearrange the order of the keywords in the Contents panel by simply dragging them up and down.

7 Drag *Performance* and *Rehearsal* so that they're at the top of the list.

For the sake of our lesson, we're going to assume that your display is only big enough to hold eight buttons.

8 Click the Add (+) button to create another preset group, and name the new group *Pickle Circus 2*.

9 Drag the remaining Pickle Circus keywords to the Contents column for the Pickle Circus 2 group. These will be *Candids*, *Group*, and *Solo*.

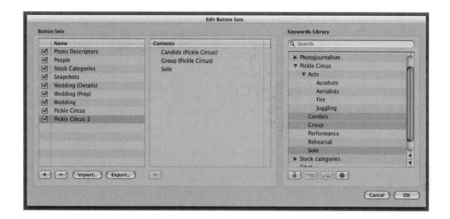

10 Click OK to create your two Pickle Circus keyword sets.

> **NOTE** ▸ You can edit your Keywords Library using the buttons at the bottom of the right column in the Edit Button Sets dialog. All four buttons—Lock/Unlock Keyword, Add Keyword, Add Subordinate Keyword, and Remove Keyword—work just like the equivalent buttons in the Keywords HUD.

Now that we've created the buttons, let's use them to apply more keywords.

Applying Keywords Using Buttons

Eagle-eyed observer that you are, you have already noticed that the keyword buttons in the control bar are unchanged—the control bar is still showing the *Photo Descriptors* keywords. We have to select our button set in order to use it. Let's do that now.

1 Click the Select Preset Group pop-up menu and choose Pickle Circus. The Pickle Circus keyword buttons now appear in the control bar. On the left side of each button is its keyboard shortcut, Option-1 through Option-6.

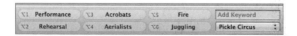

2 If they're not already open, open all Stacks by pressing Option-'.

3 Press Control-D to open the Metadata Inspector and, if necessary, click the Keywords button at the bottom of the Inspector to show the Keyword summary area.

4 Drag the Thumbnail Resize slider at the bottom of the Browser so that you can see a fair number of images at once, but don't make them so small that you can't see what's in an image.

5 Select the two images in the second stack at the top of the Browser. Both images appear in the Viewer.

6 Make sure that the Primary Only button is off (*not* highlighted) in the control bar. We want to apply keywords to all the selected images.

7 Press Option-2 to assign the *Rehearsal* keyword. *Rehearsal (Pickle Circus)* should appear in the Keyword field. The parenthetical lets us know that *Rehearsal* is a subordinate keyword of *Pickle Circus*.

8 Now assign the *Aerialists* keyword by pressing Option-4.

 We also want to tag these images with the *Group* keyword, but that keyword is not in this preset group; it's in the Pickle Circus 2 preset group.

9 Press the period (.) to change to the next preset group, and then press Option-2 to assign *Group (Pickle Circus)*.

The Keyword summary area in the Metadata Inspector should show four keywords assigned to your images:

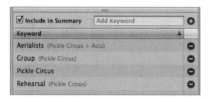

Applying Keywords Using Keyboard Shortcuts

Now let's try another method to assign keywords: using keyboard shortcuts. Not having to use the mouse will greatly speed your keywording work.

1 With the aerialist images still selected from the previous exercise, press the right arrow key once or twice as necessary to select the first image in the next stack: a shot of an acrobat vaulting over the head of someone who's jumping rope.

2 Press Shift–right arrow two times to select all three images in the stack.

3 Press comma (,) to switch back to the previous preset group. Press Option-2 to assign the *Rehearsal* keyword, then Option-3 to assign *Acrobats*. We also want to assign the *Group* keyword, but it is in our other preset group.

4 Press the period (.) to switch to the next keyword preset group.

5 Press Option-2 to add *Group*. Note that although it is open here, the control bar doesn't have to be open for the keyword keyboard shortcuts to work.

6 Press the right arrow to move to the first image in the next stack, and then use Shift–right arrow to select all the images in the stack.

7 Assign the *Group* keyword by pressing Option-2.

8 Press comma (,) to switch back to our other preset group, and apply *Rehearsal* and *Aerialists* as keywords.

Excellent. Moving right along, let's learn how to apply keywords using the Lift and Stamp tools.

Applying Keywords Using the Lift and Stamp Tools

You've probably noticed that many of your images need the same keywords. Once you've gone to the trouble of assigning keywords to one image, you can easily copy those keywords to other images using Aperture's Lift and Stamp tools.

1 Using the arrow keys and the Shift key, navigate to and select the four images in the next stack:

This is a pair of rehearsing acrobats. We want to apply the same keywords to these images as we applied to the stack in the previous exercise. Let's use the Lift and Stamp tools to do so.

2 Select the Lift tool in the toolbar, or press O. As you learned in Lesson 4, the Lift tool lets you copy the metadata and adjustments from one image and apply them to other images. When you select it, the Lift & Stamp HUD appears.

3 With the Lift tool, click either thumbnail in the second stack. When you click, Aperture adds the keyword metadata from this image to the Lift & Stamp HUD.

4 Click the Keywords disclosure triangle in the Lift & Stamp HUD to see the keywords that have been lifted.

5 Click the Stamp Selected Images button at the bottom of the Lift & Stamp HUD to apply the lifted keywords to the four selected images in the Browser.

Because these images were imported as references and aren't actually stored in the Aperture Library, Aperture may give you a warning alert.

6 Look at the Keyword summary area of the Metadata Inspector to see the keywords you just added to the selected images.

7 Close the Lift & Stamp HUD by clicking the X in the upper left corner or by pressing A to switch to the Selection tool.

Autofilling Keywords

Even though it helps to copy keywords from one image to another, there will still be times when you find yourself repeatedly typing the same keyword tags. Fortunately, Aperture provides an autofill feature to speed you along by automatically completing keywords that you've entered at another time.

1 In the Browser, select the next image:

2 Press Option-2 to apply the *Rehearsal* keyword. This image also needs the *Acrobats* keyword.

3 In the Add Keyword field to the right of the buttons, type *acro*. Aperture automatically fills in the word *Acrobats*. Press Return to assign the keyword.

This image also needs the *Candids* keyword.

4 Begin typing *Candids*. Aperture will automatically complete the word for you.

However, if you still have the default Wedding keywords installed, Aperture will also present you with a pop-up menu. It turns out that there's also a *Candids* keyword in the Wedding group.

5 Use the arrow keys to select *Candids (Pickle Circus)* and then press Return to assign the keyword.

6 If the cursor is still flashing in the Add Keyword field, press Return to exit the field.

NOTE ▸ Mispelled entries that you make in the Metadata Inspector can sometimes show up in your autofill choices. This can quickly become a big headache. Fortunately, Aperture lets you easily edit the autofill text that it has gathered up. Just select Metadata > Edit AutoFill List to access the Autofill editor.

Mixing Techniques

Because Aperture provides so many ways to assign keywords, you can easily mix and match techniques depending on what's the most convenient method at any given time. If your hand is already on the mouse, you might find it easier to drag a keyword onto an image, while if you're already typing, then using keyboard shortcuts might be the best approach. You'll often find yourself combining techniques and using them interchangeably as productivity dictates.

1 Select the following two images in the Browser. Let's say that you just realized these two images need to be stacked. Even though you're keywording right now, you can still stack them immediately. Choose Stacks > Stack (Command-K).

2 After stacking, the female acrobat is selected. She already has keywords applied; we want to apply them to the other image. Click on the male acrobat to select his image.

Now, while you've got them selected, you want to apply keywords.

3 Press Option-2 and Option-3 to assign the keywords *Rehearsal* and *Acrobats*, respectively. Alternatively, click the buttons on the control bar to apply these keywords.

4 Press the period (.) key to switch to the next keyword preset group. Then press Option-3 to assign the keyword *Solo*, and Option-1 to assign *Candids*.

In the Browser, you can see that the following stack of three images requires the same keywords we applied to these two acrobats earlier.

5 Press O to select the Lift tool.

6 Click the thumbnail of one of the images of these two acrobats that we tagged earlier to lift its keywords.

As in the earlier exercise, the Lift & Stamp HUD appears and the Lift tool changes to the Stamp tool. (The upward-pointing icon changes to the downward-pointing icon.) Note that we have not changed our selection; we can freely lift and stamp between unselected images, without changing our current selection.

7 Click each of the three images that need the keywords that we just lifted. The Stamp tool applies the lifted keywords to each image in turn.

8 Press A to switch to the Selection tool and close the Lift & Stamp HUD.

Copying and Pasting Metadata

Aperture provides keyboard shortcuts for copying and pasting metadata, which offers yet another way to copy keywords from one image to another. Essentially, it's a keyboard shortcut for lifting and stamping.

1 In the Browser, locate the five images of the head-balancing ballet acro-
 bats—a stack of four images and a standalone image. Earlier, we key-
 worded a stack of three similar images, using the autofill technique.
 Let's copy and paste those now, using shortcuts.

2 Select one of the previously keyworded images.

3 Press Command-Shift-C to copy all the metadata from this image to the
 Clipboard. This is the same as lifting.

4 Select the five images of the balancing ballet acrobats that need to be
 keyworded:

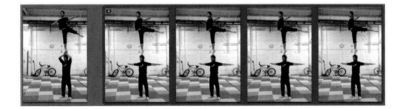

5 Press Command-Shift-V to paste the copied metadata onto these images.
 You may have already recognized that these keyboard shortcuts are intu-
 itive variations of the normal copy and paste shortcuts.

6 Check the Keyword summary area of the Metadata Inspector to make
 sure that the keywords were copied correctly. If only the primary selection
 received the keyword, then you need to toggle off the Primary Only option
 by pressing S, and then pasting again.

Project Task

You've learned so many ways now of applying keywords that we'll allow you some creativity in how you apply them.

Work your way through the rest of the images in the project, applying keywords using any or all the techniques you've learned. Try to follow the keyword organization that we've established (for example, don't tag performance images with rehearsal keywords). Later in this lesson, we'll be using these keywords to generate albums and webpages.

Editing Metadata in Batches

As long as we're editing the keywords of our images, there are some other metadata changes that we can make now that will make future searching and organizing a little easier.

When we imported these images, we had Aperture rename them from their original camera-generated filenames to *Pickle Circus* with a sequential number. However, because we have big plans to develop a long-term relationship with this client, we'd like the images to have a more descriptive name, so we'd like to rename the images *Pickle Circus 2005*. After the images are imported, you can use the Batch Change command to rename the images and edit other metadata.

1 Choose Edit > Select All or press Command-A to select all images in the project in the Browser.

2 Choose Metadata > Batch Change, or press Command-Shift-B.

3 Choose Version Name Format > Custom Name with Index.

4 In the Custom Name field, type *Pickle Circus 2005*.

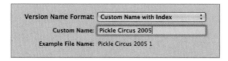

The Example File Name field shows what your final filenames will look like. Aperture is going to rename your files using the words *Pickle Circus 2005* with a sequential counter as a suffix.

The Batch Change dialog also lets you change the keywords (or any other metadata) of an image. Note that by choosing *Append* or *Replace* when changing metadata, you can choose to replace your current metadata or simply append it with any new values that you enter.

Let's make a metadata change in addition to our renaming.

5 Choose IPTC – Expanded from the Add Metadata From pop-up menu.

6 In the Category field, type *Event*.

7 Click OK.

Aperture will take a few moments to rename your files. Let's take a look at our new metadata.

8 At the top of the Metadata Inspector, change Metadata View to IPTC – Expanded.

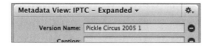

In the Category field, you should now see *Event*.

Now that we've applied all of our keywords exactly as we want, we can use them to filter images in the Browser and to search for images using the Query HUD. Before we do that, however, let's go back to our stacks and choose picks.

Choosing Image "Picks"

Earlier we spent a lot of time organizing our images into carefully arranged stacks, and now it's time to explore the payoff for all of that work. In this section you'll learn how to use Aperture's comparison features to make quick work of selecting the pick and alternate images from each stack.

Remember, one of the goals of stacking images is to ultimately choose the best image (or pick) from each burst or sequence. These will be the images you'll take to the next stage of your workflow, be it editing, client approval, or final output.

1 Press Command-Shift-A (or choose Edit > Deselect All). Then select the first image in the Browser and then press Command-Option-S to switch to the Basic layout. Choose Stack from the Viewer Mode pop-up menu, or press Option-T.

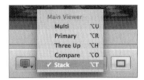

In Stack Viewer mode, Aperture shows you the current pick on the left, bordered by an orange rectangle, and the second image in the stack on the right.

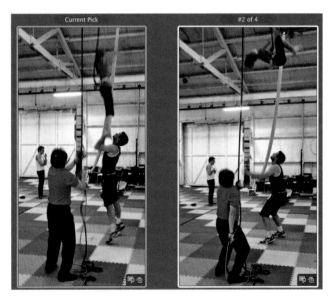

2 Press the right arrow key. The right-hand image changes, but the pick image remains this same. With this mechanism, we can easily compare other images in the stack to the pick.

3 Press the left arrow key to go back to the second image.

Β Β Β Β The second image in the stack is a better shot than the current pick, so we want to make it the pick.

4 Press Command-\. Image number 2 becomes the new pick, the old pick falls to second place, and Aperture automatically selects the third image.

Β Β Β Β Come to think of it, the third image is even better.

5 Press Command-\ to make the third (selected) image the pick.

Β Β Β Β Your images should now be in the following order:

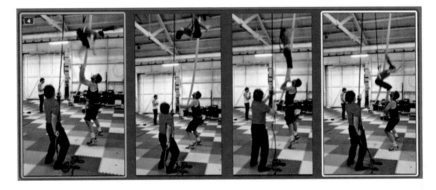

6 Press the down arrow key. Aperture closes the stack you were just viewing and opens the next stack in the Viewer for you to evaluate.

As you can see, Stack mode is designed to let you quickly navigate the individual images of a stack to make comparisons and select picks. It also makes it simple to jump from stack to stack as you finish your comparisons.

Promoting and Demoting Alternates

In addition to selecting a pick from each stack, you might also want to order the remaining images so that the best alternates appear in descending order, left to right, from the pick. This makes it much easier to find a high-quality alternate image later if you need one.

1 Find the stack of images of the juggling bicyclist. (One way to do this is to simply press the down arrow repeatedly until you arrive at the stack.)

2 Select the first image in the stack. You should still be in Stack Viewer mode, so the stack pick should appear next to the first alternate image.

3 The second image is better than the current pick, so press Command-\ to make it the new pick. Aperture will select the third image for comparison.

The third image is not as good as the pick, but it's better than the second image, so let's promote it to the second position.

4 Choose Stacks > Promote or press Command-[to move the third image into second place.

As you move through stacks selecting picks, you can promote alternate images in this way, and demote them by choosing Stacks > Demote or pressing Command-]. By promoting and demoting alternate images, you ensure that the images in your stacks are in descending order of quality, from best on the left to worst on the right.

5 Press Option-U to return to Multi Viewer mode.

> **NOTE ▶** You can use the Promote and Demote commands in any view mode, and you can also use the Pick and Promote/Demote buttons at the top of Aperture's main window.

Using Compare Mode

Aperture provides one other Viewer mode, Compare, which is useful for comparing images in a stack and choosing picks and alternates.

1 Select the following image:

If the image's stack is not open, open it now by pressing Command-'.

2 Press Return. Aperture enters Compare mode, which has some similarities to the Stack mode you were just working in. In Compare mode, the selected image appears on the left, and the arrow keys let you cycle through images for comparison on the right.

3 Select the third image in the stack, and press Command-\ to make it the new pick.

In Compare mode, as opposed to Stack mode, the leftmost image doesn't always show the pick. Instead, it shows whatever image you originally selected for comparison.

4 Press the right arrow key to select the third image for comparison.

5 Press Option–left arrow. In Compare mode, you can use Option with the arrow keys to change the compare image, and the unmodified arrow keys to change the other image.

6 Command-click the left image to exit Compare mode.

As in Stack mode, you can use the Promote and Demote commands to change the ranking of the images on the right. Compare mode differs from Stack mode in that you can compare images from different stacks, or images that are not stacked at all.

Project Task

Work your way through the rest of the stacks and select picks as desired. Keep in mind that you can zoom in to images or use the Loupe tool at any time for a closer look at image quality.

Applying Ratings to Images

In Lesson 3, you learned how to apply five-star ratings to define images as "selects." Aperture offers many other ratings, however, from 0 to 5 stars. In a larger project, ratings—like keywords—are an essential organizational tool

because they can help you quickly find alternates if a client rejects your initial recommendations. Let's explore those ratings now.

1 Press Command-Option-S to switch to Basic layout. Make sure that all stacks are open (Option-') so that you can see all of your images.

You can rate as many or as few images as you want, and we will be leaving some images unrated. We know for sure that we want to rate our picks with the highest possible rating, and give alternate images a slightly lower rating. This will allow us to easily filter out our picks and quickly turn to alternate images if we need them.

2 Choose View > Metadata Overlays and be certain that Viewer is checked. This will ensure that you can see the ratings superimposed over the images in the Viewer.

3 Select the first image in the Browser. This image is a pick, so give it a five-star rating.

4 Press the 5 key to tag the image with five stars. The five stars appear in the lower left corner of the image.

5 Press the right arrow key to move to the next image. This is our second-choice alternate, so we want to give it a rating of four stars.

6 Choose Metadata > 4 Stars or press 4 to give this image a four-star rating.

7 Press the right arrow to go to the next image.

8 Choose Metadata > 3 Stars or press 3 to give this image a three-star rating.

How far to take your ratings is up to you. The more metadata you apply—including star ratings and keywords—the more information you have to search and filter your images at any time.

9 Continue to rate the rest of the images in this stack if you'd like.

Assigning a Reject Rating

In addition to assigning a rating of 1 to 5 stars, you can also assign a Reject rating. This allows you to easily filter images that you know you won't want to use. You can, of course, leave unwanted images unrated, but you can't base queries on unrated images. Consequently, there's no way to filter unrated images *out* of a selection, as you can with images with a Reject rating.

1 Navigate to and select the following image:

Because it's a little soft, this image isn't very good. We could delete it by pressing Command-Delete, but that's a little radical. We might find a use for it some day.

2 Press the 9 key to assign a Reject rating. Later, if we want, we can filter out the rejected images. The image in the Viewer now shows a Reject rating.

Changing a Rating

As you continue to rate your images, you may find that you want to go back and change your ratings. Sometimes you'll want to change a rating simply because you change your mind about a particular image. At other times, you may change your mind about your whole scale of comparison and will want to apply a relative adjustment to a range of images—downgrading all of your images, for example, because you've found a new hero image. Aperture provides simple controls for making either absolute or relative rating changes.

1 Navigate to the following stack:

2 Select the first image and give it a rating of five stars.

3 Select the second through fourth images and then press 4 to give them all a four-star rating. Because the Primary Only mode is off, the rating is applied to all three images.

4 With the images still selected, press the – key or click the red downward-pointing arrow in the control bar. Aperture removes one star from each rating.

5 Press the + key or click the upward-pointing red arrow in the control bar. Aperture increases the rating by one star.

Creating Albums from Stacked Images

When you create albums from stacks of images, it helps to understand exactly how Aperture handles the picks.

1 Switch to Basic layout, close all stacks, and then select the first three stacks in the project.

2 Select File > New From Selection > Album, or press Command-L. Aperture creates a new, untitled album that contains all of the images in the three selected stacks, not just the picks. Note that your stacks may appear different from what's shown here, depending on which images you selected as picks.

By default, the stacks in the new album are closed, and only the pick images appear in the Browser even though the album includes all of the images from all three stacks. Aperture displays only the picks because for the rest of your workflow, you'll probably only work with these pick images, but all of the images are there in case you need them.

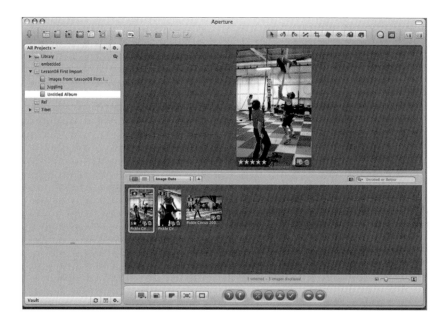

What if, however, you want different picks in the album than in the original stacks? For that, you can define album picks. Album picks can be any images in the album; they don't have to be the stack picks.

3 Select the Lesson08 First Import project in the Projects panel to see all of its image thumbnails in the Browser.

4 Open the stack shown in the following image and drag the middle image to the album that you created in step 2.

5 Select the album in the Projects panel to view its contents in the Browser.

Aperture copied the entire stack to the album, and it's showing the stack pick, not the second image that you actually dragged. But we want that image to be an album pick.

6 Open the stack and select the middle image.

7 Choose Stacks > Set Album Pick or press Command-| (vertical bar).

A small checkmark in a circle appears at the top of the image to indicate that this image is an album pick.

8 Close the stack. The album pick appears on the front of the stack.

Every album you create can have a unique set of album picks, making it possible to create albums with different images at the top of each stack. Your original pick is always preserved, though.

You might use album picks, for example, to create one album that shows all of your pick images, and a second album that shows all of your first alternates.

Searching and Filtering Images

Stacking, rating, keywording—all of that organizing takes time, as you've seen. At last, however, you get to experience the payoff. We're going to use Aperture's Browser Search field and Query HUD to see how you can quickly search and filter images based on the metadata and rating information that we've applied to the images in our Lesson08 First Import project.

1 Press Command-Option-B to switch to the Maximize Browser layout. Then select the Lesson08 First Import project.

2 Click in the Browser and press Command-A to select all of the images in the project.

3 Close all stacks by pressing Command-;. When you use the Browser search feature, Aperture searches only pick images, so there's no need to show the contents of your stacks. Don't worry, you can use different means for searching images within a stack.

The Browser Search field pop-up menu allows you to quickly search for images by their star rating. You specify the rating criteria, and the Browser will show only those images. Let's begin by filtering the images to display only those with five-star ratings.

1 In the Browser, click the Search field and choose the five-star rating from the pop-up menu.

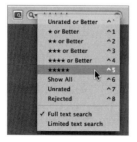

The Browser filters the images to display only those with a five-star rating.

Filtering Images Using the Query HUD

The Query HUD, as you may recall from Lesson 3, allows you to specify any number of search criteria—rating, keywords, and more. Now, let's open the Query HUD and winnow out a subset of these five-star images by selecting ones tagged with certain keywords.

1 Open the Query HUD by clicking the Search Query button (next to the Search field) at the top of the Browser.

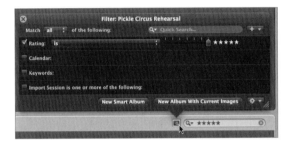

Notice that the Rating box is checked. That's because you already filtered the images by their five-star rating. Let's filter now by keyword.

2 Select the Keywords checkbox.

Aperture displays all of the keywords that are attached to the currently selected images. Let's tell Aperture that we want to see only our rehearsal images.

3 Select the Rehearsal checkbox.

Only Pickle Circus images tagged with the *Rehearsal* keyword (and five stars) appear in the Browser.

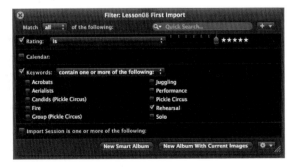

4 Select the Acrobats checkbox.

The five-star performance shots of acrobats appear in the Browser alongside the rehearsal images.

5 Change the Keywords pop-up menu to "contain all of the following."

The Browser shows only those images that are tagged with all of the checked keywords.

6 Deselect the Acrobats checkbox.

The Browser displays your five-star rehearsal images.

7 Change the Match pop-up menu from "all" to "any" of the following.

All of your five-star images will appear, regardless of their keywords. You've told Aperture that if an image matches any of your chosen criteria, it should be displayed.

Using various combinations of "any" and "all" criteria, you can conduct powerful searches of images in Aperture.

Searching by Additional Criteria

As you've seen, Aperture supports a tremendous number of metadata tags, ranging from the EXIF metadata generated by your camera to star ratings to IPTC metadata. All of these metadata tags are searchable using the Query HUD, even though you can't see all of these criteria in the Query HUD at the moment. You have to add them using the Add Filter pop-up menu.

1 Choose Match > "all of the following" in the Query HUD and set the Keywords pop-up to "contain all of the following."

2 Make sure the Acrobats checkbox is deselected. (You may get different results if you did not apply ratings to all photos.)

3 Click the Add Filter pop-up menu (the button with the plus sign in the upper right corner of the HUD), and choose EXIF. EXIF filter options appear at the bottom of the Query HUD.

Digital cameras automatically embed EXIF information in images that they capture. EXIF information includes camera settings such as shutter speed, ISO, focal length, and exposure. Let's use the Query HUD to search for images with different ISOs.

4 Choose ISO Speed Rating from the first ISO pop-up menu at the bottom of the Query HUD. Set the second pop-up menu to "is," and then enter *400* in the text field, and press Return. One image appears in the Browser—this is the only five-star image that we shot at ISO 400.

5 Enter *800* in the EXIF text field. Eight images appear in the Browser. Because Rehearsal is still checked and the Rating is set at five stars, however, the Browser only displays the five-star rehearsal images that were shot at ISO 800.

6 Enter *1600* in the EXIF text field. The Browser now displays five images.

7 Close the Query HUD. Even when the Query HUD is closed, your images are still filtered according to the Query HUD's search criteria. The text field next to the Query HUD button indicates that the current image selection has been filtered.

In this case, the three icons indicate that rating, keywords, and EXIF data are all being searched. To clear the filtering and view all images, click the X button in the right side of the Query HUD field.

We could continue, but you get the idea. A common use of the Query HUD is to find images that you need to edit, so often you'll just use it to find five-star images.

It's important to note that the Query HUD is not global: It filters only the currently selected item in the Projects panel. Each project in Aperture has its own filter settings, so you can sort one project one way, and then go to another and

define completely different filters. When you return to the first project, you'll find your Query HUD settings just as you left them.

Aperture's Query HUD is a powerful tool for sifting through your images. The ability to search on any combination of multiple criteria can help you quickly find the images you need. However, good searching depends on having good metadata assigned to your images. If you take the extra time to apply IPTC data, ratings, and keywords, you'll be able to quickly find images shot on specific dates, by specific photographers, of particular events. As your Library grows, this functionality will become increasingly valuable.

To help you with your IPTC keywords, Aperture can even find images that *lack* IPTC metadata. For example, you can search for images that *don't* have a copyright. In the Query HUD, add an IPTC criterion, and then configure it as follows:

The ability to search for empty fields makes it simple to find images that need additional rating and tagging.

Congratulations. You can now consider yourself a pro at stacking, rating, keywording and doing all other tasks related to organizing images in Aperture. It's a lot to digest, but once you do, you'll savor the robust and powerful control that Aperture provides you over your image Library.

Metadata Templates

You've seen how powerful metadata can be. With it, you can search, filter, and sort your Library to find specific images. You've also probably come to see that applying metadata can be time-consuming. Fortunately, if you find yourself regularly applying the same metadata—such as your name and copyright— then Aperture has one other feature that might be very useful.

1 Select any image in the Pickle Circus project.

2 If the Metadata Inspector is not visible, press Control-D.

3 From the Action pop-up menu in the upper right corner of the Metadata
Inspector, choose "Save as Preset."

Aperture will prompt you for a name. Enter any descriptive title and click
OK. Now, any time you want to apply that same metadata to an image or
group of images, just select the images and choose either "Append with
Preset" or "Replace with Preset" from the Metadata Inspector Action menu.

Over time, you can build a collection of metadata templates that you can
quickly apply.

Lesson Review

1. In a stack, what is the difference between the pick, the current selection,
and the primary selection?

2. How does the Primary Only button affect keywording and rating?

3. What is the Keywords HUD and when do you use it?

4. Aperture offers a multitude of ways to apply keywords to images. Name four.

Answers

1. The *pick* is the first image in the stack, the one that you have selected as
the best image in the stack. The *current selection* is the single image or
group of images that you have selected. The *primary selection* is the single
image within a current selection that you have chosen to work on. If a sin-
gle image is selected, it is also the primary selection.

2. When the Primary Only button is on, only the primary selection will
receive a keyword or rating. When it is off, all of the images in the selec-
tion will receive the keyword or rating.

3. The Keywords HUD lets you define keywords to apply to your images. The
Keywords HUD can also be used to apply keywords to the current selection.

4. You can apply keywords by dragging them from the Keywords HUD;
by entering keywords manually into the Keyword summary area of the
Metadata Inspector; by using the keyword buttons in the control bar; by
using keyboard shortcuts; by copying and pasting keywords from one image
to another; and by lifting and stamping keywords from one image to another.

Keyboard Shortcuts

Command-K	Create a stack from selected images
Option-K	Split a stack
Option-Shift-K	Extract an image from a stack
Command-Delete	Delete a version
Shift-H	Open the Keywords HUD
. (period)	Open the next keyword preset group in the control bar
, (comma)	Open the previous keyword preset group in the control bar
Command-Shift-C	Copy metadata to the Clipboard (lift metadata)
Command-Shift-V	Paste metadata to selected image(s) (stamp metadata)
Command-Shift-B	Open the Batch Change dialog
Option-T	Switch to the Stack Viewer mode
Option-U	Switch to Multi Viewer mode
Option-O	Switch to Compare Viewer mode
Command-[Promote an image in the stacking order
Command-]	Demote an image in the stacking order
Option–right arrow	Set comparison image
Command-4	Apply a four-star rating to an image
Command-3	Apply a three-star rating to an image
+	Increase rating by one star
–	Decrease rating by one star
Command-Shift-	Set an album pick

9

Lesson Files	APTS_Aperture_book_files > Lessons > Lesson09
Media	Lesson 09 Images
Time	This lesson takes approximately 2 hours to complete.
Goals	Adjust the white balance in RAW and non-RAW files
	Extend adjustment effects beyond slider values
	Change the metadata overlay
	Apply a Highlights & Shadows adjustment
	Use the Highlights & Shadows controls as a fill flash
	Sharpen an image and reduce noise
	Use the Exposure slider to recover lost detail in an image
	Apply adjustments using an external image-editing program
	Delete image versions

Advanced Editing

Shooting is often only half the battle of getting a good image. No matter how skilled a photographer you are, the editing phase is what frequently makes the difference between a usable and an unusable image. Sometimes you'll use your editing tools to correct problems, but your editing and adjusting tools are also the key to fine-tuning your image. With them, you'll turn the raw shot into the finished image that you saw in your mind's eye when you captured it.

In Lessons 4 and 7 you took a look at Aperture's editing tools and so should be comfortable using exposure and tint, levels, and other basic correction features. In this lesson we're going to go a little deeper and explore the rest of Aperture's editing options as well as spend some time discussing why you should choose one tool rather than another.

Preparing the Project

Up to this point, you've been importing images into projects that you've created within Aperture. However, Aperture also lets you import and export entire projects, making it simple to pass projects to your colleagues.

When you export a project, you're exporting not just the images but also all the metadata, adjustments, albums, websites and other information you've attached to those images inside Aperture. To start off this lesson, we'll import a project from the APTS DVD files.

1 Choose File > Import > Projects, navigate to the APTS_Aperture_book_files > Lessons > Lesson09 folder, and import the project **Lesson 09 Images**.

For the exercises in this lesson, we will be referencing many of the images in this project by their version name. Therefore, you'll want to be sure your Browser is configured to show version names.

2 Choose View > View Options or press Command-J to open the View Options window.

3 Make sure the Grid View checkbox is selected, and then select the Set 2 radio button to activate the Set 2 option.

4 Choose Grid View – Expanded from the Set 2 pop-up menu. This will display the version name beneath each image.

5 Click Done to close the View Options window.

Adjusting White Balance

Light has inherent color qualities. These qualities are measured using a temperature scale. When you change the white-balance setting in your camera, you're simply letting your camera know a little more about the color of the light under which you are shooting. The information is used by your camera to calibrate its color calculations so that they will be more accurate.

When you open a RAW file in Aperture, the first thing the application does is calculate the color of every pixel in your image. It uses the temperature and tint settings that you (or your camera) specified as image metadata to calibrate its settings for the color of the light you were shooting under. When you change these settings, you're doing nothing more than changing the calibration reference that Aperture uses for its calculations.

In Chapter 7, you adjusted tone and contrast using the Exposure and Levels adjustments, and you neutralized color casts using the tint controls. Now you're going to work with the White Balance adjustment, one of the most powerful color correction tools in Aperture. The White Balance adjustment appears in the lower portion of your Adjustments Inspector by default.

The idea behind white balance correction is that because white light contains all the other colors, if you properly represent white in your image, you'll get every other color correct.

The White Balance adjustment in Aperture has two slider controls, Temp and Tint. The Temp slider adjusts color in your image from blue to yellow (left to right). The Tint slider adjusts your image from green to magenta (left to right). Most of your white balance correction is done with the Temp slider; you typically use the Tint slider sparingly to correct any green or magenta casts that the Temp slider has introduced.

We'll start by correcting a JPEG image that was shot with an incorrect white balance setting on the camera. Since you weren't at the scene, we've provided a RAW file with the correct white balance to use as a color reference.

1 With the Lesson 09 Images item selected in the Projects panel, press Command-Option-S to switch to Basic layout. Then, press Control-A to open the Adjustments Inspector.

2 In the Browser, select the image **dafnis for bad wb jpeg**. If you can't read the image title, adjust the thumbnail size until you can. As you can see, this image has a white-balance problem. We'll try to correct it using the White Balance controls.

3 Still in the Browser, Command-click the image **dafnis for bad wb raw**. This is a copy of the same image, but one that was shot with the correct white balance. We'll use it as a reference for our correction efforts.

4 In the Viewer, click the image **dafnis for bad wb jpeg** to make it the primary selection.

The image is plainly too blue, so we'll use the Temp slider to skew the image's color toward yellow.

5 In the White Balance controls in the Adjustments Inspector, drag the Temp slider to the right to about 9185. This helps the image a lot, but it's getting a little too green.

6 Move the Tint slider to the right until the Tint value field says 10. This removes some of the pink from the image, but the color is still not quite the same as in our correct image.

7 Play with the sliders some more and see how close you can get the image to the correct white balance. You'll find that it's difficult to get it there. What's more, as you get more accurate skin tones, you'll be adding a color cast to the white of the clouds and altering the blue hue of the sky.

8 Now select the RAW file, and experiment with the Temp and Tint sliders to get a feel for how the white balance adjustment works on a RAW file. You will find that you can get more accurate color throughout the entire color range of the image.

In a non-RAW file, the color of every pixel is already set. The white-balance calculation was made by your camera when you took the shot, and can no longer be altered. In Aperture, therefore, when you adjust the Temp or Tint sliders while editing a non-RAW file, the application has to work with existing color information and adjust existing pixel colors.

Simply put: the White Balance controls are not nearly as effective on a non-RAW file as they are on a RAW file.

Let's take another look at how white-balance adjustments differ between RAW and non-RAW images.

9 In the Browser, click to select the **boat jpeg** image, and then Command-click to also select the **boat raw** image.

Two versions of the same image appear. The image on the left is a JPEG copy of the RAW file that's shown on the right.

10 In the Viewer, click the left-hand image (the JPEG file) to make it the primary selection.

11 In the White Balance controls, drag the Temp slider all the way to the left, until the temperature value reads 2500 K.

12 Now click to make the right-hand image (the RAW file) the primary selection and set its temperature value to 2500 K.

While both images now have a strong blue cast, you should see that the colors are still quite different. In the JPEG image, the blue cast doesn't go through all of the different color ranges as thoroughly as it does in the RAW file. In the JPEG image, the red on the bottom of the boat is much redder than in the RAW file. The same is true of the greens in the background.

What you've seen from these exercises is that the white-balance adjustment packs a lot more power when you're working with RAW files. If you're shooting RAW, then, you should be sure to make all of your white-balance adjustments in RAW format *before* you save to any other formats. When working with JPEGs, you may need to rely more on the Tint wheels than on the White Balance controls for your color corrections.

Adjusting White-Balance Temperature Extremes

Before we move on from these boat images, we're going to take a look at one more characteristic of the Adjustments Inspector controls.

In the last exercise, you dragged the Temp slider all the way to the left, to a value of 2500 K. If you're experienced with lighting, you may have been surprised to

find that Aperture didn't let you move the slider any lower than 2500 K. Don't worry, Aperture actually provides a much broader range of temperature options than what you've seen so far.

1 With the **boat raw** image still as the primary selection, drag the Temp slider all the way to the right. The Temp value field should read 10000 K. This might seem a little conservative since there are lights that can increase color temperatures to values as high as 50,000 K.

In Aperture, the default maximum and minimum values offered in the Adjustments HUD controls reflect the "sweet spot" range that you're most likely to use. In the case of color temperature, adjustments that require values of less than 2500 or greater than 10,000 are pretty rare, so Aperture limits the slider values to a smaller range to give the slider a finer level of control. However, you can easily move beyond these ranges.

2 Hold the cursor over the Temp value field. You should see the cursor change to an I-beam with two small arrows on either side.

3 Click inside the Temp value field and drag to the right. As long as you drag, the value will continue to rise until it finally reaches a value of 50,000 K.

Similarly, you can drag the Temp value to the left to decrease the temperature to values below 2500.

TIP▶ All of Aperture's value fields work this way. Each value field can extend beyond the default sweet-spot range. You can also double-click the value and type a specific number in the value field, or you can click the left or right arrow or drag inside the value field to set a value. When using the value sliders, you can use a modifier key (Shift, Option, Control) to make value adjustments in normal, small, or large increments.

4 Click the Reset arrow above the Temp value field to return the Temp slider
 to its default value.

Each adjustment control has a Reset button for easily returning to the
default value.

Most likely, you'll rarely need the additional range that Aperture's adjustment
controls allow. However, if you shoot in extreme situations—in very low light,
or mixed lighting situations, for example—then adjusting the values beyond
the slider values could become a part of your correction workflow.

Using Metadata Views

In earlier lessons, you learned how to switch between two metadata views in
both the Viewer and Browser. You can also use the View Options window to
choose which metadata view you would like to have displayed, as we did earlier
in this lesson.

But what if none of the standard metadata views displays the exact metadata
you'd like to see? Fortunately, Aperture lets you define your own custom meta-
data view. What's more, once you create a view you can access it from any
metadata list.

One common use of the metadata view is to check an image's file format.
(This is important while editing an image, for example, because you use
Aperture's White Balance and Exposure controls differently to correct a RAW
file than a non-RAW file.)

When working with projects that contain images with different file formats,
you'll want to be able to quickly determine the original filename and format
of each image. Of course you can always check the Metadata Inspector to find
that information, but there's an easier way.

Creating a Metadata View

In this exercise, you'll create a custom metadata view that displays the original filename and format along with your thumbnails.

> **TIP** ▶ Metadata views are global within Aperture—they're not attached to any particular project, so you can create them at any time regardless of what you're currently working on.

1 Open the Metadata Inspector by pressing Control-D. If you'd like to have more room for the Metadata Inspector, you can close the Adjustments Inspector by pressing Control-A.

2 In the Metadata Inspector, choose New View from the Metadata Action pop-up menu.

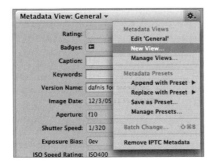

3 You will be prompted to enter a name for the new metadata view. Type *Version and Filename* as the name of your new view, and press OK.

The new view will automatically be selected and will be shown in the Metadata Inspector. Because it doesn't yet have any metadata tags in it, the pane will appear empty.

To add metadata tags, simply open a metadata category from the various categories at the bottom of the Metadata Inspector. Click to select the checkboxes next to each tag you want to include. The metadata tags we're interested in are in the Other category.

4 Click the Other button at the bottom of the window and then click to
select the File Name checkbox and add a filename tag to the current set.

5 Click to select the Version Name checkbox to add it as well. You may need
to scroll down the list to find it.

6 Click the Other button to close the Other metadata category.

Our new metadata view is now defined. Notice that so far, it does not
appear in either the Viewer or the Browser. We've simply defined the new
view; we haven't told Aperture to use it anywhere. Let's do that next.

Selecting a Metadata View

We'll modify the View Options to define where our new Version and File-
name metadata view will appear.

1 Press Command-Option-S to return to the Basic layout.

2 Press Command-J to open the View Options window.

The View Options window lets you select which metadata views are displayed in the Viewer, the Browser, and elsewhere in the interface. As you've seen, you can select two different metadata views for the Viewer and the Browser, and switch between them using keyboard shortcuts. Let's configure the Grid View Set 1 so that it displays our new Version and Filename metadata view.

3 Make sure that the Grid View checkbox is selected. This will make the Browser Grid View active, so we can see the effects of our changes as we make them.

4 In the Grid View area, click the radio button next to Set 1.

5 Choose Set 1 > Version and Filename.

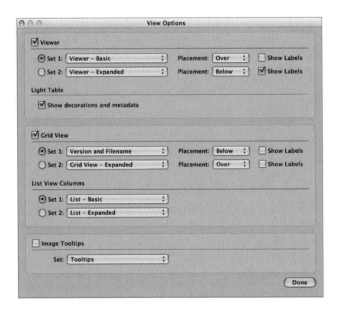

Both the file and version names should now appear below your image thumbnails in the Browser.

6 Click Done to close the View Options window.

TIP ▶ You can attach your new view to either Set 1 or Set 2. We recommend that you leave the Grid View – Expanded set as the default for Set 2, because it provides a lot of valuable information that you'll find useful to access while editing.

From the Metadata View Action pop-up menu, you can also edit an existing view. Choose Manage Presets. A dialog appears that lets you edit the order of the metadata views in the View Options window.

Notice that the menu also includes a Remove IPTC Metadata command, which lets you strip out all IPTC keywords, giving you a clean slate for tagging.

Adjusting Highlights and Shadows

Compared to your camera, the human eye can perceive a substantially larger range of brightness, from near-darkness to the brightest light. While your eye can see a range of roughly 18 to 20 stops of light, even the most sophisticated digital (or film) camera can only capture about eight to ten stops of light.

NOTE ▶ In photography, each doubling of available light is measured as a single stop.

Because your camera sees a narrower range of brightness levels than your eyes do, you usually have to choose between trying to capture detail in the shadows or the highlights of your image.

Adjusting Overall Contrast

You've already seen how you can use the Exposure, Brightness, and Levels controls to change the brightness of different parts of your image. Aperture includes another tool, Highlights & Shadows, that makes short work of extremely difficult brightness adjustments. We'll start by adjusting the overall

contrast of an image, and then use a Highlights & Shadows adjustment to achieve better results.

1 Make sure the Lesson 09 Images item is selected in the Projects panel, and switch to the Maximize Browser layout by pressing Command-Option-B. Locate the image **Shadows & Highlights1**.

2 Double-click the image in the Browser. Double-clicking an image in the Browser view will always take you to the Basic layout, so you can immediately see a larger view.

This image has a fairly broad range of brightness from the shadow on the lower part of the building to the gray in the middle.

3 Press F to switch to Full Screen mode, and then press H to open the Adjustments HUD.

Before performing any adjustments, let's crop the image. It's always a good idea to crop before adjusting the shadows and highlights of your image. If you crop first, then your histogram will only show the tonal ranges that are within the cropped area.

4 Press C to select the Crop tool, and then crop the image as shown in the following figure.

Because of the broad tonal range in this scene, the image is a little *too* contrasty. We want to reduce the difference between the highlights and shadows. To reduce contrast, the most obvious thing to try first is the Contrast slider.

5 In the Exposure controls, drag the Contrast slider to the left until the contrast value field reads roughly –0.2.

The image has less contrast now, which the histogram confirms. But because there's no true black in the image, it now looks washed out and generally gray. This is not the result we want, so let's fix that now.

6 Press Command-Z to undo the Contrast adjustment.

Adjusting Shadows and Highlights

Using the Contrast slider to reduce the contrast in this image is not going to give us the result we're looking for. Instead, we're going to use a Highlights & Shadows adjustment.

1 If the Adjustments HUD doesn't already contain a Highlights & Shadows adjustment, add one by selecting Highlights & Shadows from the pop-up menu, or press Control-H. You may have to scroll down the Adjustments HUD to see the Highlights & Shadows control. If you want, you can resize the Adjustments HUD to make Highlights & Shadows visible.

The Highlights & Shadows controls are very simple. If you drag the Highlights slider to the right, the bright areas of your image will get darker. If you drag the Shadows slider to the right, the dark areas of your image will get brighter.

Because a bigger part of this image is highlighted, let's begin by darkening the highlights.

2 In the Highlights & Shadows controls, drag the Highlights adjustment slider to the right until the value field reads approximately 30.

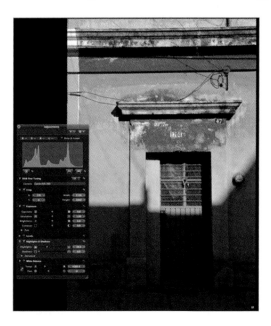

Notice that the bright parts of the image darken. Although you can set this control to your own taste it's probably best to keep it around 30. If you go much further than that, the image gets a little dull.

3 Drag the Shadows slider to the right until the value field reads about 10.

The image already looks much better, with more equal tones, but without an overall loss of contrast.

The Highlights & Shadows controls do more than simply brighten or darken the specified range of tones in an image. When you adjust either control, Aperture analyzes your image to more intelligently decide which tones should be adjusted and by how much. For each pixel it analyzes, the Highlights & Shadows control considers the tones of adjacent pixels to calculate how much that one pixel should be brightened or darkened.

Now, let's fine-tune our adjustments.

4 Click the left arrow next to the Highlights value field to decrease the value to 26.

5 Press M to view your original master image. As you may recall, pressing M toggles between your current edited version and your original master image, which provides a simple way to quickly see the effects of your edit.

6 Press M again to return to your edited version.

Let's add a final bit of punch to the image.

7 Drag the Saturation slider to the right to about 1.25.

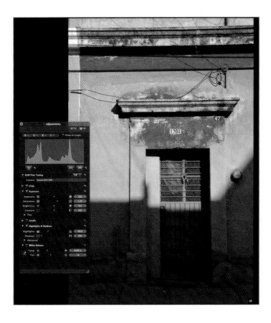

Using the Highlights & Shadows Controls as a Fill Flash

While the Highlights control is useful, you'll probably find that you mostly use it for brightening up dark shadows. As you play with this adjustment, you'll find that you can dramatically brighten areas that were almost completely dark. But the Highlights & Shadows controls can also be used for more every-day tasks, such as simulating a fill flash.

1 Press F to exit Full Screen mode, select the image **Dafnis Prieto** in the Browser, and then press F to switch back to Full Screen mode.

> **TIP** You can also use the filmstrip to select images in Full Screen mode.

The shadow on the left side of this man's face is too dark. This is because the camera was set to meter for the bright, right side of his face as well as the sky, leaving the shadows a little dark. Using a fill flash while shooting would have solved the problem, but we can easily correct it now using the Shadows slider.

2 In the Adjustments HUD, click the Add Adjustments button and choose Highlights & Shadows from the pop-up menu. (If the Adjustments HUD is already showing a Highlights & Shadows adjustment, you can skip this step.)

3 Drag the Shadows slider to 25.

The shadow on the man's face brightens significantly. The shadow on the subject's sweater should also brighten a little. Overall, though, the contrast and dark tones—such as those in the man's hair—remain the same.

The Highlights & Shadows controls can solve innumerable contrast and shadow problems, but they are extremely processor-intensive. You'll get better performance if you perform all of your other adjustments before applying Highlights & Shadows.

Adjusting Color

In addition to adjusting white balance and contrast, Aperture lets you adjust the hue, saturation, and brightness of specific color ranges. Using the Color controls, we'll make some changes to the **Shadows & Highlights 1** image that we worked on earlier.

1 Press Command-Option-S to switch to the Basic layout, and open the Adjustments Inspector by pressing Control-A.

2 If the Adjustments Inspector doesn't already have a Color controls group, add one by choosing Color from the Add Adjustments pop-up menu, or press Control-C.

3 Select the **Shadows & Highlights 1** image and press F to display Full Screen mode.

The Color controls group lets you pick a specific color—red, yellow, green, cyan, blue, or magenta—and then adjust the hue, saturation, and luminance of the colors in your image that fall into that range.

Notice that when we increased the saturation in this image, the bright tones at the top of the picture improved. The shadow tones, though, still look a little flat. We'll use the Color controls to give them some of the punch that the bright colors at the top of the image have.

4 Click the blue swatch at the top of the Color controls group (the second swatch from the right). This tells Aperture that you want to adjust only the blue tones in the image.

We picked blue because the shadow tones at the bottom of the image have a strong blue cast. Sunlight casts blue shadows, so we should be in good shape adjusting the blue values.

5 Drag the Luminance slider to the right until it reads about 40. The brighter blue tones in the shadow areas should get a little brighter and more saturated. They're a little too cold now, so let's try to warm them up by applying a slight hue shift.

6 Drag the Hue slider to the right to approximately 10. The shadows should get a little warmer, striking more of a neutral tone.

7 Deselect the Color checkbox to see the image before the Color adjustment is made. This particular edit is subtle, but effective.

You can also use the Range slider to expand the range of blues that are affected by the controls. In this particular image, you won't see a huge change.

The Color controls group is a simple but powerful tool that you will probably use very frequently. With a little practice, you'll quickly learn how to identify and isolate the particular color swatch and range that you need to select to make your adjustments.

Converting Color Images to Grayscale

As you've seen, Aperture has lots of tools for correcting and adjusting color, but it also has some special adjustments for converting color images to grayscale.

1 Press F to exit Full Screen mode and select the image **Tea Time** in the Browser.

2 Press Option-V to create a new version of the image. The stack will open, and you'll see a monochrome version of the image. You'll create another just like it now.

3 Press H to open the Adjustments HUD, if necessary.

4 In the Adjustments HUD, open the Add Adjustments pop-up menu and choose Monochrome Mixer, or press Control-M.

5 Click the disclosure triangle next to Monochrome Mixer to open the controls group.

By default, the Monochrome Mixer is set to a preset monochrome conversion recipe. The Red, Green, and Blue sliders let you control how much of each individual color channel is used to create a single grayscale channel.

6 In the Monochrome Mixer controls group, choose Monochrome with Orange Filter from the Preset pop-up menu.

This is one of a number of presets designed to mimic the traditional filtering operations that black-and-white film photographers have relied on since the inception of photography.

7 Drag the Red slider to the right.

Aperture automatically changes the preset to Monochrome with Custom Filter, and you can begin to define your own monochrome mix. There's no right or wrong to the mixing process. As you adjust each slider, you'll brighten or darken different details in your image.

TIP ▶ It's best to not let the sum total of the three sliders exceed 100 percent, as this will likely result in overexposure. Similarly, a total value that is less than 100 percent will yield a darkening of your image.

Applying a Color Monochrome Adjustment

Aperture also has a Color Monochrome adjustment, which lets you create monotone effects and adjust their color and intensity. Let's apply a Color Monochrome adjustment to the Tea Time image.

1 Make sure the original **Tea Time** image is selected in the Browser.

2 Press Option-V to create another version of the image.

In the Browser, you should now see four versions of the **Tea Time** image: The original image, the two monochrome versions, and a third version that you will adjust now.

3 With Version 3 of the **Tea Time** image selected in the Browser, open the Add Adjustments pop-up menu in the Adjustments HUD and choose Color Monochrome.

4 Click in the Color swatch in the Color Monochrome controls to choose a color.

5 Select a color in the color wheel and then close the Colors window.

6 Drag the Color Monochrome Intensity slider to the right or left to change
the degree of the effect.

The color you defined will be used as a wash over your entire image. The
Intensity slider controls how much of the image's original color will remain.

Sometimes, the best way to deal with serious color problems is to eliminate the color altogether through a monochrome conversion. The Color Mixer and Color Monochrome controls provide a simple way to do this effectively.

Sharpening and Noise Reduction

All digital cameras soften their images as part of their internal processing when they calculate color values. Fortunately, this softening is nothing that can't be corrected with some simple postproduction sharpening. All cameras are able to perform this sharpening internally, and most offer controls for specifying how much sharpening to apply.

If you shoot RAW images, however, no sharpening will be applied to your image by the camera. What's more, even after your camera applies sharpening to non-RAW images, you might still need to add more if your camera's sharpening settings are not very aggressive. Many JPEG photographers deactivate their camera's in-camera sharpening (or set it as low as possible) so that they can take more control of the sharpening in postproduction.

Many cameras also produce noise, especially if you're shooting at high ISO settings.

Aperture provides sharpening and noise-reduction filters for handling both of these problems. In this exercise, we'll take a look at how to use these tools effectively.

Applying Sharpening

One of the risks of sharpening an image is that the process of sharpening will often increase the noise in your image. At the same time, noise reduction can result in a *softening* of your image. Therefore, you'll usually want to apply sharpening and noise-reduction adjustments at the same time, to try to achieve a balance between the two effects.

Sharpening in Aperture is very simple.

1 Select the image **Sharpening Fodder** in the Browser.

Like many of the other images in this shoot, this image is soft due to the shooting conditions (low light and, therefore, slow shutter speed). Fortunately, these images will most likely be printed at smaller sizes with a coarse line screen—in newspapers and on postcard mailers—so the softness won't be as visible. Nevertheless, this picture needs to be sharpened.

2 Press F to switch to Full Screen mode. Press H to open the Adjustments HUD if it's not already open.

3 Position your mouse over the woman's face and then press Z. This will zoom the image to 100 percent while keeping the zoom centered around the current pointer position, ensuring that the woman's face remains visible.

4 In the Adjustments HUD, choose Sharpen from the Add Adjustments pop-up menu. A Sharpen controls group is added to the Adjustments HUD.

Aperture's Sharpen adjustment works just like the Unsharp Mask filter that you might have in your image-editing program. It looks for areas of high contrast in your image—since a high-contrast area is usually an edge—and then it darkens the pixels along the dark side of the edge and lightens the pixels along the light side of the edge. This makes the edge look more contrasty, and therefore sharper.

The Intensity slider lets you specify how much of this lightening and darkening you want applied to an edge, while the Radius slider lets you control how thick the brightened and darkened areas will be.

Usually, you'll keep the radius fairly small and perform the bulk of your adjustments using the Intensity slider.

5 Drag the Radius slider to the right until you see some sharpening, at around 2.75. Next increase the Intensity. We found good results around 0.72.

6 Click to deselect the Sharpen checkbox to return the image to its unsharpened state. By selecting and deselecting the checkbox, you can see the improvement in sharpness.

Note that it is possible to oversharpen an image. Too much sharpening will result in too much lightening and darkening along your edges, producing an image peppered with strange tiny halos and blotchy, posterized areas.

Applying Edge Sharpening

As you just saw, Aperture's Sharpening adjustment does a good job of sharpening, but it can also get you into trouble. Sharpening sharpens *everything* in your image, including any noise or artifacts. In a low-light situation such as this circus shoot, the results can be unpleasant. There are times when you don't want everything in your image sharpened. Portraits are the most common example, because sharpening an entire portrait will often exaggerate unflattering skin textures and blemishes.

Aperture's Edge Sharpen controls group lets you apply subtle sharpening effects to only the edges in your images. A much more subtle effect than the normal Sharpen adjustment, Edge Sharpen is particularly effective when used on portraits, as you'll see in the following example.

1 In the Lesson 09 Images folder, select the image called sharpen edge.

2 Press F to enter Full Screen mode, and then press H to bring up the Adjustments HUD.

Knowing how much to sharpen is always tricky, but in a portrait your main concern is that your subjects' eyes are sharp. When you apply any sharpen filter, you should be looking at your image at 100 percent.

3 Place your cursor on one of the woman's eyes, and then press Z to zoom to 100 percent.

4 Press Control-S to add an Edge Sharpen adjustment.

Edge Sharpen searches for edges by identifying areas of sudden contrast change. Edge Sharpen provides three controls. Intensity controls the strength of the effect. The Edges control lets you control how strong a contrast change must be before Aperture considers it an edge. Falloff attenuates the sharpening effect into and out of the edges that the filter finds.

The default Intensity value of 0.81 is a good starting point, so let's work with the other controls.

1 Drag the Edges slider to the right to about 0.50.

Note that the eyelashes, eyebrows, and edges of the face and eyes are sharper. However, the adjustment has not overly sharpened the pores on the woman's face. Already the image looks better, but a slight adjustment to the Intensity slider will improve things further.

2 Slide the Intensity slider to the right to about 0.95.

Our skin texture still looks good, but the eyes have better definition. The Falloff setting is OK where it is, but you should still move it around to try to get an idea of what it does. Pay particular attention to the pores on her face as you move the slider. You'll see them get slightly sharper as you move to the right.

As a point of comparison, try a quick experiment. Deactivate the Edge Sharpen controls group by deselecting it, and then add a normal Sharpen adjustment. Set its intensity to *0.6* and its radius to around *3.1*. Note how the results are not as attractive due to the global sharpening that has been applied. The woman's skin texture has not fared as well under the more aggressive sharpening.

Saving Adjustment Presets

You may often want to apply the same adjustments to many different images. You've already seen how you can use the Lift and Stamp tools to copy adjustments from one image to another, but Aperture also lets you save presets for specific adjustments.

Every controls group has a small menu in the upper right corner that provides access to the preset-saving options. After configuring an adjustment, open the menu and choose Save Preset. Next time you use that adjustment, you'll be able to select your saved preset from the Preset menu.

Note that this preset is *only* for the specific controls group that it's attached to. You cannot save an entire set of adjustments as a preset. For that functionality, you need to use the Lift and Stamp tools.

> **TIP** ▶ Sharpen and Edge Sharpen are particularly good candidates for saved presets, as most cameras consistently produce images with the same sharpness issues. Once you find a good set of sharpness settings for your camera, those settings will probably work well for all images from that camera.

Applying Noise Reduction

It doesn't really matter whether you apply noise reduction before or after sharpening. Thanks to Aperture's nondestructive editing, you can continue to tweak these adjustments after you've applied them to get them properly balanced.

> **TIP** ▶ If your image needs a lot of noise reduction and some sharpening, you'll get the best sharpening results with the Edge Sharpen controls, as they won't sharpen the noise in your image as much as the regular Sharpen controls will.

Because of the low-light, high-ISO shooting conditions, the circus images we've been working with have a lot of noise.

1 If you're not already there, zoom to 100 percent. As with sharpening, it's best to work at 100 percent when applying noise reduction.

2 In the Adjustments HUD choose Noise Reduction from the Add Adjustments pop-up menu. A Noise Reduction controls group is added to the Adjustments HUD.

The Radius slider lets you select the size of the noise that you want to reduce.

The Edge Detail slider gives you some control over the softening of your image, by telling Aperture how much edge detail to preserve. Again, high-contrast areas are usually edges, so if you don't apply as much noise reduction to those areas, there's a good chance that your image will suffer less from softening.

There's no right or wrong to applying noise reduction. Try it for yourself:

3 Adjust the Radius and Edge Detail sliders, and see what effect you like best.

4 Now set the Radius slider to 0.72 and the Edge Detail slider to 2.75.

5 Select and deselect the Noise Reduction checkbox. You should notice a slight reduction of noise. However, the image is still very noisy overall.

Given that the image is also a little soft, you're probably better off minimizing noise reduction on this image.

NOTE ▶ Digital cameras produce two kinds of noise, luminance noise and chrominance noise. Luminance noise appears in your images as speckled patterns: from one pixel to the next, there will be a sudden change in brightness, or luminance. Chrominance noise appears as brightly colored pixels or splotches of pixels.

Sharpening and Noise Reduction for RAW Images

If you're working with RAW images, then you have an extra set of sharpening and noise-reduction controls at your disposal.

Because the **Sharpening Fodder** image is a RAW file, the Adjustments HUD shows an extra controls group called RAW Fine Tuning. These controls provide an additional set of sliders for tweaking the appearance of your RAW files.

> **NOTE** ▶ If you have selected a RAW file and you *don't* see these sliders, it may be because the selected image has been set to use the Aperture 1.0 RAW converter, rather than the Aperture 1.1 RAW converter. The pop-up menu in the upper right corner of the RAW Fine Tuning controls group indicates which converter is being used. If the RAW Fine Tuning sliders are not appearing, choose 1.1 from the pop-up menu. If you don't see the RAW Fine Tuning controls group at all, it's because you have not selected a RAW file.

Aperture will automatically detect the type of camera that was used to shoot the image and will show the camera's name in the Camera field. Apple has profiled all cameras supported by Aperture and created RAW-conversion parameters for each camera. The Settings pop-up menu defaults to Apple, indicating that the Apple-defined RAW-conversion parameters are being used.

We'll explore the Boost slider in a later exercise. For now, we're going to focus on the other Fine Tuning sliders, which handle sharpening and noise reduction.

1 Select the **Sharpen Fodder** image and press F to enter Full Screen mode. If the image is not already set for 1.1 RAW conversion, set it now by selecting 1.1 from the small pop-up menu at the upper right of the RAW Fine Tuning controls group.

As with any other sharpening tool, your goal with the Fine Tuning controls is to improve the sharpening in your image without accentuating the noise. This image has very soft edges, so we'll start with the Edges slider, which sharpens the edges in your image.

2 Drag the Edges slider to the right to about 0.75.

3 Slide the Intensity slider to about 0.72. Your image should appear noticeably sharper.

Now take note of the noise. By default, the 1.1 RAW converter has its Auto Noise Compensation and Chroma Blur options selected.

4 Deselect Auto Noise Compensation and Chroma Blur.

You should see the image get noisier in the area under her neck. Note the bright-colored speckles in the shadow under her neck, as well as grainy noise patterns. (Although you may not see the artifacts well on the printed image, you should be able to see them clearly onscreen.)

5 Select the Chroma Blur control and drag its slider to around 6.8.

Most of the colored noise patterns on the woman's neck should disappear. Chroma Blur looks for pixels that have a sudden change in color and then applies a slight blur to them to smear the color away.

6 Select the Auto Noise Compensation checkbox.

You should see a lot of bright red pixels beneath her arm disappear, and the grainy patterns in the shadow of her neck should become less obvious.

As with all sharpening and noise-reduction tools, you'll usually perform a balancing act with these sliders, as you try to sharpen your image without making the noise more visible. On some RAW images, you'll probably find that you can achieve all of the sharpening and noise reduction that you need with the Fine Tuning sliders. On others, you might need to also apply the normal sharpening and noise-reduction adjustments.

Adjusting Boost

Now let's look at another adjustment control in the RAW Fine Tuning controls group: Boost. As mentioned earlier, Aperture includes a set of camera profiles for all supported cameras. These profiles give Aperture specific details about each camera's imaging characteristics, and are used to determine what color and contrast adjustments should be automatically applied to the RAW file.

The Boost slider lets you control the degree to which this default adjustment is applied to your image.

By default, the Boost slider is set at full strength: your image appears with the full level of correction. As you drag the slider to the left, the correction is reduced.

The Boost slider is handy for times when you feel your images are a little too contrasty or a little too saturated.

1 Press F to exit Full Screen mode and select **boat raw** in the Browser.

We first need to perform an Exposure adjustment to set the highlights in the image properly.

2 In the Adjustments HUD, drag the Exposure slider to about –0.76. Watch the histogram to see when the image's highlights are no longer clipped.

3 In the RAW Fine Tuning controls group, drag the Boost slider to 0.46.

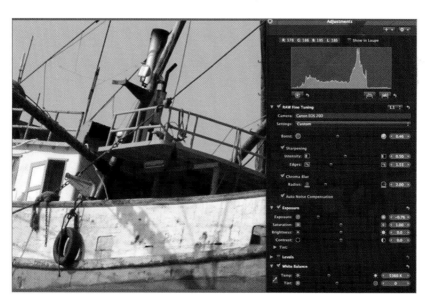

Your image should appear slightly less saturated, and you will probably see some brightening in the shadowy areas under the boat.

As the contrast in the image is reduced, the shadows will brighten up a little bit. Overall, the image will appear a little more flat. In many cases, a flatter image will be more pleasing than an image with harsh contrast.

Saving RAW Fine-Tuning Presets

You'll often find that images from your camera consistently need to be fine-tuned in the same ways. Just as you can save presets for Aperture's image adjustments, so you can save presets for your RAW fine-tuning adjustments.

The "Save as Preset" command lets you save the current settings as a preset. The command appears in the RAW Fine Tuning Action pop-up menu just below the Apple – Camera Default preset.

You might find that you consistently use one preset for daylight images, and another for tungsten images. Or, you might develop a preset that's particularly suited to the noise and sharpness issues involved in shooting in low light.

If you find that *all* of your images need a particular fine-tuning adjustment, then you might want to save your settings as the camera default. Choose "Save as Camera Default," and Aperture will use your defined setting on *any* RAW file produced by your camera model.

Taking a Closer Look at Exposure

Since both the Exposure and Brightness adjustments can make an image brighter or darker, how do you know which control to use?

As you've seen, the Exposure slider is similar to the White Point slider in the Levels controls group. With it, you can change the white point of the image, and all of the intermediate tones will be adjusted accordingly.

Similarly, the Brightness slider is akin to the Midpoint slider in the Levels controls group. When you move it, Aperture tries to maintain your white and black points while expanding and contracting the tones in between.

But there's another important difference between the Brightness and Exposure controls. In certain instances, when working with RAW files, the Exposure slider gives you the ability to recover detail that has been lost to overexposure.

Overexposure is a problem because when pixels are overexposed, they turn to complete white and lack all detail. The good news is that, in a RAW file, pixels that appear to be overexposed may be only partially overexposed.

Remember that a digital image is composed of separate red, green, and blue channels, which are combined to create a full-color picture. In many instances, only one or two channels will be overexposed. If the remaining channel(s) are intact, then Aperture may be able to restore detail that appears to be lost.

In addition, some cameras capture a little extra "headroom." Aperture can sometimes reach into this extra data to gather the information it needs to rebuild blown-out detail.

Checking RGB Values

In this exercise, we're going to take a break from circus pictures and spend a little time exploring Exposure and Brightness with the help of a sailboat.

1 Select the image **Highlight Recovery** and press F to switch to Full Screen mode.

This RAW image plainly has some exposure problems in the sky. The bright clouds on the left have blown out to complete white, and lack the level of detail found in the clouds on the right side of the image.

2 If necessary, press H to open the Adjustments HUD.

You can see the evidence of the overexposure on the right side of the histogram, where the highlights crash into the right side and create a big spike. Let's explore this a little further.

3 Drag the pointer over the bright part of the sky. In the Adjustments HUD, note the RGB readout above the histogram. These numbers indicate how

much of each color channel is used to make up the color of the pixel that you're mousing over.

4 Choose View > Show Color Value in Loupe. Then, press the ` (accent grave) key to display the Loupe.

5 Position the Loupe over the image and notice the RGB readout superimposed over the middle of the tool. This provides another way to check RGB values within your image.

6 Close the Loupe by pressing ` (accent grave).

 While this image is plainly overexposed, and the sky is blown out to complete white, there's more to this overexposure story than meets the eye.

Reading the Histogram

The default histogram in the Adjustments HUD is a graph of the luminance values of all of the pixels in your image. However, you can change the histogram display to show graphs of other types of pixel data.

1 Click the Adjustment Action pop-up menu in the upper right corner of the histogram (the one that looks like a small gear). Choose RGB from the Histogram Options section to reveal a histogram that shows separate graphs for each color channel.

Now it's easier to see that most of the extreme clipping is occurring in the blue channel. The red and green channels don't seem to be as bad. This is a good indication that some highlight recovery might be possible.

Obviously, an overexposed area is an area that is too bright. To try to get the overexposure back under control, we want to darken the image.

Aperture has an additional feature that will help us identify the blown highlights in our image.

2 Press Option-Shift-H (Highlight Hot Areas). Aperture will show any clipped highlights as red pixels.

You can leave this feature on while editing and simply drag your sliders left and right until all the red is gone. For the sake of this demonstration, though, we want to see the original pixels.

3 Press Option-Shift-H to turn off the Highlight Hot Areas feature.

4 Drag the Brightness slider to –0.5.

The entire image will get darker, and the sky will appear to have a little more contrast, but you will see no new detail in the overexposed cloud areas.

5 Press Command-Z to undo the Brightness adjustment.

6 Drag the Exposure slider to –2. The overexposed clouds should now sport far more detail.

7 Press Command-Z to undo, and then Command-Shift-Z to redo. This will allow you to toggle between the corrected and uncorrected versions to see the improvement in cloud detail.

For the moment, don't worry about the fact that the foreground is far too dark. We're only concerned right now with correcting the overexposure in the sky.

Notice that there's still a bright, detail-less section in the sky—an area that is still overexposed. Let's see if we can recover some of that detail by using Aperture's ability to extend exposure values beyond their apparent range.

8 Hold the cursor over the Exposure value field until it changes to an I-beam with small arrows next to it. Then, click in the field and drag until the Exposure reads approximately –3.5.

Your image will darken further, but you will see virtually no further improvement in cloud detail. Plainly, some pixels in this image are blown out beyond the point of recovery.

9 Press Command-Z to undo the last Exposure change, and return to an exposure of –2.

As you can see, when working with a RAW file, dragging the Exposure slider to the left automatically tells Aperture to try to rebuild any clipped highlights. Since this image has both recoverable and non-recoverable highlights, you should be able to get a feel for how much the Exposure slider can rebuild.

Brightening the Image

Now we need to brighten the foreground detail. But we can't do it by moving the Exposure slider to the right, or we'll lose the highlight recovery in the clouds. Instead, we'll use the Brightness slider.

1 Drag the Brightness slider to the right to about 0.45.

This will brighten the foreground while preserving the sky detail that we retrieved with the Exposure slider.

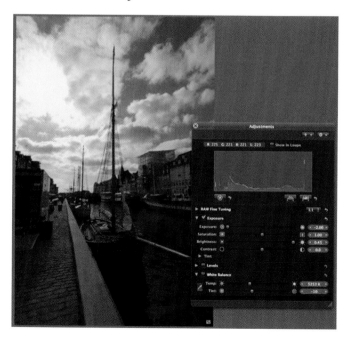

The Brightness adjustment cost us a tiny bit of contrast. We could use the Contrast slider to try to restore our black levels to where they need to be, but this would also change the midpoint and white point that we've set using the Exposure and Brightness sliders.

Instead, we'll use Levels to alter our black point.

2 Select the Levels checkbox to open the Levels controls group.

3 Drag the B (black point) slider to the right to about 0.07. This boosts the shadow tones a little bit and gives the image more contrast. It also darkens the image a tiny bit.

4 Drag the midtone slider to the left to 0.43. This restores a little foreground brightness without compromising our highlight recovery, but we still need more brightness in our shadows.

5 Click the Quarter-Tone button in the Levels controls group, if necessary.

6 Drag the lower leftmost quarter tone to 0.17. This brightens the sky, but adds a necessary boost to the foreground tones.

Aperture's highlight-recovery capabilities can be incredibly valuable, often allowing you to salvage otherwise unusable images. As you can see, the Brightness and Exposure sliders serve very different purposes when correcting an overexposed image. On overexposed images, use the Exposure slider to recover your highlights, and use the Brightness slider or Levels controls, or both, to perform the rest of your brightness and contrast adjustments.

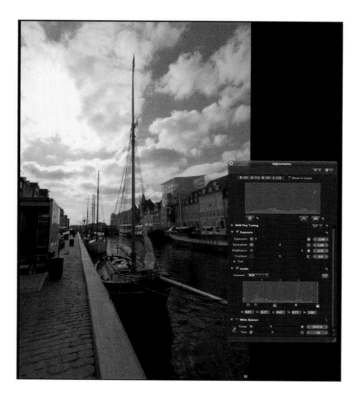

Working with an External Editor

While Aperture provides good tools for adjusting tone, contrast, and color, it is not intended to be a full-fledged image-editing application.

While its toolset will probably be all that you need for the bulk of your images, there will be times when it doesn't have the tool required to fix a particular problem. For these instances, Aperture is designed to work seamlessly with an external editing program such as Adobe Photoshop.

Aperture provides a built-in "round-trip" facility for importing and exporting images to another editing program. This capability allows you to open Photoshop from within Aperture, and integrate it easily into your Aperture workflow.

Choosing an External Editor

To use Aperture's round-trip feature, you must first configure it to use your editor of choice.

1 Press F to exit Full Screen mode and then choose Aperture > Preferences.

In the Output preferences, notice a field called External Image Editor. By default, it is set to No Application Selected.

2 Click the Choose button beneath the External Image Editor field.

3 In the dialog that appears, navigate to the application that you would like Aperture to use when you want to edit an image in an external editor.

For our exercises, we'll be using Adobe Photoshop CS2, so choose it if you have it installed on your system. Click the Select button and close the dialog.

4 In the Preferences window, set the External Editor File Format pop-up menu to the format you'd like to use for exchanging files.

We selected PSD since we'll be using Photoshop as our external editor. We could also have selected TIFF, but we know that PSD will support all of the Photoshop features that we might choose to use.

5 Next to the External Editor File Format pop-up menu is a small field labeled DPI (dots per inch). Set this to 300. This will specify that the image should be exported with a resolution setting of 300 pixels per inch.

6 Close the Preferences window.

Switching Between Aperture and an External Editor

As you know, Aperture keeps all of its images in its internal Library. If you want to edit one of those images somewhere else, you can use the specified external editor, and then Aperture's round-trip capability automatically reimports the image for you.

1 Switch to Basic layout and select the image **Round Trip** in the Browser.

This image has already been cropped and had some exposure adjustments applied to it. Now what it needs is to have some of the debris on the stage cleaned up and the rope in the background removed. The Spot & Patch tool is not enough for either of those tasks, so we're going to take the image into Photoshop. We've included a second, Photoshop-edited image within the stack for you to use as a comparison image.

2 Choose Images > Open With External Editor, or press Command-Shift-O.

If it's not already running, Aperture will open the application that you defined in the Preferences window.

Next, your image file will automatically be opened in that program. As you can see, Aperture took care of rendering a version with our crop and edits applied. We're now ready to start editing.

3 Click the Aperture icon in the Dock to switch back to Aperture, and then look in the Browser.

When you choose Open With External Editor, Aperture automatically creates a duplicate version of the current selection. Just as it does when you select Images > Duplicate Version, Aperture automatically stacks this new version with your original version. It is this new version that is sent to your external editor.

Notice that, because you configured the metadata overlay to show image names with extensions, it's very easy to keep track of which versions have been edited in Photoshop: they have a .psd extension.

4 Switch back to Photoshop and, using the Rubber Stamp tool, remove the debris and tape spikes from the stage.

5 Next, use the Clone tool to erase the rope in the background. The rope casts a slight reflection onto the stage, so you'll need to take that out also.

6 When you've finished editing, press Command-S to save the document, and then close it.

7 Switch back to Aperture. The new version that appears in your project should now show all of the edits that you just made.

8 Select the new version and press Command-Shift-O to open it in Photoshop again. Then, switch back to Aperture. Note that this time, Aperture did not create another new version. Instead, it opened the file you were just working on.

The goal of Aperture is to provide a single application that tends to all of your postproduction workflow needs. Because Aperture handles all of the file management, version control, and archiving, taking an image out to another program for additional work is very simple and works seamlessly with your Aperture workflow.

Deleting Versions

No matter how good a photographer you are, you'll undoubtedly import some duds at one time or another. As you learned in Lesson 2, you generally want to keep all images when you import them unless they're completely no good (does the inside of your camera bag ring a bell?). So more than likely, your projects will contain some obviously out-of-focus or otherwise undesirable images, which you may eventually want to delete. Deleting images in Aperture requires a little consideration, however, due to the program's master/version file structure.

Let's experiment now with deleting two images of the fire performer.

1 Locate and select the following four images in the Browser. If the stack is closed, then you'll need to open it to select all of the images.

2 Select the last image in the stack, **_MG_0429 Version 2**. Note that this image is an alternate version of the third image in the stack; it is not a master file.

3 Choose File > Delete Version. The image will disappear from your Library.

4 Select the third—now last—image in the stack and press Command-Delete. (This is the same as choosing File > Delete Version.) This time, instead of simply deleting the version, Aperture displays a warning.

Because this file is the original master file for these two images, Aperture is a little more hesitant to throw it in the trash.

5 Click the Delete button and the file will be deleted.

We could have deleted both images at once by selecting them both and pressing Command-Delete, or by selecting either image and choosing File > Delete Master Image and All Versions.

6 Now select and delete the two remaining images in the stack.

If you are deleting the last image of a series of versions, Aperture will always put up a warning, because the last version always represents the original master file.

It's really a shame that we deleted these images, because the fact is they *do* make good source material for learning more about the Highlights & Shadows control.

Luckily, Aperture didn't erase the images; it merely moved them to the Trash. This means we should be able to drag them out.

7 Open the Dock and click the Trash icon.

 The Trash folder opens. Inside, you should find a folder named Aperture. Within the Aperture folder, you will see separate folders for every project from which you've deleted images.

8 Open the **Lesson 09 Images** folder and you'll see the images we just deleted.

9 Drag them to your Aperture project. Aperture will reimport them.

Like any other document in the Finder, the deleted Aperture folder remains in your Trash until you choose to empty the Trash.

Now that you've recovered the images, why not spend a little time experimenting further with the Highlights & Shadows adjustment controls? It's amazing how much background detail the tool can bring out of these pictures, once you start playing with it.

Lesson Review

1. How can you make an adjustment beyond the values shown on Aperture's adjustment sliders?

2. The Exposure and Brightness sliders are both capable of brightening or darkening an image. How do they differ?

3. What does the Boost fine-tuning adjustment control do?

4. How does Aperture's "round-trip" feature allow you to work with an external image editor?

Answers

1. Hover the cursor over the value field for that adjustment control. When the cursor changes to an I-beam with little arrows next to it, click in the value field and drag. The value of the slider will increase or decrease beyond its normal limit.

2. Exposure adjusts the white point of an image, while Brightness adjusts the midpoint. In addition, the Exposure slider allows you to recover overexposed highlights if those highlights were not overexposed in all three channels.

3. The Boost slider lets you control the degree to which a default adjustment is applied to your image. By default, the Boost slider is set at full strength: your image appears with the full level of correction. As you drag the slider to the left, the correction is reduced. The Boost slider is handy for times when you feel your images are a little too contrasty or a little too saturated.

4. Aperture provides a built-in "round-trip" facility for importing and exporting images to another image-editing program. This capability is useful when you need to mask or composite images, selectively apply edits, or apply brush-driven retouching operations. To seamlessly work with another imaging application, such as Photoshop, you specify that external editor in Aperture's Preferences. Then, with the image you need to edit selected in the Browser, choose Images > Open With External Editor, or press Command-Shift-O. Make your edits in the other application, save the file, and switch back to Aperture. A new version of the image appears in the project, showing all of the edits that you just made.

Keyboard Shortcuts

Command-J	Open the View Options window
Control-H	Add a Highlights & Shadows adjustment
Control-S	Add a Sharpen adjustment
Option-Shift-H	Turn Highlight Hot Areas on/off
Command-Shift-O	Open image with an external editor

10

Lesson Files APTS_Aperture_book_files > Lessons > Lesson10

Media Lesson 10.approject

Time This lesson takes approximately 90 minutes to complete.

Goals Proof images onscreen

Configure a second display for additional viewing options

Design a courtesy book of images

Create a Smart Web Gallery Album

Advanced Output

After all of this work, we're finally up to the moment you've been striving for since you first saw the scene you wanted to photograph. While you can perform amazing edits and adjustments on your images, your ultimate goal is to show them to someone else. These days, of course, that can mean prints, emails, webpages, discs full of files, and even high-quality softback and hardcover books.

Aperture can create all of these different types of output for you. However, although we've put this section near the end of the book, output is something that you can choose to do at any time during your workflow. As you've seen, you'll often create different types of output throughout your workflow as you create proofs for clients and work with a production team. Remember that with Aperture you can output images at any time without giving up any editing flexibility, and you can even continue to perform image adjustments while you prepare your webpages, books, and other forms of output.

In this lesson, we're going to take an in-depth look at Aperture output capabilities, starting with onscreen proofing.

Soft Proofing Images

No matter what your final output type, you'll often perform preliminary proofs onscreen. Onscreen proofing, also called soft proofing, is the most cost-effective way to get client approval before spending money on printed materials.

While onscreen proofing is a perfectly accurate way to judge the composition of an image, when it comes to color, contrast, and tone, things get far more complicated. Because of the different technologies used to generate color onscreen and in print, your onscreen images may look very different from the printed versions. In order to make accurate assessments of the color, contrast, and tone of images onscreen you need to use ICC profiles.

An ICC profile is a description of the color characteristics of a particular device. ICC profiles are used by ColorSync, the color-management system that's built in to the Mac OS, to create accurate onscreen soft proofs without actually changing the color data in your image file. If you're using an Apple display, then your Mac already includes a built-in generic ICC profile for that device. Third-party displays and printers usually ship with their own profiles, and you can also create custom profiles using third-party software. For the purposes of this exercise, the built-in profiles that came with your display and printer will suffice.

1 Open Aperture and select any image, such as one of the images from the Tibet project that we imported in Lesson 1.

2 Choose View > Proofing Profile and then select the ICC profile that matches your output device. Your menu may look different from the one shown here, depending on which profiles you currently have installed.

3 Choose View > Onscreen Proofing, or press Option-Shift-P if it is not already selected..

Aperture adjusts the onscreen appearance of the image so that it more closely resembles the way it will look when it's output from your chosen device.

4 After viewing the image, press Option-Shift-P to turn off soft proofing.

Your success with soft proofing will vary depending on the quality of your display and the quality of your ICC profiles. Also, be aware that no matter how good your profiles are, your printed output will never exactly match your display. The difference between a self-illuminated image created from an additive mixture of light is simply different from a reflective image created from a subtractive mixture of pigments. However, a soft proof should be closer to your print than a regular onscreen image, and over time you'll learn how to predict the differences and adjust accordingly. To learn more about color management and ICC profiling, see *Apple Pro Training Series: Color Management in Mac OS X*, by Joshua Weisberg.

> **TIP** Use the ColorSync utility that comes with Mac OS X to see what ICC profiles you have installed: Open the utility, located in the Applications > Utilities folder, click the Devices icon, and then click the disclosure triangles from the device list at left to see the profiles on your system for each type of device. Most printers ship with multiple profiles, so you may see several listed.

Using Multiple Displays

For the ultimate image-editing and onscreen proofing experience (and to really impress your clients), you'll can use a system with multiple displays. The Mac OS has long supported more than one display, allowing you to create a large desktop that spans two screens. Aperture improves on this simple "extended desktop" capability by letting you specify what the second screen should be used for. For example, you can have your primary display show the normal Aperture interface, while your secondary display shows a full-screen view of the currently selected image.

To configure your computer with multiple screens, you'll need, obviously, multiple displays, as well as a video card that can drive both of them. The *Aperture: Getting Started* manual details how to connect your displays to your Mac.

Once the displays are attached, you're ready to configure Aperture for multi-screen viewing.

When two displays are connected to your Mac, Aperture considers the main display—the one with the menu bar—to be the *primary Viewer.* The other display is the *secondary Viewer.* By default, the primary Viewer displays the Aperture application.

Let's specify the function of the secondary Viewer.

1 From the control bar, click to open the Viewer Mode pop-up menu.

If you have two displays connected, then you'll see separate sections for each display.

2 Choose Mirror from the Secondary Viewer Mode pop-up menu.

3 In the Browser, select any three images. You should see all three images
appear on both displays. The second display is showing an exact mirror of
the Viewer of the first display. Obviously, the difference is that the second
display shows the selection full-screen, with no interface elements.

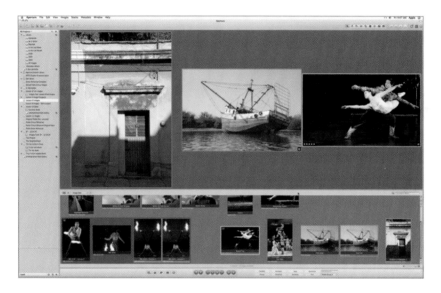

4 From the Viewer Mode pop-up menu choose Alternate. Your primary Viewer should still show all three selected images, but the secondary Viewer should change to show only the primary selection.

5 Use the left and right arrow keys to navigate through the images in the Browser. The second display will update to show only the current primary selection.

6 Choose Span from the Viewer Mode pop-up menu. Some of your selected images should move to the second display, while the rest of the images in the selection remain on the main display. Span mode spreads the selection across both displays, so your images can be viewed at a larger size. How Aperture chooses to divide them up will depend on the size of your Viewer and the size of your displays.

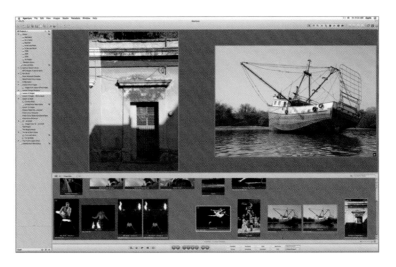

If you want to use your second display for something other than Aperture, you can choose Desktop from the Viewer Mode pop-up menu. This reveals your Mac desktop and frees the display for showing the Finder or another application.

If you want to completely eliminate the distraction of the second display, choose Blank from the Viewer Mode pop-up menu.

Creating Book Albums

You can create high-quality printed and bound books using Aperture's built-in book-making feature. After designing the book using Aperture's special design tools, you can either save it as a PDF or upload it to Apple's book-printing service. Apple will print the book and mail it to you. These make excellent courtesy books for clients. Say, for example, that you photographed an event. In addition to providing the final images to the client, you might compile some of the best shots into a courtesy book for them to have on hand.

Creating the Book

Creating a book is easy, and as you'll probably discover, it's a lot of fun. You can choose from a number of prebuilt book themes or design one from scratch. Your first step when creating a book is to select the images you want to include. We've taken care of that step for you.

1 Import the **Lesson 10 Images.approject** from the APTS_Aperture_ book_files > Lessons > Lesson10 folder.

This project contains 23 images from a shoot of jazz great Don Byron and his band performing at Joe's Pub in Manhattan. We're going to turn these images into a book to give to the producer of the event as a thank you for his promotional efforts. We'll begin by setting up the book within our project.

2 Select the project in the Projects panel, then click in the Browser and press Command-A to select all of the images in the project.

3 Click the New Book From Selection button in the toolbar or choose File > New from Selection > Book.

Aperture will present a sheet that provides a number of thematic design choices for your book. Different themes simply provide different default layouts. You can always modify the layouts yourself, as you'll see in this exercise. All of the same editing features and layout tools are available no matter which theme you pick.

If you want to know how much the book costs, click the Options & Prices button to view the latest pricing from Apple.com.

4 Choose the Picture Book theme and then click the Choose Theme button.

Aperture adds a book to your project with its name highlighted and ready to be edited.

5 Change the name of the book to *Courtesy Book*.

Just like a webpage or an album, a book is simply another element in your project. At any time, you can open it for edits, just as you would any other type of element.

When you're editing a book, the Browser is visible for selecting images, while the Viewer shows the current page or page spread you're editing. The Pages panel shows thumbnails of all of the pages in your book for easy navigation.

Pages panel Viewer

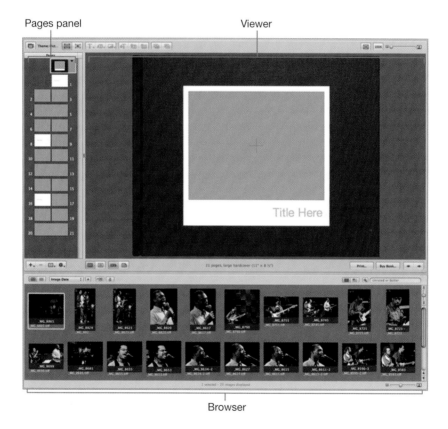

Browser

Note the Theme button in the upper left corner of the Viewer. You can click this button to change the theme of your book at any time. However, if you have already edited the content or layout, you may lose some text and custom layouts.

> **TIP** To prevent losing text when you change your theme, first copy the text to another document as a backup.

By default, Aperture creates a hardback book project. You can change it to a soft-cover book by clicking the Large Softcover button at the bottom of the Viewer.

Large Hardcover button Large Softcover button

There is no difference in print quality or layout options between hardcover and softcover books. The only thing that changes is the binding and the price. For this exercise, you can select either.

Designing the Cover

Let's start laying out the book by designing its cover.

1 In the Browser, find image **_MG_8865**.

2 Drag the **_MG_8865** image to the book cover displayed in the Viewer. Release the image over the gray box that contains a crosshair.

In a book layout, a gray box with a crosshair is a photo box into which you can drag an image. This is how you can manually place images into your book layouts. (Later, you'll see how you can automate the placement of images in the book.)

While the image looks OK, it's a little small. Let's scale the image to make it look better.

3 Double-click the image in the Viewer. A selection highlight appears around it, and an Image Scale slider pops up.

4 Drag the Image Scale slider to the right to zoom in on the image as shown in the following figure.

Now the image is larger than the frame it's sitting in, but that's OK. We can adjust the image's position within the photo box.

5 Drag the image in the photo box to reframe it so that the band is centered.

6 When you're finished, click anywhere in the gray area of the Viewer to deselect the image.

Now we're ready to give our book a title. The band was performing at Joe's Pub as a warm-up for the next day, when they went into the studio to record an album of Junior Walker songs. The album was ultimately titled *Do the Boomerang.*

7 On the cover of the book, double-click the *Title Here* text to select it. Type *Do the Boomerang.*

8 Click the gray area of the Viewer to deselect the text.

Notice image **_MG_8865** in the Browser. After you place an image in a book layout, a small badge appears on its thumbnail in the Browser to indicate that it's used in the book. The number on the badge indicates how many times the image appears.

The cover looks pretty good. We're ready to move on to designing the interior pages.

Designing the Title Page

Designing the pages is similar to designing the cover.

1 In the Pages panel, click the thumbnail for Page 1. The Viewer will show the first spread of the book: the inside of the front cover and page 1. You cannot place anything on the inside front cover. Page 1 is fully editable and customizable, but we're going to leave it as a title page.

2 Double-click the text on the first page and change it to *Joe's Pub*.

Book layouts do not allow you to change font, nor can you combine different text sizes in one block of text. You can, however, create multiple text blocks on a page.

3 Click the Set Master Page button to open the pop-up menu. The button is located directly beneath the Pages panel.

The Set Master Page pop-up menu provides a selection of prebuilt page layouts. You can apply any of these master page selections to the current page. Each theme has a different selection of layouts. It's good for you to know they're there, but unfortunately, none of these layouts provide what we're looking for, for page 1. Leave the Set Master Page menu as-is.

4 Click the Edit Layout button above the Pages panel.

When in Edit Layout mode, you are free to change the layout of any page. Note that after clicking Edit Layout, more buttons become active above the Viewer. These buttons let you add new elements to a page and to change the characteristics of those elements.

5 Click the Add Text Box button to add a text box.

A new text box will appear in the middle of your layout.

6 Drag the text box so that it sits just below the *Joe's Pub* text that you entered earlier. As you drag, Aperture will automatically display guides to help you align the text box with the other text box on the page.

By default, the text box is set to use the smallest text size that Aperture supports. Let's make it a little larger.

7 Click the Text Style pop-up menu button and choose Cover Title.

As you can see, Aperture provides three text sizes. When we changed the text size, we obscured some of the text. Let's increase the size of the text box to accommodate the new text size.

8 Drag the lower right handle of the new text box to the right to make it larger.

9 Edit the text so that it says *Manhattan • December 2, 2005.* Press Option-8 to create the bullet.

10 Adjust the size of the text box again so that all of the text is visible and nicely positioned below the *Joe's Pub* text.

You can use this same technique to add a text box to any page, even one with images on it.

Adding Images to Pages

Now let's add some images to the inside pages of the book.

1 In the Pages panel, click page 2 to select it and view its spread.

Since Don is the leader of the band, let's start with a picture of him.

2 From the Browser select the image **_MG_8557** and drag it to the photo box on page 2.

By default Aperture always fits your images to a photo box, no matter what the size of the box or image. In this case, the photo box aspect ratio needs to be tweaked to fit our image.

3 Make sure **_MG_8557** is selected. Then, click to open the Book Action pop-up menu beneath the Pages panel, and choose Photo Box Aspect Ratio > Photo Aspect Ratio.

The photo box assumes the same aspect ratio as the photo itself and scales to fit the page. Now our entire image is visible.

4 Drag image **_MG_8681** into the photo box on page 3. If you want, you can scale and position it, just as we did with the cover image. Any picture can be scaled and positioned within its box.

5 In the Pages panel, click page 4 to view the next spread. This spread shows a single gray photo box that spans both pages.

6 Drag image **_MG_8745** into the photo box on page 4. The image will appear across the full spread.

7 Double-click the image to position it. Leave the scale alone, but drag the image down until the performers' heads are completely visible.

Note that the image has a small exclamation mark in the upper right corner. This is Aperture's way of warning you that the image does not have enough resolution to print at the size you have specified. Due to space limitations on the DVD that accompanies this book, we have had to supply low-resolution

JPEG files for these book samples; hence, the warning for this image. If you receive this warning in a real production workflow, you should use a higher-resolution file to ensure that the image will print correctly.

Next, let's customize some page layouts.

Customizing Pages

Aperture's preset layouts work fine, but we can do more. Let's design the next spread with a little more customization.

1 In the Pages panel, click page 6 to change to the next spread. Page 6 defaults to a full-page photo box. However, we want something a little smaller.

2 Choose Set Master Page > Blank. An empty white page will be revealed.

3 Click the Add Photo Box button above the Viewer to add a new photo box to the page.

4 Drag image _**MG_8820**_ to the new photo box.

5 Control-click the image in the new box (or right-click if you have a multi-button mouse). Choose Photo Box Aspect Ratio > Photo Aspect Ratio from the contextual menu.

The photo box changes size to fit the photo. This is a simpler way of accessing the same command you used earlier.

6 Press the Shift key and drag the corner of the image to resize it. Pressing Shift while resizing constrains the aspect ratio of the box. Resize and reposition the image so that it is the same height as the page.

Adjusting Images in a Book

Remember, though we're making a book, all of the normal Aperture function-
ality and features are still available. If we wanted, we could edit any of these
images by simply selecting it in the book layout and making changes using the
Adjustments HUD. As we've stated before, one of Aperture's biggest strengths
is that all editing tools are available at any time. Let's first delete a photo box
and then look at an image in Full Screen mode.

1 Select the photo box on page 7 and press Delete to delete it.

2 In the Browser, select image **_MG_8755**, then press F to view it in Full
 Screen mode.

 Because of the low-light conditions in the club, this image is extremely
 noisy. Noise that's visible onscreen doesn't always show up in print, but
 this image is noisy enough that we'd rather not take the chance. So we'll
 use it in a different way.

3 Press F again to exit Full Screen mode.

4 Drag the image to page 7. Though there is no photo box there, the
 image still appears and fills the entire page. You can drag an image
 directly to a page even if there's no photo box. However, because you
 can't resize the page, there's no way of adjusting the size of the image.
 In this case, that's OK.

5 Click the image in the book layout to select it.

6 Click the Photo Filter button above the Viewer and choose Wash – Light.

The image is screened back to a much fainter, washed-out look. With the image filtered this way, the image now becomes a good background element, and its noise problems become invisible.

The Photo Filter menu allows you to apply these types of wash effects as well as sepia toning and black-and-white conversions. These effects are not applied to your original image. If you look at the original picture in the Browser, you'll see that it still appears normal.

Adjusting the Stacking Order of Page Elements

When designing a book, you can freely layer graphic elements on top of each other to create more sophisticated layouts. Let's try to do something along those lines now.

1 Click page 7 to select it, then click the Add Photo Box button to add a new photo box to the page.

2 Drag image **_MG_8725** to the new photo box, then set the box's aspect ratio to match the picture.

3 Scale and position the new image as shown.

You can stack as many images as you want and use the layering buttons above the Viewer to move each image forward or back in the stacking order.

Send Backward button Bring Forward button

Note that an image placed directly on the page—as opposed to being placed in a photo box—cannot be moved forward in the stacking order. It can only sit behind other images.

Automating Page Flow

As you can see, Aperture provides excellent manual layout controls for designing your book, and this is the best way to get exactly the results you want. However, there will be times when you need to produce a book very quickly. When that's the case, you can automate the process of adding images to the

book. Before we can automate the process, however, we have to quickly adjust the layout of a couple of pages in our book.

1 Click page 8 to view the next spread. By default, this book has three title pages: the first one you previously edited, one on page 8, and one on page 16. We don't need the second two.

2 Click the button for the Master Page pop-up menu and choose 1-up. This will change the page to a picture page.

3 Navigate to page 16 and again choose Master Page > 1-up.

4 Select page 8 again.

Now we're ready to use Aperture's auto-flowing feature.

5 From the Book Action pop-up menu, choose Autoflow Unplaced Images.

Aperture processes the rest of your images, placing one image per page. The images may not be positioned or scaled properly in their photo boxes, but they will provide a good starting point for other layout ideas.

6 After the images are placed, navigate through the pages and rearrange and fix any pages that have problems.

Finishing the Design

Finally, let's add a credits page to the end of the book. This will appear on the last right-hand page of the book (not the inside of the back cover—no content is allowed on the inside back cover or the left-hand page that faces it).

1 Click page 27 to select it. Select and delete the photo box that's currently on the page, and then add a new text box.

2 Control-click the text box and choose Text Box Alignment > Right.

3 Create another text box and change the text box alignment to the left.

4 Position the text boxes as shown, and enter the following text.

5 Finally, create one more text box, as shown, and enter the suggested text.

Outputting the Book

Once you've finished laying out your book, you have several options for turning it into an actual printed piece. If you click the Buy Book button beneath the Viewer, Aperture will open a dialog that lets you order a bound, printed book directly from Apple.com.

You need to have an account with Apple in order to use the Buy Book feature; if you don't have an account, you can create one from this dialog.

Aperture provides other output options, as well. With the Print command you can print your books direct to your own printer, or output them to a PDF for electronic distribution or delivery to a non-Apple book-printing service.

> **NOTE** ▶ For information on how to customize Aperture's book layouts and web templates, see the author's website, www.completedigitalphotography.com.

Creating a Smart Web Gallery Album

There are few tasks as tedious, or as important, to a photographer than creating a portfolio. However, with Aperture's Smart Web Gallery Albums, you can let Aperture build your portfolio for you.

Smart Web Gallery Albums work just like Smart Albums: any images that match the criteria defined for the Smart Web Gallery Album are automatically placed in the gallery. Smart Web Gallery Albums and Smart Albums can also sit at the Library level, outside any particular project. Because they can reside at the top of the hierarchy, they can pull images from any project, making them ideal for keeping an automatic web gallery of all of your best images.

1 Click the Library in the Projects panel to select it. We want Library selected to ensure that anything we create appears at the top of the hierarchy.

2 Choose File > New Smart > Web Gallery. Aperture will create a new Smart Web Gallery Album and highlight it for renaming.

3 Name the Smart Web Gallery Album *5-Star portfolio.*

When you create a Smart Web Gallery Album, the Query HUD will automatically appear next to the web gallery. This is where you'll specify the criteria for including images in the gallery.

4 Select the Rating checkbox and configure it to select images whose rating is "greater than or equal to" five stars.

5 Select the "Ignore stack groupings" checkbox at the bottom of the Query HUD. By selecting the checkbox, you tell Aperture that you want to include every five-star image, even those in a stack that are not the primary selections.

6 Close the Query HUD. The Browser will tell you how many images were placed in the Smart Web Gallery Album, while the Viewer will show you the layout of the gallery.

7 Click the Theme button above the Viewer to select a new theme for the gallery.

There are a number of prebuilt themes to choose from. Let's leave our Web Gallery Album theme set to Stock.

8 Click Cancel.

Smart Web Gallery Albums allow for a little bit of customization. You can change the number of columns and rows using the Columns value slider and Rows value slider above the Viewer, for example, and select which metadata you'd like to use for a caption by clicking the Metadata Set button.

You can rearrange the order of the images by simply dragging them to new positions, just as you do in the Browser, and you can edit any text on the page by double-clicking it.

Refining Your Portfolio Criteria

In the last exercise, we built a Smart Web Gallery Album based on rating, and now, anytime you tag an image with five stars, it will automatically be added to your portfolio gallery. If desired, you can also use the Query HUD to specify far more complex criteria for Smart Web Gallery Albums and Smart Albums.

1 In the Projects panel, click the magnifying glass next to the 5-Star portfolio Smart Web Gallery Album name.

The Query HUD opens, allowing you to change the criteria that define which images go into this gallery.

2 Select the Calendar checkbox in the Query HUD. Calendars of the last three months appear. Aperture does some of the work for you here, highlighting only dates that have associated images. If no dates are highlighted, then there are no images in your Library that were captured in those months.

3 Click the arrows at the top of the Calendar area to navigate to a month that has highlighted dates. These are dates for which you currently have images in your Library.

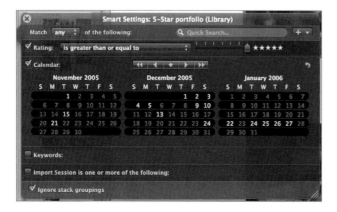

4 Click a highlighted date to add all of the images from that date to your gallery. If you want to select more dates, Command-click additional highlighted dates.

Note that because the Rating box is still selected, Aperture is only selecting five-star images shot on the dates that you're specifying.

5 Select the Keywords checkbox. Aperture displays all of the keywords used by the images in your Library. You can select the checkbox next to a keyword to add images tagged with those words to your gallery.

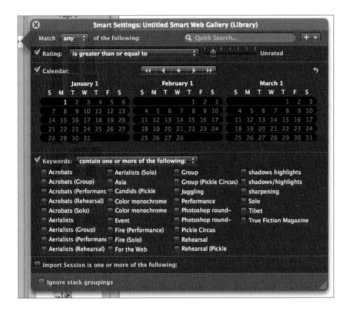

You can freely mix and match all of these criteria to select a specific set of images. For example, if your images are keyworded properly, you could create a portfolio of just your indoor, five-star event shots, or your five-star landscape shots. Aperture also lets you add additional metadata criteria.

6 Click the plus sign in the upper right corner of the Query HUD to open the Add Filter pop-up menu.

Here you'll find an assortment of other criteria that you can add to your search. With these items, you can easily select images based on their creation date, EXIF and IPTC tags, and other metadata.

Of course, you can also create Smart Web Gallery Albums inside a project to limit your searches to just the images in a particular project.

Lesson Review

1. When you're using the book layout tools, what does a photo filter do?

2. How do you change the crop of an image in a book layout?

3. Why would you choose to put a Smart Web Gallery Album at the Library level of the Projects panel, rather than in a specific project?

Answers

1. Photo filters change the appearance of an image on a book page. The original master image is not altered.

2. Double-click the image in the book layout, then drag the image to change its position within its photo box.

3. If you want the Smart Web Gallery Album to pull images from any project, then you should place it at the root level of the Projects panel.

Keyboard Shortcuts

Option-Shift-P View onscreen proof

11

Lesson Files APTS_Aperture_book_files > Lessons > Lesson11

Media Lesson 11 Images.approject

Time This lesson takes approximately 1 hour to complete.

Goals Export original master images

Study the contents of the Aperture Library

Move the Aperture Library to a new location

Create multiple Libraries

Back up a project by exporting it

Back up your Library using multiple vaults

Restore your Aperture Library from a vault

Advanced File Structure and Archiving

Document management and "housekeeping" are often a big part of your digital photography workflow. Aperture is designed to handle many of these chores for you, allowing you to easily create multiple versions, backups, and archives.

Aperture provides all of the features that you need to manage and back up your images. Because you can choose to keep managed images inside Aperture's Library, and referenced images stored on other drives, it's possible to create sophisticated workflows for your own archiving and image-tracking purposes, as well as for projects where you are collaborating with others who need to share your image files.

In this lesson, we'll explore Library management as well as Aperture's various export options.

Preparing the Project

For this lesson you'll need to import the Lesson 11 Images project into your Aperture Library.

1 Open Aperture.

2 Choose File > Import > Projects.

3 In the Import dialog, navigate to APTS_Aperture_book_files > Lessons > Lesson11 > **Lesson 11 Images.approject.**

4 Click the Import button.

 Aperture imports the project into your Library. Now we're ready to begin.

Managing the Aperture Library

As you saw in Chapter 8, Aperture lets you choose between importing images into the managed Library or leaving them where they are and simply importing a reference. The advantage to importing images into the Library is that Aperture will always know where they are—you don't have to worry about taking drives or volumes offline—and the images will be backed up anytime you use Aperture's built-in backup feature.

The advantage of referenced images is that they can sit on external drives, so your Library isn't limited by the size of your internal hard disk.

One of Aperture's best features is that you can freely mix and match managed and referenced images. Let's explore some ramifications of these choices.

1 Select the Lesson08 First Import project that you created in Lesson 8. As you'll recall, the first batch of images that you imported into this lesson were imported as references from the *APTS_Aperture1.5* DVD. The second batch of images were imported into the Library.

 To help you keep track of which are which, Aperture displays a small "alias" arrow on images that were imported as references.

In the image above, the leftmost image was imported as a reference.

2 If the *APTS_Aperture1.5* DVD is not mounted, insert it in your drive now.

3 After the DVD has appeared on your desktop, go to Aperture and select the leftmost image shown in the figure above.

4 Choose File > Show in Finder.

The Finder appears and the folder containing the selected image opens. This is one way to find the location of an original image.

5 Return to Aperture and, with the same file selected, choose File > Manage Referenced Files.

In the File Path column at the top of the dialog, you can see the path to this file. The path is also shown beneath the thumbnail in the upper right area of the dialog. As we'll see, the Manage Reference dialog lets you easily move your images around without breaking the links to your Library.

6 Click Done to close the Manage Reference dialog, and then switch to the Basic layout.

The preview image that you're seeing on your screen is being generated from the image data stored in your master file. Aperture is reading the data from the referenced file and creating a preview at the appropriate size. This is also what Aperture does for images stored in its Library.

If you want, you make add an adjustment of some kind to the image and immediately see the results onscreen. But what happens when Aperture doesn't have access to that RAW file?

7 Eject the *APTS_Aperture1.5* DVD by pressing the Eject key in the upper right corner of your keyboard.

The selected image is still visible. As you'll recall, when you import an image as a reference, Aperture builds a full-resolution preview and stores that in its Library. This means that Aperture can show you a high-quality, very large image, even when the original file is offline.

8 You can perform any metadata, keywording, rotation, or ratings tasks that you want. These changes are all stored in small text files inside the Aperture Library, so Aperture doesn't need the master data file to perform them. Experiment now by changing the rating for the image.

Notice, however, that the Adjustments Inspector is grayed out and you cannot add any adjustments or edits to the image, because the master file is offline.

Aperture stores its preview images as JPEG files. As you learned in Lesson 9, editing a JPEG file yields very different results from editing a RAW file. Aperture can't properly adjust the white balance or perform any highlight recovery on a JPEG approximation of a RAW file, so rather than fake it, Aperture simply requires you to have your master image data to perform an edit.

9 Reinsert the *APTS_Aperture1.5* DVD. Once the disc is mounted, the controls in the Adjustments Inspector become available. This is because Aperture now has access to the master data file.

When to Import as a Reference

There are a lot of reasons to import a file as a reference, and Aperture's ability to work with managed or referenced files opens up the possibilities of *many* different Library architectures and workflows. Here are a few ideas for when you might want to work with referenced files.

- ▶ **When you're in a hurry.** It takes some time to import an image into Aperture's Library because the program has to copy the image into the Library folder. If you're in a hurry, importing as a reference will save you the time of making that copy.

- ▶ **When you want to share data.** If you're working with a group of people who all need access to the same image data, you can keep your images on a central server and import them as references into as many copies of Aperture as you want. Depending on your network speed, you may suffer a performance hit, but because Aperture never alters your master data file, multiple users can reference the same files without fear of stepping on each other's toes.

- ▶ **When you want to use the image in another application.** Although Aperture provides excellent export capabilities as well as the very effective "round-trip" feature, there may still be times when you want to easily access your master file from another application. By keeping the master in a regular Finder folder and importing it as a reference into Aperture, you'll have no trouble using the same file in other applications.

- ▶ **You regularly move from a laptop to a desktop Mac.** If you take your laptop with you into the field to shoot, sort, and organize, but prefer to do your editing on a desktop machine at home, you can keep all of your images on an external drive and import them as references. Then, you can simply move the drive from machine to machine.

These are just a few reasons to choose the reference option when importing. As you work more with Aperture, you'll be able to fine-tune your importing strategy.

When to Copy into Aperture's Library

Reference files are fine in many situations, but importing into Aperture's main Library is often a better option. Here are some examples:

▶ **You need to send complete projects to your colleagues.** When your images are stored in the internal Library, you can easily export entire projects. With referenced images, you must export the project and all the referenced images.

▶ **You want to take advantage of Aperture's vault system** for making backups. Referenced images are not included in the vault system.

▶ **You don't want to keep track of external volumes.** This can be particularly critical for laptop users. If you just want to grab your laptop and go, knowing that you have all your images with you, then importing images into the Library is a better option.

Consolidating Masters for a Project

If you've created a project with a mix of managed and referenced images, like the one we created in Lesson 8, there might come a time when you want the images all in one place. Aperture provides a simple Consolidate Masters command, which gathers up all of your master images and puts them in the Aperture Library.

1 Select the Lesson08 First Import project in the Projects panel.

2 Choose File > Consolidate Masters for Project.

Aperture presents you with an option to either copy or move your masters.

If you choose Copy files, then your master files will be left in their current location, and a copy will be made in your Library. If you choose Move files, then the masters will be copied and subsequently deleted from their original location.

The dialog also warns you that if you move the file (thus deleting the masters from their original locations), any other projects that point to those images will have their links broken. In our case, this project is the only one linking to these images, so we don't have to worry.

Our masters are on a nonrewritable DVD, so choose Move files.

3 Click Continue. Aperture will display a progress bar while it copies the referenced images into its internal Library.

When it's finished, none of your images will have a reference badge attached to them, since they're no longer referenced files. Now your entire project is in the internal Library.

Changing the Location of a Master

At times, you may want to move some master images to a new location outside your Aperture Library.

For example, let's say that you have finished your edits to the Lesson08 project and now want to archive the project on a CD-ROM for long-term storage. You don't have enough space to keep the masters in your Library, but you don't want to throw them away. Consequently, CD or DVD archiving is a great way to go.

You could simply export the project, burn it on a disc, and delete it from your Aperture Library, but in this case you want to keep it in your Library so you can continue to search and browse the images.

> **NOTE ►** You'll need a blank CD to perform this exercise.

1 Open Disk Utility, which is located in ~/Applications/Utilities.

You will use Disk Utility to create a disk image for your master images, and then burn that disk image to a CD or DVD.

2 In Disk Utility, click the New Image button at the top of the Disk Utility window.

3 Set the Size pop-up menu to 610 MB. Leave the Encryption and Format menus set to their defaults.

4 In the Save As field, enter *Lesson 08 Masters*, and set the Where pop-up menu to Desktop.

5 Click Create. Disk Utility will create a new disk image and mount it on your desktop.

A mounted image is virtual disk. As far as the computer is concerned, Lesson 08 Masters is just like any other writable volume (hard drive, USB drive, etc.) that you might attach to your Mac. Now let's write some data to this virtual disk.

1 In Aperture, go to the Projects panel and select the Lesson08 First Import project.

2 Click in the Browser and then press Command-A to select all of the images in the project.

3 Choose File > Relocate Masters.

A Save dialog will appear.

4 Select the Lesson 08 Masters disk image you just created.

Using the Subfolder Format and Name Format menus, you can choose to have Aperture automatically create a special folder to save your masters in. We're fine with the defaults.

5 Click Relocate Masters. Aperture will spend some time copying your masters.

6 Switch to the Finder and open the Lesson 08 Masters disk image. You should see 32 items.

7 In Disk Utility, select the Lesson 08 Masters.dmg item in the left pane, then click the Burn icon at the top of the window.

The images total about 350 MB. When the CD is burned, Aperture will mount it on your desktop. You'll now see two volumes with the same name. One is the CD you just burned; the other is the virtual disk.

8 In the Finder, eject the disk image volume called Lesson 08 Masters.

9 Move the Lesson 08 Masters.dmg file to the Trash and empty the Trash.

Return to Aperture and explore your project. Note that all the images are now listed as references. If you check the original location of any of the images, you'll see that Aperture lists them as being stored on the virtual disk you just copied them to.

Note that you have successfully moved your master data to another volume (you could have also used a DVD if your images were too big to fit on a CD), and yet they're still visible in your Aperture Library because Aperture preserved the necessary links. You can rate them, add metadata, sort them, even view full-resolution previews.

The ability to move your masters around in this way gives you a *tremendous* level of power and control. You can arrange your Library to suit your storage capabilities, offloading some masters to CDs, DVDs, or hard disks, and keeping others on your local hard disk. No matter where they are, though, you'll always have a full-resolution preview and a record of where the original is.

However, note that it *is* possible to break the link to a file.

Reconnecting a Master

Suppose you're cleaning house one day, rearranging your files and moving folders from one disk to another in an effort to be more organized. (Or perhaps you're simply procrastinating.) Without thinking, you move a folder full of images from one disk to a disk with a different name. When you return to your current Aperture project, you find that all of your links are broken, because you've moved the images out of the location where Aperture was looking for them.

Fortunately, using the Relocate Masters dialog, you can relink these files.

1 In Aperture, select the Lesson08 First Import project.

 Note that all of the images are listed as references. They are linked to master files on the CD that you just made.

2 Eject the CD by pressing the Eject button in the upper right corner of the keyboard.

Aperture will update the reference badge on your images to indicate that the linked file is no longer available.

By ejecting the CD, you have broken the link to the file. You can still edit metadata and view a full-resolution preview, but you won't be able to perform any edits until you make the master files available again to Aperture.

3 Quit Aperture.

4 Create a new folder on the desktop called *Lesson 8 Images*.

5 Reinsert the CD and copy its contents into the folder you just created.

6 Eject the CD.

You have now moved all of the master images to a new location that Aperture doesn't know anything about. This is just the sort of thing we might do during "housekeeping," and it's the sort of maneuver that will break links in your Aperture Library. Let's fix those links.

1 Open Aperture and select the Lesson08 First Import project.

As you can see, the links are still broken. (If they're not, then you didn't eject the CD. Do so now.)

2 Select all of the images in the project.

3 Choose File > Manage Referenced Files.

4 If the reconnect options are not already visible, click the Show Reconnect Options button.

5 In the lower dialog pane, navigate to the Lesson 8 Images folder that you created on your desktop.

6 Click the name of an image in the File Path column in the upper pane.

7 Find the corresponding image in the lower pane (in the folder that you created). In this case, we selected **mg6016.jpg** in both places.

8 Click the Reconnect All button. Aperture will process the new links. When it's finished, click Done.

Now your project should show good links for all of your images.

Using Manage Referenced Files, you can easily move your master images and reconnect them if your image links get broken.

Exporting a Master File

If you want to export a copy of an adjusted image from Aperture, you use the Export Version command, which applies your current edits to a copy of the original master image to generate a new file.

There might be times, though, when you want to export a copy of the original master file. Perhaps you need to give a copy of the original master file to someone who doesn't use Aperture, or maybe you find yourself working for a client who has a very specific custom workflow, and you need the original RAW file to fit into that workflow.

Whatever the case, you can easily create copies of your unedited master files using Aperture's Export Master command. If the file in question is a referenced image, you can make a copy of it in the Finder. If you're working with a managed image that's been imported into your Aperture Library, you use File > Export Master.

1 Press Command-Option-S to make sure you're in Basic layout.

2 Select the Lesson 11 Images project in the Projects panel.

3 Select the **boats** image in the Browser.

This image has been heavily edited in Aperture, but you can see the original master image at any time.

4 Press M to view the original unedited master file of the **boats** image.

5 With the **boats** image still selected, choose File > Export > Export Master, or press Command-Shift-S. The Export Master dialog opens.

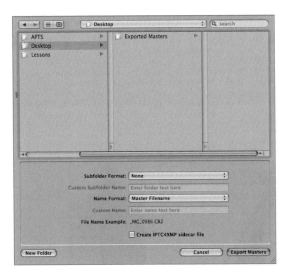

This dialog is similar to the Export Version dialog you saw in Lesson 7, "Finishing, Delivering, and Archiving Images."

6 Navigate to the desktop as the location for the saved master image, and choose Name Format > Master Filename.

7 Click the Export Masters button to begin the export. A copy of the master image will be exported to your desktop.

The Export Masters command always exports the original master file, even if you are executing the command with an adjusted version selected. Once you have a duplicate of the master file, you can share it with colleagues or clients as needed, and you'll still have the original master file in your Aperture Library.

Exporting a Photoshop Master File

Remember, any image that you import into Aperture is stored in the Library as a master file. This file is never altered, no matter what format it is in, and the Export Master command always saves an exact copy of that original file. This is true for both RAW and non-RAW images, such as Adobe Photoshop files.

1 Select the image **windows 2**. This is a layered Photoshop file.

2 Choose File > Export > Export Master and save the file to your desktop, preserving its master filename.

3 Click the Finder icon in the Dock to select it and look for the **windows 2.psd** file you just created.

4 Double-click the image icon to open the file in Photoshop (if you have it). Notice that Aperture preserved the original Photoshop layers when it exported a copy of the master image.

Some people are worried that if they import their images into Aperture, they're committed to some sort of proprietary Apple technology and that they won't be able to get their originals back. As you've just seen, though, all of your original images are stored as masters in the Library and can easily be exported in their original state at any time.

Moving the Aperture Library

Throughout this book you've heard a lot about the Aperture Library, the all-important receptacle where essential image data is stored.

The Library itself is simply a special kind of folder called a package, and by default it's kept in the Pictures folder in your home directory. However, the Library can be located anywhere you like.

If you don't have a lot of space on your main hard disk, it might make more sense to store the Aperture Library on a larger, external hard disk. With the Library on an external disk, you can easily move it from one Mac to another.

Changing the location of the Aperture Library is very simple to do using Preferences.

1 Open Aperture.

2 Choose Aperture > Preferences

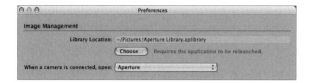

At the top of the Preferences dialog is a field called Library Location. This field shows the path to your current Library. Directly below this field is a Choose button. Note that since you changed the location of your Library in Lesson 1, the location you see in the Preferences dialog may be different from the one shown here.

3 Click the Choose button.

Aperture displays a standard Finder dialog.

4 Navigate to the location where you'd like to keep your Library, and then click Select.

NOTE ▶ If you don't want to move your Library, click Cancel.

In the Preferences dialog, the Library Location field should now show your new location.

5 Close the Preferences dialog and quit Aperture.

You've pointed Aperture to the new location, but your Library isn't actually there—yet. You have to move it.

6 In the Finder, move your Library from its old location to the new one you just defined.

TIP▶ If this location is on a different disk, then it would be a good idea to delete the copy on your own hard disk so that you don't get confused as to which one is current.

7 Open Aperture.

Browse through your Library. If no images appear, then the location of the Library file doesn't match the location denoted in Aperture's Preferences. Check your Library Location in the Preferences dialog again and confirm that it matches the location that you copied your Library to.

If you decide to keep your Library on an external disk, you'll need to be sure that the drive is always connected and powered up before you open Aperture. If you open Aperture and the disk isn't available, Aperture will create a new Library in the Pictures folder of your home directory. (Or, if you still have a Library at that location, then Aperture will use it.) You'll have to reset your preferences to regain access to your external Library, and quit and reopen Aperture.

Backing Up and Archiving

To ensure that you don't lose any image data in the event of a disk crash or other calamity, you should make regular backups while working on a project and archive the entire project when you're finished. Aperture provides several mechanisms for backing up and archiving content.

One way to back up is to export all of the versions and the master images of a project to a storage device or an optical disc such as a CD or DVD. This will provide you with duplicates of your original data and your final images, but you won't have any of the project elements that you created in Aperture, meaning you won't be able to go back and change any of your edits. Nor will you have any of the stacks, albums, or other organizational structures that you created within your project.

To preserve all the version information and organizational structures, you need to export the entire project. An exported project preserves *all* of the work that you've done within the project, and it can be easily reimported into Aperture, or even imported into another copy of Aperture on another computer.

1 In Aperture, click to select the Lesson 11 Images project in the Projects panel.

2 Choose File > Export > Export Project or press Command-Shift-E.

3 In the dialog that opens, select a location for the exported project and name it *Lesson 11 Images*.

4 Click the Save button.

5 Switch to the Finder and look in the specified location. You should see a project file.

To import the project into Aperture at any time, use the File > Import command as you learned in Lesson 2.

> **TIP** ▶ You can also export a project simply by dragging it from the Projects panel to a location in the Finder.

Creating Multiple Vaults

In Lesson 7, you learned how to create a vault to make a complete mirror of your Library on another hard disk. What's nice about vaults is that although the initial backup takes a long time, future backups are speedy, because Aperture only has to update new or changed files.

> **NOTE** ▶ Remember, referenced master files are not backed up when you use a vault. You must back up those files by hand.

For extra safety, you might want to create an additional vault on yet another disk, perhaps one that you keep off-site for added security. Because hard disk

drives are so inexpensive now, keeping multiple vaults on multiple drives is an affordable, easy safeguard against lost images and projects.

You create an additional vault using the same procedure that you used to create an initial vault.

1 Connect an additional drive and turn it on.

2 Click the Vaults Panel button at the bottom of the Projects panel.

The Vaults panel opens.

3 Choose Add Vault from the Vault Action pop-up menu.

4 In the Add Vault dialog, navigate to your external drive.

5 Click the Add button.

Aperture will begin to create the new vault. Bear in mind that you will now need to update both vaults to keep both Library backups up-to-date. However, you don't need to have both vaults connected at the same time. For example, you can update one vault daily, and the other weekly. To update multiple vaults simultaneously, choose File > Vault > Update All Vaults.

> **NOTE ▶** You can't create a vault on an optical medium such as a record-able DVD. To store Aperture content on a CD or DVD, you'll have to export the projects to a hard disk and then burn them to the optical disc yourself.

Restoring Your Aperture Library

Hopefully you'll never need to do it, but if you ever need to restore your Library, Aperture can automatically rebuild it from a vault.

1 Connect the disk drive that contains the vault that you want to restore.

2 In Aperture, choose File > Vault > Restore Library.

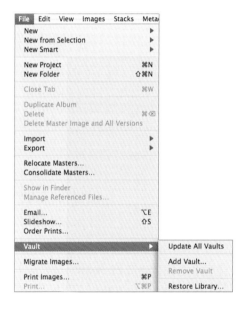

3 In the Restore Library dialog, choose Source Vault > Select Source Vault.

4 Navigate to the vault on your external disk and click Select. Then click Restore.

By default, Aperture will restore your Library to the default location inside your Pictures folder. However, you can specify a different destination by opening the Library Destination pop-up menu and choosing Select Destination.

Lesson Review

1. What's the difference between exporting a master image and a version?

2. For what reasons might you want to move your master images (using the Consolidate Masters or Manage Referenced Files commands)?

3. How can you back up Aperture projects to a CD or DVD?

4. What's the difference between backing up using a vault and backing up by exporting a project?

Answers

1. When you export a master, a duplicate of the original file that was initially imported into Aperture is exported to the location of your choice. When you export a version, any edits that you've made are applied to the original master image, and the resulting file is exported in the format that you specify.

2. You might want to move your master images if you need to free up space on the disk where they're stored. Or you might want to consolidate your images to ensure that everything you need for a project is in one location. You can move the masters to another disk or to a CD or DVD, and keep the references to those masters in your Aperture Library.

3. You can back up projects to a CD or DVD by exporting them using the Export Project command, and then copying the duplicate projects to a CD or DVD and burning it.

4. When you create or update a vault, your entire Library is backed up. The Export Project command allows you to back up individual projects.

Keyboard Shortcuts

M	View master image
Command-Shift-S	Export master image
Command-Shift-E	Export project

12

Aperture Automation

While software can do all sorts of amazing things, such as changing the color of a photograph, it's particularly adept at the types of tedious tasks that most people find painfully boring. Sorting this or finding copies of that are the types of repetitive tasks that computers are good at.

Many tedious, repetitive tasks in a digital photography workflow can be simplified using Aperture. You've already seen how the Lift and Stamp tools can be used to speed the process of applying the same edits to multiple images, but Aperture has other capabilities that make it possible to streamline your work.

If you ever shoot with a tethered setup (that is, with your camera connected directly to your computer so that you can immediately download and review your images), then you'll appreciate Aperture's facility for automatically importing images from the camera.

If you work in a production environment, then you'll want to take a look at how you can automate the importing of images from other people in your workgroup. In this lesson, we'll introduce you to two possibilities.

Tethered Shooting

In a tethered shooting setup, you connect a camera to your Mac using a USB or FireWire cable. As you shoot with the camera, your images are automatically transferred to your computer via the connecting cable. You need special software to run this kind of rig, which many camera vendors include on their higher-end cameras. Often, the software lets you control the camera directly from the computer, allowing you to create time-lapse sequences and more.

Using a special application included on the DVD for this book, you can configure the remote-capture software that runs the tethered rig so that images it captures are automatically imported into Aperture.

To do this, you need to be able to specify a custom folder to hold the transferred images. The Create Aperture Hot Folder application included with the DVD watches that folder and automatically tells Aperture to import each new image that appears in it.

Note that, in theory, the scheme you'll learn here will work with any remote-capture program that can save images in a specific folder. However, some remote-capture programs export extra, custom files that Aperture doesn't recognize. The Create Aperture Hot Folder application tries to filter out these custom files. At the time of this writing, the application has been successfully tested with all popular Nikon and Canon SLRs. It might also work if you're using a different type of camera. There's no risk in trying it out with an unsupported camera, so go ahead and follow along with the directions presented here.

1 Copy the Create Aperture Hot Folder application from the Lesson 12 folder on the DVD to your Applications folder.

2 Create a new folder on your desktop and call it Remote Capture.

> **NOTE ▶** You can, of course, name the file anything you want and locate it anywhere. For the sake of this exercise, it's probably easiest to use the same names we do.

3 Configure youre remote-capture software to save images into your new
 Remote Capture folder. If you're not sure how to do this, consult the doc-
 umentation that came with your software.

4 Open the Create Aperture Hot Folder application.

 The program gives a short explanation of what to do next.

5 Click Continue.

6 In the next dialog, select the Remote Capture folder that you created on
 your desktop, and click the Choose button.

 If it's not already running, Aperture will open.

7 Aperture will prompt you to enter the name of a new project into which
 your remote-capture images will be imported. Enter *Remote Capture* and
 click OK.

8 Next, choose whether you want to import the captured images as refer-
 enced images or directly into the Library as managed images.

9 Now take a shot with your camera. If everything is configured right, your
 remote-capture software should automatically download the image to the
 Remote Capture folder. Aperture should then begin importing it.

NOTE ▶ There can be a slight pause between any of these steps.

Aperture will continue to import any images placed in your Remote Capture folder until you quit the Create Aperture Hot Folder application. To quit it, just select it in the Dock and then choose File > Quit.

You can also drag images into the Remote Capture folder, and they will automatically be imported into Aperture.

Using Aperture with Automator

Automator is an application that's included with OS X version 10.4 and later. With Automator, you can easily create custom automation routines that can perform complex tasks for you. Automator performs *actions,* or individual commands, such as Choose Projects or Set IPTC Tags. An action relays data to the next action. A string of actions constitutes an Automator *workflow.* With Automator, you can easily build simple automated workflows that can be saved as standalone applications or attached to folders.

For example, you might use Automator in conjunction with Aperture to

▶ Create a special "hot folder." You can configure this hot folder so that any images dropped into it are automatically processed by Aperture. For example, you could specify that the images be assigned specific keywords, and tagged with particular IPTC tags.

▶ Create a standalone application that automatically exports all of the images from the selected project, compresses them into a ZIP archive, and then uploads them to an FTP server.

▶ Automatically open an image in Adobe Photoshop and perform operations using tools that aren't available in Aperture, and then save the image directly back into your Library.

Automator is handy not only because it allows you to automate tasks within Aperture, but also because it lets you automate processes that span multiple applications.

Building an Export Workflow

The easiest way to learn Automator is to start using it. In this exercise, we're going to build a simple workflow that exports all of the images in an album, compresses them into a ZIP file, and then attaches that ZIP file to a message using Apple's Mail.

1 Open Aperture. Then open Automator. You should find it in your Applications folder.

An empty Workflow document will appear.

The Library pane on the left side of the Workflow window displays all of the currently installed applications that can be controlled by Automator.

2 Click the Aperture icon in the Library pane. All the Aperture actions you
 can execute from within Automator will be displayed in the Action pane.

3 Click each action in the Action pane. A description of what the action does
 appears in the panel in the lower left corner of the Workflow window.

In Automator, you link actions together to create a workflow. A workflow sim-
ply does a bunch of tasks that you would normally perform by hand.

Creating the Workflow

To create a workflow, it's best to think about how you would perform a series
of tasks if you were doing them manually. In this example, the first thing we
want to do is export the images; so if we were driving Aperture ourselves, we
would need to select the album of images we want to export.

Once you've decided what task you want to perform, look through the Action
list to find the action that appears to do that task.

1 Click the Choose Albums action.

 The description says, "This action will pass references of the chosen
 Aperture albums to the next action in the workflow." Automator work-
 flows function by passing chunks of data from one action to the next for
 processing.

2 Double-click the Choose Albums action to add it to the workflow. It will
 appear in the Workflow pane on the right side of the window.

In the Workflow pane, you'll see a panel that contains controls for configuring the action. For the Choose Albums action, you'll see a list of all of the albums in your current Aperture Library.

3 Select the checkbox next to one of your albums.

4 In the Action pane, double-click the Export Versions action to add it to your workflow just beneath the Choose Albums action.

Notice there is a link between the two actions.

The link between the actions indicates that data is flowing from the first action to the second. In this case, the name of the album that you selected in the Choose Albums action is being passed on to the Export Versions action.

Now you need to configure the Export action.

5 In the Export Versions pane select "JPEG – Fit within 640 x 640" from the Export Preset pop-up menu.

The items in this menu are simply the Export presets defined in Aperture. In this case, we're telling the Export Images action to export JPEG images that have been resized to fit within 640 x 640 pixels.

6 From the Destination pop-up menu, choose Other.

7 In the dialog that appears, create a folder on the desktop called *Test Export*.

8 Click Open.

This is the location that Aperture will export your images into.

Note that at the bottom right of the Export Versions action, the output indicator says Files/Folders. This indicates that this action passes the name of a folder, in this case Test Export. This is good news for the rest of our workflow.

Compressing the Folder

After the workflow exports the images, we need it to compress the folder as a ZIP file and archive it. Aperture can't perform this function, so we'll tell Automator to use a different application.

1 Select Applications at the top of the Library pane.

The Search function at the top of the Workflow window searches the currently selected Library item. We select Library before searching to ensure that the entire Library of actions gets searched.

2 In the Search field, enter *zip*.

The Action pane shows the results. Most likely, you'll only have one entry, Create Archive. However, if you've installed any other applications that provide Automator support for file compression, then they'll appear here also.

3 Double-click the Create Archive action in the Action pane to add the action to the end of the workflow.

Now we need to configure the Create Archive action to tell it where we want the ZIP archive placed.

4 In the "Save as" field, enter a name for the archive. In this case, enter *test archive.* Leave the Where pop-up menu set to Desktop.

Setting up Mail

So, our workflow begins by selecting an album in Aperture, and it then exports the contents of that album to a folder. That folder is compressed into a ZIP archive on the desktop. Now we want to create a new message in Mail and attach the ZIP file to that message.

1 In the Search field, click the small X on the right side to clear the search criteria.

We want to be able to view all of our actions now, not just the ones that have to do with *Zip compression.*

2 In the Library pane, click Mail to view the Mail actions provided. In the Action pane, you should see New Mail Message.

3 In the Action pane, double-click New Mail Message to add it to the end of your workflow.

Note that our workflow is now running Mail instead of Aperture. You can move seamlessly from one application to another in a workflow without having to issue any special commands.

4 Configure the Mail message as desired. If you want, you can go ahead and fill in address and subject lines, or leave them blank and fill them in after running the workflow.

5 In the Action pane, double-click Add Attachments to Front Message.

This will add the archive created in step 3 of our workflow to the new Mail message created in step 4.

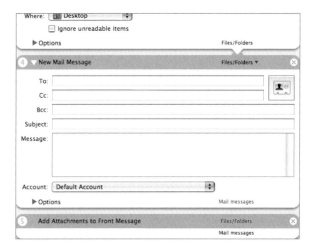

At this point we could add a Send Outgoing Message action to the end of our workflow, which would cause our new Mail message to be sent. We don't want to actually send the mail; we just want the message to be pre-pared, so we're going to end the workflow here.

6 Choose File > Save and save the workflow on your desktop. Name it Export Album to Mail.

Now, anytime you want to perform this series of tasks, you can simply double-click the Export Album to Mail file to open it in Automator.

7 Click the Run button in the upper right corner of the window, or press Command-R.

Automator will begin executing your workflow. A progress indicator in the lower left corner of each action will show where the workflow is in its execu-tion. Depending on the size of the album you choose to export, and the speed of your computer, the workflow may take more or less time. When it's finished,

you should have a new, empty message in Mail, with a ZIP file attached to it. You can now address and send the message.

This workflow demonstrates one of the biggest advantages of Automator: its ability to employ multiple applications. However, to make your workflow even more useful, you'll want to give more thought to how you save it.

Creating a Standalone Application

The workflow that we built in the previous exercise is handy, but you need to open Automator to run it. Well, you can take this workflow even further: In fact, you can create a standalone application that you can run directly from the Finder.

To give you more options let's also deselect the specific album we nominated earlier in our workflow.

1 In the Choose Albums action, click the Options disclosure triangle, and select the Show Action When Run checkbox.

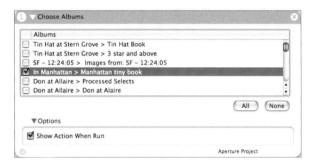

2 Deselect the album you selected before.

Now, at runtime, the workflow will display this list of albums and allow you to select one. Obviously, if you want the workflow to always export the same album, then there's no need to select this box. Using it provides more flexibility.

3 Choose File > Save As.

4 Choose Application from the File Format pop-up menu, and then click Save.

Automator will save your workflow as a standalone application.

5 Quit Automator and find the application you just created. Double-click it, and your workflow should prompt you for an Aperture album to export and then run through all the steps it did before.

Creating standalone applications provides a simple, intuitive way to access your custom workflows. However, for some tasks, you might want to employ even more automation.

Prebuilt Workflows and Other Actions

You can download a number of prebuilt workflows from Apple's Automator website, including some fantastic Automator actions that let you easily perform complex operations with a single click.

From the Automator website, automator.us/aperture, you can download the following workflows:

▶ Auto-Backup on Import

▶ Import from Desktop Hot Folder

▶ Aperture to Keynote Slideshow

▶ Export Image Metadata to Excel

▶ Auto-Import Mail Image Attachments into Aperture

▶ Create iDVD Magic DVD from Albums

▶ Create iDVD Slideshow from Albums

▶ Instant Web Publishing

▶ Burn Masters to Disk

All of these workflows are small, free, and ready to download.

Photoshop Round-Trip Action

If you find yourself sending a lot of images to Photoshop via Aperture's round-trip feature (the Open in External Editor command), then you might want to consider downloading the Photoshop Round-Trip action.

This action lets you incorporate Aperture's Open in External Editor command into your Aperture workflows. If you combine it with the Photoshop Action Pac—a collection of more than 70 Automator Actions for Photoshop—you can easily create complex workflows that take your images from Aperture to Photoshop for processing, and back again.

You can download both the Photoshop Round-Trip action and the Photoshop Action Pack for free from Complete Digital Photography (www.completedigi-talphotography.com).

Lesson Review

1. In Automator, what is the difference between a workflow and an action?

2. Does Aperture provide tethered shooting support?

3. Name two methods of executing an Automator workflow.

Answers

1. An action is an individual command performed by Automator. A workflow is a string of these commands.

2. Yes, but not on its own. You must use an AppleScript application, available from Apple and provided on this book's DVD, to facilitate tethered shooting.

3. You can execute an Automator workflow (1) by clicking the Run button from within Automator or (2) by saving the workflow as a standalone application and opening it.

Glossary

additive color The color space of computer displays. It uses primary elements composed of the light source itself to produce other colors. RGB is a common form of additive color. See also *RGB*.

Adjustments HUD A heads-up display, or floating panel of contextual controls, that enables adjustments to be applied to images.

Adjustments Inspector An area of the main window where image adjustments can be viewed or performed. The inspector shows a luminance histogram along with controls for three basic filters: exposure, levels, and white balance.

Adobe DNG Adobe's Digital Negative archival format for raw digital camera files. Aperture supports the DNG format.

Adobe RGB (1998) A commonly used color profile often used for printing. Many professional labs request that image files be delivered in this color space. See also *color space*.

album A type of folder in Aperture that contains only versions. See also *Smart Album*.

alternate The image immediately below the pick in a stack. Alternate images are used when more than one image in a stack merits the pick position. See also *pick, stack*.

ambient light The natural light in a scene, indoor or outdoor, without additional lighting supplied by the photographer.

analog-to-digital conversion The transformation of light energy voltage values captured by the camera's digital image sensor into binary (digital) numbers for processing and storage. See also *quantization*.

angle of view Determined by the focal length of the lens, *angle of view* refers to the area of the scene displayed within the frame.

aperture An adjustable iris or diaphragm in the lens through which light passes. The aperture is measured in f-stops. See also *f-stop*.

aspect ratio The ratio of height to width of a photograph. Common aspect ratios are 3.5 x 5, 4 x 6, 5 x 7, 11 x 14, and 16 x 20 inches.

B

background The area in the rear of the image appearing behind the subject. See also *depth of field, foreground*.

backlighting A light source that faces toward the lens of the camera emanating from behind the subject. Backlighting makes the outline of the subject stand out from the background, often resulting in a silhouette. See also *frontlighting, sidelighting, silhouette*.

Bayer Pattern color filter array A specific arrangement of red, green, and blue lenses attached to the surface of a CMOS sensor. There are roughly twice as many green lenses as blue and red to accommodate how the human eye perceives color. See also *complementary metal oxide semiconductor (CMOS), digital image sensor*.

bit-depth The number of tonal values or shades of a color that a pixel is capable of displaying. The number of bits is equivalent to the number of possible tonal values. See also *channel, color depth*.

bounce lighting Natural and unnatural light sources (flash and tungsten) redirected toward the subject using a reflective surface to give the effect of natural light and to fill in shadows. See also *color temperature, fill-in lighting, white balance*.

bracketing Taking three shots of the same image according to the aperture and shutter values recommended by the light meter: one shot underexposed, one shot dead-on, and one shot overexposed. The aim is to ensure the scene is captured with the correct exposure.

Browser The central storage area in Aperture, which displays thumbnails for all the photos in a given project, folder of projects, or album. Images can be selected, moved, copied, and sorted in the Browser.

burning Exposing a portion of the image longer than the rest of the image—the opposite of dodging. Burning a portion of the image results in that area being darker than other areas.

calibration The process of creating an accurate color profile for a device. Calibrating a device ensures accurate color translation from device to device. See also *device characterization*.

C

camera A photographic device usually consisting of a lightproof box with a lens at one end and either light-sensitive film or a digital image sensor at the other. See also *digital point-and-shoot camera, digital single-lens reflex (DSLR) camera*.

capture Taking an image received by the digital image sensor and storing it on the capture card in the camera. See also *camera, capture card, digital image sensor*.

capture card The device in the camera on which the digital images are stored. See also *camera, capture*.

center-weighted metering A type of metering that measures the light in the entire viewfinder but gives extra emphasis to the center of the frame. Center-weighted metering is the most common type of metering in consumer cameras. See also *light meter*.

channel This term refers to a color channel when used with regard to digital images. Color and transparency information for digital images is divided into channels. Each channel represents one of the three primary colors that combine to represent colors in the final image. The bit-depth of each is usually 8 bits, for 256 levels of color or transparency. See also *bit-depth, color depth*.

charged-coupled device (CCD) A type of digital image sensor that records pixel information row by row. See also *complementary metal oxide semiconductor, digital image sensor*.

close-up An image in which the subject usually appears within three feet of the camera. Head shots are often referred to as close-ups.

CMYK A subtractive color space used for print pieces combining varying proportions of cyan, magenta, and yellow inks to create a color that reflects the proper color of light. Black ink (K) is added to the image last to generate pure black on the page.

color depth The possible range of colors that can be used in an image. Digital images generally provide three choices: grayscale, 8-bit, and 16-bit. See also *bit-depth, channel.*

color interpolation The calculation of additional color values by the digital image sensor, which measures the levels of red, green, and blue.

color management system An application that controls and interprets the reproduction of color between devices and software for accuracy. See also *ColorSync.*

color space A model that represents part of the visible spectrum. Color from one device is mapped from the device-specific value to a device-independent value in a color space. Once in an independent space, the color can be mapped to another device-specific space. See also *device independent.*

color temperature Describes the color quality of light. Color temperature is measured in kelvins (K). See also *kelvin (K), white balance.*

colorimeter An instrument that measures the color value of a sample, using color filters. A colorimeter can determine if two colors are the same, but it does not take into account the light under which a sample is measured. Colorimeters are often used to calibrate displays. See also *calibration.*

colorimetry The science of measuring color objectively and perceptively.

ColorSync A color management system that has been part of the Mac operating system for about ten years. In Mac OS X, ColorSync is thoroughly integrated with the entire operating system.

ColorSync Utility A centralized application for setting preferences, viewing installed profiles, assigning profiles to devices, and repairing profiles that do not conform to the current ICC specification.

Commission Internationale de l'Eclairage (CIE) A organization established in 1931 to create standards for a series of color spaces representing the visible spectrum of light. See also *color space, device independent, LAB plot.*

"compare" image In Aperture, the photo against which other candidates are compared when a "select" image or stack pick is being chosen.

Compare mode An advanced method of evaluating one image against other images. Accessed through the Viewer mode, it can select any image (which it then indicates by a yellow border) against which other images can be compared.

complementary metal oxide semiconductor (CMOS) A type of digital image sensor capable of recording the entire image provided by the pixels in parallel (essentially all at once), resulting in a higher rate of data transfer to the storage device. See also *charged-coupled device (CCD), digital image sensor.*

compositing A process in which two or more digital images are combined into one. See also *effects.*

composition The arrangement of elements in a scene.

compression The process by which digital image files are reduced in size. *Lossy* compression refers to the reduction of file sizes through the removal of redundant or less important image data. *Lossless* compression reduces file sizes by mathematically consolidating redundant image data without discarding it. See also *LZW compression.*

contact sheet A print preset in Aperture that provides a selection of thumbnail-sized images with or without associated metadata. Contact sheets in Aperture are similar in appearance to contact prints made by exposing negatives against photographic paper.

contrast The difference between the lightest and darkest values in an image. The difference is greater in high-contrast images than in low-contrast images, which can look "flat." See also *density, flat.*

crop Trimming part of an original image. Cropping an image usually results in a more effective composition. See also *effects.*

definition The clarity of details in an image. See also *resolution.*

D

densitometer An instrument designed to measure the optical density of photographs. See also *device characterization.*

density The ability of an image to reproduce distinct dark colors. An image with high definition in the darker colors is referred to as dense. See also *contrast, flat.*

depth of field The area of the image that appears in focus from the foreground to background. Depth of field is determined by a combination of the opening of the aperture and the focal length of the lens. See also *aperture, background, focal length, foreground.*

desaturate To remove color from an image. Desaturation of 100 percent results in a grayscale image. See also *saturation.*

destination profile The working-space profile that defines the results of a color conversion from a source profile.

Detail Images panel Area of the Webpage Editor where images can be clicked to display a detailed view.

device characterization The process of creating a unique, custom profile for a device, such as a monitor or printer. Characterizing a device involves specialized dedicated hardware and software to determine the exact gamut of the device. See also *calibration.*

device dependent Refers to color values that are contingent on the ability of a device to reproduce those colors. For example, some colors on a display are not capable of being produced by a printer. The colors on the display are outside the gamut of the printer and are thus device dependent. See also *gamut.*

device independent Describes standard color spaces, like CIELAB and XYZ, in which the interpretation of a color is not dependent on a specific device. See also *color space, Commission Internationale de l'Eclairage (CIE).*

diffused lighting Light scattered across a subject or scene. Diffused lighting results in low contrast and detail, as seen in images captured outdoors on an overcast day. See also *contrast.*

digital A description of data stored or transmitted as a sequence of 1s and 0s. Most commonly, refers to binary data represented by electronic or electromagnetic signals. JPEG, PNG, RAW, TIFF, and Adobe DNG files are all digital.

digital camera A camera that captures images in an image sensor rather than on film. The images can then be downloaded to a computer.

digital image sensor Located at the image plane inside a camera, it is a computer chip that converts the light it senses into data by measuring the levels of red, green, and blue and assigning values to each pixel in the image. See also *charged-coupled device (CCD), complementary metal oxide semiconductor.*

digital noise Misinterpreted pixels occurring as the result of high ISO settings, also known as chrominance signal-to-noise ratio. Random bright pixels, especially in solid colors, are the result of digital noise. See also *ISO speed.*

digital point-and-shoot camera A lightweight digital camera with a built-in autofocus feature aptly named after the two steps required of the photographer to capture an image. The lens, aperture, and shutter are one assembly, usually irremovable from the camera. See also *camera, digital single-lens reflex (DSLR) camera.*

digital single-lens reflex (DSLR) camera An interchangeable-lens camera in which the image created by the lens is transmitted by a reflexing mirror through a prism to the viewfinder. The mirror reflexes, or moves up, so as not to block the digital image sensor when the shutter is open.

disclosure triangle A small triangle that is clicked to show or hide details in the Aperture interface.

display The computer's monitor.

distort Perform an adjustment that changes the shape or composition of an image.

dodging Limiting the exposure of a specific portion of an image—the opposite of burning. Dodged areas appear brighter than the rest of an image. See also *burning, effects, exposure.*

dot gain A printing press term used to describe the enlargement of halftone dots as they are absorbed into paper. Dot gain can affect the quality of an image's appearance by reducing the amount of white reflected off the paper.

dots per inch (dpi) A printer resolution value referring to the maximum number of dots within a square inch. See also *resolution.*

drift Changes in the way a device reproduces color over time. The age of inks and type of paper can cause a printer's color output to drift. See also *device characterization, gamut.*

drop shadow An effect that creates an artificial shadow behind an image. Typically used on websites and in photo albums to create the illusion of three dimensions.

dust and scratch removal See *Spot & Patch.*

dye sublimation A type of printer that creates images by heating colored ribbon to a gaseous state, bonding the ink to the paper.

E

editing Arranging and deleting images. See also *photo editing.*

effects A general term used to describe unnatural visual elements introduced into an image. See also *compositing, filters.*

electromagnetic radiation A type of energy ranging from gamma rays to radio waves that also includes visible light. See also *light.*

embedded profile The source profile saved in the digital image file. See also *device characterization, profile.*

emulsion Tiny layers of gelatin found in film consisting of light-sensitive elements. When the emulsion is exposed to light, a chemical reaction occurs resulting in an image. See also *film.*

EXIF Short for Exchangeable Image File. The standard format for storing information about how an image was shot, such as shutter speed, aperture, white balance, exposure compensation, metering setting, ISO setting, date, and time. See also *IPTC, metadata.*

export The process of formatting data in such a way that it can be understood by other applications. In Aperture, images can be exported in their native RAW format, JPEG, TIFF, and PNG. The EXIF and IPTC metadata associated with an image can be exported as well.

exposure The amount of light in an image. Exposure is controlled by the aperture, which limits the intensity of light, and the shutter, which sets the duration of time that light comes into contact with the digital image sensor. Exposure affects the overall brightness of the image as well as its perceived contrast. See also *aperture, contrast, digital image sensor, shutter.*

extended desktop mode A setting in System Preferences that allows the workspace to span multiple monitors. See also *mirroring.*

F

fill-in lighting The use of an artificial light source, such as daylight lamps or a flash, to soften a subject or to fill in shadows. See also *bounce lighting, color temperature, white balance.*

film A flexible transparent base coated with a light-sensitive emulsion capable of recording images. See also *emulsion.*

filmstrip In Aperture, a panel along the bottom or side of the display that is seen in Full Screen mode. It shows thumbnails of all the images being reviewed.

filters (1) Modifiable search criteria used in Smart Albums to return a specific selection of images. (2) Effects that change the visual quality of the image or clip to which they're applied. (3) A colored piece of glass or plastic designed to be placed in front of the lens to change, emphasize, or eliminate density, reflections, or areas within the scene. See also *compositing, density, effects, Smart Album.*

finishing Applying the final adjustments to a digital image just prior to distribution. Finishing may involve exporting a RAW image file as a JPEG for publication on a website. Finishing may also involve applying an additional gamma adjustment upon export. See also *export.*

FireWire Apple trademark for the IEEE 1394 cabling technology used to connect external devices to computers. Well suited to moving large amounts of data quickly, it is the most common connection for vaults in Aperture.

fixed lens See *prime lens.*

flash A device either on a camera or attached to the camera that emits a brief intense burst of light when the shutter-release button is pressed. Flashes are synchronized with the shutter to obtain a correctly exposed image in low-light situations. See also *exposure, hot-shoe bracket.*

flat Lacking of density in an image due to a low contrast. See also *contrast, density.*

focal length The distance from the rear nodal point of the lens to the point where the light rays passing through the lens are focused onto the image plane. Focal lengths are measured in millimeters (mm). It determines how much of the scene is included in the image and how large the objects are.

foreground The area of the image between the subject and the camera. See also *background, depth of field.*

frontlighting Refers to a light source that faces toward the subject emanating from the direction of the camera. See also *backlighting, sidelighting.*

f-stop The ratio of the focal length of the lens to the diameter of the opening of the aperture. See also *aperture.*

Full Screen mode Aperture's feature that displays images as large as the screen permits.

G

gamma A curve that describes how the middle tones of an image appear. Gamma is a nonlinear function sometimes confused with brightness or contrast. Changing the value of the gamma affects middle tones while leaving the whites and blacks of the image unaltered. Gamma adjustment is often used to compensate for differencses between Macintosh and Windows video cards and displays.

gamut The range of colors an individual color device is capable of reproducing. Each device capable of reproducing color has a unique gamut determined by age, frequency of use, and other elements such as inks and paper. See also *device characterization, device dependent, ICC profile.*

gamut mapping The process of identifying colors outside a device's gamut and then calculating the nearest colors within its gamut. See also *color space.*

H

highlights The brightest areas of the subject or scene. See also *contrast.*

histogram A chart that displays the frequency with which pixels of various intensities (dark or light) appear in an image.

hot-shoe bracket An apparatus at the top of a camera designed to hold a portable flash. See also *flash.*

HUD Heads-up display: a floating panel with various options. Different HUDs can adjust levels, increase brightness, modify color temperature, assign keywords, straighten horizons, or make any other adjustments.

hue An attribute of color perception, also known as color phase. Red and blue are hues.

ICC profile Created as a result of device characterization, an ICC profile contains the data about a device's exact gamut. See also *device characterization, gamut.*

importing Bringing digital image files of various types into a project. Imported files can be created in another application, captured from a camera or card reader, or brought in from optical media, networked volumes, an iPhoto library, or another Aperture project. See also *project.*

Import arrow Armlike arrow that appears along with the Import dialog and points to the Library or a project in the Projects panel.

Import Arrow button Button with an arrow icon that appears on the Import arrow. Clicking it will initiate an import.

Import button Button in the lower right corner of the Import dialog. The text on the button changes depending on what is selected for import. Clicking it will initiate an import.

inspector An area in a window that enables a user to examine and edit settings. See also *Adjustments Inspector, Metadata Inspector.*

International Color Consortium (ICC) An organization established to create the color management standard known as the ICC profile. ICC profiles are universally accepted by hardware and software vendors. See also *ICC profile.*

IPTC Short for International Press Telecommunications Council. IPTC metadata is used by photographers and media organizations to embed keywords in the image files themselves. Large publishers typically use image management systems to quickly identify images based on their IPTC information. See also *EXIF, metadata, tag.*

ISO speed The relative sensitivity of film provided as a benchmark by the International Standards Organization (ISO). In digital cameras, the minimum ISO rating is defined by the sensitivity of the digital image sensor. See also *digital image sensor, digital noise.*

J

JPEG An acronym for Joint Photographic Experts Group, JPEG is a popular image file format that creates highly compressed graphics files. Less compression results in a higher-quality image.

K

kelvin (K) A unit of measurement used to describe color values of light sources, based on a temperature scale that begins at absolute zero. See also *color temperature.*

keyword A word that describes the characteristics or content of the image or gives other information about it, such as the client's name. In Aperture, keywords are added to image versions and saved as metadata. See also *IPTC.*

Keywords HUD A heads-up display from which keywords can be dragged to an image or a group of images.

L

LAB plot A visual three-dimensional representation of the CIELAB color space.

layout The arrangement of text, images, and other graphic elements. Aperture has three preset workspace layouts: Basic, Maximize Browser, and Maximize Viewer.

lens A complicated series of elements—usually glass—constructed to refract and focus the reflective light from a scene at a specific point. See also *camera, digital image sensor.*

Library See *master Library.*

Lift and Stamp A procedure in Aperture that takes (via the Lift tool) a set of adjustments or metadata from one image and applies them (via the Stamp tool) to any number of other images.

light Visible energy in the electromagnetic spectrum with wavelengths ranging between 400 and 720 nanometers. See also *electromagnetic radiation.*

light meter A device capable of measuring the intensity of reflective light. Light meters are used as an aid for selecting the correct exposure settings on the camera. Most cameras have internal light meters. See also *center-weighted metering.*

Light Table Area of the Aperture interface where free-form arrangements of images can be made. Multiple Light Tables can be saved as part of any project.

Loupe A lens-shaped tool in Aperture that, when dragged over an image, instantly shows a 100-percent magnification of the portion of the image within the circular viewing area, and can increase magnification up to 1,600 percent. A second Loupe tool, the Centered Loupe, is fixed in position, and magnifies whatever the cursor moves over.

luminance A value describing the brightness of a digital image.

LZW compression A lossless data-compression algorithm developed by Abraham Lempel, Jakob Ziv, and Terry Welch in 1984. LZW compression algorithms are typically used with JPEG and TIFF graphic files to reduce the file size for archiving and transmission at a ratio of 2.8:1. See also *compression, JPEG, TIFF.*

M

managed image An image stored in the Aperture Library.

mask An image used to define areas of transparency in another image. See also *compositing, effects.*

master The source image file copied from a computer's file system or a camera's capture card. In Aperture, the master file is never altered. Anytime a change is made to the image, that change is applied to a version. See also *project, version.*

master Library The place where master images are kept. The default location is in the Pictures folder of the home directory, but the Library can also be on an external hard disk. See also *vault.*

matte An effect that uses information in one layer of a digital image to alter another layer. Matte filters can be used by themselves to mask out areas of an image, or to create alpha channel information for an image to make a transparent border around the image that can be composited against other layers.

megapixel One million pixels. For example, 1,500,000 pixels is 1.5 megapixels. See also *pixel*.

metadata Data describing other data, including image files. Databases use metadata to track specific forms of data. Aperture automatically extracts all industry-standard EXIF and ITPC metadata when importing images and also allows metadata such as copyright, captions, and keywords to be added.

Metadata Inspector Where all the information associated with an image is displayed in the Aperture interface. Industry-standard metadata can also be added in the inspector.

midtones The values in an image between absolute white and absolute black.

mirroring Displaying the same image on two or more monitors. See also *extended desktop mode*.

N

negative Developed film with a reverse-tone image of the subject or scene. See also *emulsion, positive*.

noise See *digital noise*.

nondestructive Said of a process that does not alter an object. Aperture is a nondestructive image-editing program because the original digital file imported from a camera or card reader remains untouched.

O

offset press A type of professional printer used for high-volume products such as magazines and brochures. Offset printing presses establish ink in lines of halftone dots to produce images on the page.

opacity The level of an image's transparency.

overexposure The result of exposing a scene too long. Overexposed scenes appear too bright. See also *exposure, underexposure*.

P

panning Moving the camera along with a moving subject in order to keep the subject in the frame. Panning a fast-moving subject with a slow shutter speed usually results in the subject remaining relatively in focus while the rest of the scene is blurred or stretched in the direction of the camera movement.

panorama Usually refers to a scenic landscape image with a wide aspect ratio. See also *aspect ratio.*

photo editing The process of choosing selects, as well as culling unwanted images (known as rejects), from a group of images. See also *ratings, reject, select.*

pick The image, usually the best, that represents a stack. See also *alternate, stack.*

pixel Picture element. The smallest discernible component of a digital image, as well as the smallest element on the display that can be assigned a color. See also *megapixel.*

PNG An acronym for Portable Network Graphics. PNG is a bitmapped graphic file that has been approved by the World Wide Web Consortium to replace patented GIF files. PNG files are royalty free.

polarizing filter A filter placed on the front of the lens capable of selectively transmitting light traveling on one plane while absorbing light traveling on other planes. Polarizing filters are capable of reducing unwanted reflections on windows and shiny surfaces. They are also used to darken the sky. See also *filters.*

positive Refers to developed film where the tonal relationship of the subject or scene is the same on film as viewed by the eye; also known as a slide. See also *emulsion, negative.*

presets Settings that can be customized, duplicated, and saved for various operations such as exporting or printing. Export presets, for example, can specify the file format, resolution, bit-depth, metadata, and watermark to be applied to an image or a group of images during export.

prime lens A lens with a fixed focal length that cannot be changed.

profile A compilation of data on a specific device's color information, including its gamut, color space, and modes of operation. A profile represents a device's color-reproduction capabilities—and is essential to making the color management system work. See also *device characterization, gamut.*

project In Aperture, the top-level file that holds all the master files, versions, and metadata associated with a shoot. A project can include up to 10,000 master files with as many versions as needed, plus elements such as albums, web gallery albums, journals, book layouts, and Light Table sessions. Projects can also reference versions from other projects. These referenced versions maintain links to the master files in their original projects. See also *album, master.*

Projects panel The Projects panel is where images in Aperture are organized into projects, albums, and Smart Albums.

PSD The file extension for Photoshop Document. PSD files are proprietary graphic files for Adobe Systems.

Publish to .Mac button A one-click way to publish a website that has been designed and laid out in Aperture.

Q

quantization The process of converting a value derived from an analog source into a digital value.

Query HUD A free-form search field. From the Query heads-up display live filtering can be done of any album, project, folder, the Browser, or the entire Library. Pinpoint searches can be based on several criteria, then saved for later use.

QuickTime A cross-platform multimedia technology developed by Apple Computer. Widely used for editing, compositing, CD-ROM, Web video, and more.

R

RA-4 A type of professional printer capable of printing digital files on traditional photographic paper. RA-4 printers use a series of colored lights to expose the paper, which blends the colors together to produce continuous-tone prints.

RAID Acronym for redundant array of independent disks. A RAID array can provide a photographer with large image libraries with many gigabytes of high-performance data storage.

rangefinder Refers to an apparatus found on many cameras used to help focus the image. See also *camera, viewfinder.*

raster image processor (RIP) A specialized printer driver that replaces the driver that comes with a printer. It takes input from applications and converts, or rasterizes, the information into data that the printer understands so that it can put dots on a page.

ratings Part of the standard set of metadata in Aperture, which can apply 1 to 5 stars to an image. The image identified as the best shot in the sequence, the "pick," tops a stack. It's the only image visible until the stack is opened again.

RAW The original bit-for-bit uncompressed digital image file captured by a camera. Aperture works with RAW images through every step of the digital workflow and supports the RAW formats from all leading digital camera manufacturers.

red-eye The phenomenon of glowing red eyes in photographs. In Aperture, the Red Eye tool eliminates the effect.

referenced image An image stored outside the Aperture Library, but for which Aperture retains a proxy image that points to the master image location.

reject In Aperture, a negative rating applied to an image as part of the photo-editing process. See also *photo editing, ratings, select.*

relative colorimetric A rendering intent suitable for photographic images. It compares the highlight of the source color space to that of the destination color space and shifts out-of-gamut colors to the closest reproducible color in the destination color space.

rendering intent The method by which colors that are out of gamut for a selected output device are mapped to that device's reproducible gamut.

resolution The amount of information a digital image is capable of conveying. Resolution is determined by a combination of file size (number of pixels), bit-depth (pixel depth), and dpi (dots per inch).

RGB Abbreviation for *red*, *green*, and *blue*. A color space commonly used on computers in which each color is described by the strength of its red, green, and blue components. The RGB color space has a very large gamut, meaning it can reproduce a very wide range of colors. This range is typically larger than can be reproduced by printers. See also *additive color*.

S

saturation The intensity of color in an image. Saturated colors are perceived to have a "purer" look resulting from the absence of the color gray. See also *desaturate*.

scale An adjustment that changes the size but not the aspect ratio of an image.

select A superior image selected for display or for review by a client.

selective focus The process of isolating a subject by using an f-stop that produces a shallow depth of field. See also *depth of field*.

shortcut menu A menu accessed by pressing the mouse button and the Control key, or by pressing the right mouse button.

shutter A complicated mechanism, usually consisting of a blade or curtain, that precisely controls the duration of time that light passing through the lens remains in contact with the digital image sensor.

shutter priority A setting on certain cameras that automatically sets the aperture for a correct exposure based on the shutter speed set by the photographer. See also *exposure*.

shutter speed The amount of time the shutter is open or the digital image sensor is activated or charged. Shutter speeds are displayed as fractions of a second, such as ⅛ or ½₅₀.

sidelighting Refers to light hitting the subject from the side, perpendicular to the angle of the camera. See also *backlighting, frontlighting*.

silhouette An image where the subject is a solid dark shape against a bright background. Extreme backlighting, such as a sunset, can create a silhouette effect when a subject is placed in the foreground. See also *backlighting, foreground*.

single image print Based on a print preset in Aperture, refers to a single image printed on a single sheet of paper.

slide See *positive*.

slideshow An animated presentation of a series of images. In Aperture, slideshows can be combined with music to present a series of images for display across up to two monitors.

Smart Album In Aperture, a dynamic collection of images based on defined criteria entered in the Query HUD.

Smart Web Gallery Album An automatically updated online portfolio. Like Smart Albums, Smart Web Gallery Albums consist of images selected according to criteria entered in a Query HUD.

soft lighting See *diffused lighting*.

soft proof The onscreen simulation by a display of the output from printer or press.

source profile The profile of a file before it undergoes color conversion.

spectrophotometer An instrument that measures the wavelength of color across an entire spectrum of colors. It can be used to profile both displays and printers.

Spot & Patch A tool in Aperture that automatically removes blemishes from an image either by blending the surrounding image texture or by cloning pixels from another part of an image to repair a problem area.

sRGB A common working space designed to represent the average PC monitor. Because of its small gamut, it is suitable for Web graphics but not for print production.

stack A group of similar versions that Aperture sequentially numbers and connects to a master file. Stacks can be manually assembled or automatically created from photos shot within a specified interval (one second to one minute). See also *alternate, pick*.

Stack button Button that is clicked to open and close a stack.

subtractive color Images with color elements derived from the light reflected off the surface of an object. CMYK is a common form of subtractive color. See also *CMYK*.

SWOP An acronym for Specifications for Web Offset Publications, a standard printing-press profile. *Web* here refers to a web press, not the Internet.

T

tabs In Aperture, tabs delineate projects in the Browser and functions within the inspectors.

tagged Refers to an image that has been saved in a working-space profile.

target A reference file used to profile a device such as a scanner or digital camera. It often contains patches whose color values have been measured. The output from a device is then compared with the target. See also *device characterization*.

template One of Aperture's professionally designed formats. Book templates can be used for proof books, stock books, art collections, special occasion albums, and picture books. Web templates can be used to create photo galleries and journals.

theme A customizable webpage layout that works as the starting point for a web gallery. The default layout is the Stock theme. Others include the Proof, Special Occasion, and Art Collection themes.

Thumbnail Resize slider Slider below the Browser and in the Full Screen mode filmstrip.

TIFF An acronym for Tagged Image File Format. TIFF is a widely used bitmapped graphics file format, developed by Aldus and Microsoft, that handles monochrome, grayscale, 8- and 24-bit color.

toolbar A strip of buttons on the default layout of Aperture's main window. Clicking them will make basic adjustments to an image. From left to right the buttons are the Selection tool, Rotate Left tool, Rotate Right tool, Straighten tool, Crop tool, Spot & Patch tool, Red Eye tool, Lift tool, and Stamp tool.

transition A visual effect applied between the display of images in a slideshow. Aperture offers settings for the duration of the cross-dissolve between images.

tungsten light Refers to a type of light with low color temperature. Tungsten light sources usually include household lamps but should not be confused with fluorescent. See also *color temperature, white balance.*

underexposure The result of not exposing a scene long enough. Underexposed scenes appear dark. See also *exposure, overexposure.*

U

untagged Refers to a document or an image that lacks an embedded profile.

vault Aperture's method of archiving an entire Library is to create a mirror image of the Library on an external device, such as a FireWire drive. Any number of vaults can be connected to a computer. Aperture indicates by color which files need backing up.

V

version The file containing all the metadata and adjustment information applied to an image. In Aperture, only versions are changed. The master image files are never touched.

Viewer A panel in Aperture that displays up to ten currently selected images in the Browser. Adjustments can be made on images in the Viewer.

viewfinder The part of the camera designed to preview the area of the scene that will be captured by the digital image sensor. See also *camera, digital image sensor.*

vignetting (1) Darkening, also known as fall-off, at the corners of the image as a result of too many filters attached to the lens, a large lens hood, or poor lens design. (2) A filter in Aperture designed to correct unwanted vignetting in the image. See also *filters.*

W

watermark A visible graphic or text overlay applied to an image indicating the image is protected by a copyright. Watermarks are used to discourage the use of images without explicit permission.

web gallery Images arranged in the Webpage Editor or on the web. A web gallery album is an album created in Aperture with the images for the web gallery.

web journal Images and text arranged in the Webpage Editor or on the web. A web journal album is the album created in Aperture with the images for the web journal.

Webpage Editor An interface that appears in place of the Viewer when a web gallery album or a web journal album is created or selected.

white balance An adjustment that changes the color temperature of a digital image. The goal is to reproduce white as true white. For example, if the white in an image is too yellow due to incandescent lighting, white balancing adds enough blue to make the white appear neutral. See also *color temperature, kelvin (K)*.

white point The color temperature of a display, measured in kelvins. The higher the white point, the bluer the white; the lower the white point, the redder. The native white point for a Mac is D50 (5000 kelvins); for Windows, it is D65 (6500 kelvins). See also *color temperature, kelvin (K)*.

wide-angle lens A lens with a short focal length that takes in a wide view. The focal length of a wide-angle lens is smaller than the image frame. See also *lens*.

working space The color space in which a file is edited. It can be different from the original color space of the file, which is called the document color space. Working spaces are based either on color-space profiles such as Apple RGB or on device profiles.

workspace The arrangement of the Browser, Viewer, Adjustments Inspector, Metadata Inspector, Projects panel, and other interface elements. There are multiple workspaces in Aperture.

Index

Training Series

pple's hardware, Mac OS X, and iLife applications!

serves as both a self-paced learning tool and the official Training and Certification Program. You can work through this urse or attend a class at an Apple Authorized Training Center. center near you, go to www.apple.com/training

Mac OS X Support Essentials
0-321-33547-3 • $49.99

Mac OS X Server Essentials
0-321-35758-2 • $54.99

Desktop and Portable Systems, Second Edition
0-321-33546-5 • $54.99

Mac OS X System Administration Guide, Volume 1
0-321-36984-X • $59.99

Mac OS X System Administration Guide, Volume 2
0-321-42315-1 • $54.99

iWork '06 with iLife '06
0-321-44225-3 • $34.99

iLife '06
0-321-42164-7 • $34.99

GarageBand 3
0-321-42165-5 • $39.99

The Apple Pro Training Series

The best way to learn Apple's professional digital video and audio software!

Final Cut Pro 5
0-321-33481-7 • $49.99

Advanced Editing Techniques in Final Cut Pro 5
0-321-33549-X • $49.99

DVD Studio Pro 4
0-321-33482-5 • $49.99

Aperture 1.5
0-321-49662-0 • $49.99

To see a full list of Apple Pro Training Series, visit: **www.peachpit.com/appleprotraining**